The Apu Trilogy

THE INDIA LIST

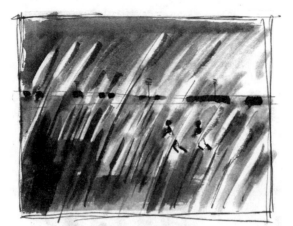

Satyajit Ray

THE APU TRILOGY

English version based on the original films
in Bengali by Shampa Banerjee

LONDON NEW YORK CALCUTTA

SEAGULL BOOKS, 2019

English version and introductory material © Seagull Books 2003
Original screenplays © 2015 Sandip Ray
First published by Seagull Books in 1985
Original drawings by Satyajit Ray

Second printing, 2021

ISBN 978 0 8574 2 643 7

British Library Cataloguing-in-Publication Data
A catalogue record for this book is available from the British Library

Typeset by Seagull Books, Calcutta, India
Printed and bound by WordsWorth India

CONTENTS

Preface to the First Edition

The Apu Trilogy was not conceived as a trilogy. When we made *Pather Panchali* ['Song of the Road'], we couldn't think beyond the film. The critical and box-office success of *Pather Panchali* triggered off *Aparajito* ['The Unvanquished'], which flopped and left me confused as to what I should do next. I made two contrasted films—*Parash Pathar* and *Jalsaghar* ['The Music Room']—by which time *Aparajito* had gone on to win the top prize at the Venice film festival. It was at the press conference in Venice that I was asked if I had a trilogy in mind. I found myself saying yes. At that time I didn't know if there was a third film in Bibhutibhusan's novel. I came back home, reread *Aparajito*, and discovered *Apur Sansar* ['The World of Apu'] in it.

Both *Pather Panchali* and *Aparajito* are largely the work of amateurs as far as the externals of technique are concerned. Both films came to inordinate lengths when first edited, and had to be whittled down, sometimes leading to the omission of entire scenes. By the time of *Apur Sansar*, we had acquired a certain amount of professional competence. The script here was tighter, and so was the shooting. As a result, nothing was found to be redundant at the time of cutting.

All three films of the trilogy have long stretches of silence. This called for a greater amount of background music than is normally required. Two sequences in *Pather Panchali*, both virtually wordless, were conceived in terms of music. One was the sequence of the rain,

and the other the long episode with Apu following the death of Durga. For the first, Ravi Shankar provided a three-minute piece on the solo sitar in a raga which is conventionally associated with rain—*Desh*. For the sombre passage following Durga's death, the raga chosen was *Todi*.

Music also played a crucial part in the scene where Sarbojaya's pent up feelings are released in a flood of tears as Harihar shows her the sari he has brought for Durga. Here, instead of the sound of weeping, we hear the dilruba's soulful lament in the upper reaches of the *raga Patdeep*.

The main theme of *Pather Panchali*, usually heard on the bamboo flute, evolved in Ravi Shankar's mind even before he had seen the film. It was certainly a stroke of inspiration. Also inspired are certain musical motifs in the other two films. The *raga Jog* is the basis of the melody which is heard in an impassioned outburst upon the death of Harihar in *Aparajito*. The same motif serves to suggest Sarbojaya's loneliness in the later stages of the film. Similarly inspired is the use of the poignant *raga Lachari Todi* in *Apur Sansar* to represent the Apu-Aparna relationship.

There is one scene in *Apur Sansar* which is crucial from the point of view of music. It shows Apu's aimless wanderings after Aparna's death, and ends with him throwing away the manuscript of his novel in a gesture of renunciation. The music here, scored for flute and strings, has the noble simplicity of a Vedic hymn.

A Note on the Text

This book has taken a long time in the making. Eight years ago, when my husband and I first sat at a Steenbeck in the Film and Television Institute of India, viewing the three films and taking copious notes on each shot, it was only an idea—something we wanted to do, but had no practical means of doing. To actually produce the book—and we had decided it must be produced well—we had to wait till Seagull Books came into being almost three years ago. I started working on the scripts; it took me a long time, being initially a labour of love, which had to take a second place beside my daily professional routine. In the end the routine went out by the window, and the script took its place. But by that time a whole year and more had passed. When I brought the first draft to Mr Ray, there followed a period of bad luck; he was not keeping well, and it was only after recovering from his operation that he took a long look at the draft and announced that he was unhappy with the way we at Seagull had conceived the book. Two months later I was back with a reworking of the draft. He took another long look at it, frowned at the wall and scribbled all over my nicely typed sheets. But this time, to my relief, he did not look unhappy.

At this point in the narrative it is necessary to explain the difference between the other Seagull scripts and the *Apu Trilogy*. So far we have always given a detailed shot-by-shot description of the film,

compressing only when a series of shots either depicted a single uncomplicated piece of action or were used to create a composite mood; we aimed at a readership that would include students of the cinema. Originally it was in this style we began reconstructing from the finally edited films of the trilogy. But Mr Ray asked for a more readable narrative style, such as used by Bergman or Antonioni in their screenplays. The problem was that these were often written before the film was made and therefore represented dramatic sequences rather than the physical boundaries of each shot in the final edited version. They were also essentially the director's statement of what he had felt and desired to express in the film. For my part, I was depending on a cinematic experience in which I could only play the role of a viewer. All I can say is that we have tried our best, and Mr Ray has generously given his time revising the final draft. He has provided a great many of the stills that we have reproduced, and written an introductory piece with special reference to the musical themes used in the trilogy. We are grateful to him for his interest in the project and his cooperation.

Support and encouragement has come from various quarters. Mr P. K. Nair, Director, National Film Archive of India, allowed us continuous use of a Steenbeck for days to view the prints of the films, which were also provided by him. Ms Manjushree Chowdhury and Dilip Ghosh of Little Cinema (Calcutta) Private Limited helped me to untangle a knotty problem and provided some rare stills of *Aparajito*. Nemai Ghosh enthusiastically produced many more stills from his personal collection. Satish Bahadur, Professor Emeritus, Film Appreciation, Film and TV Institute of India, gave me the censor script of *Pather Panchali* and his personal notes on the trilogy. We are grateful to all of them.

In translating the dialogue, I came upon some curious problems, especially in the first two films of the trilogy. Though no identifiable dialect has been used in the village sequences, beyond a broad rural accent, words often brought with them their own local associations

that would be destroyed in translation. To keep the flavour of the language, I have retained the localization inherent in the spoken word, as well as some of the images and actions. Taking stock of the Indian words and allusions in the book, we came to the conclusion that most of them could be bunched together under a set of broad headings. So they go into an appendix to this note, instead of a glossary. I should also mention here that the dialogues were translated mostly from a direct transcript made during the viewing of the films, the exception being *Apur Sansar*, where, following Mr Ray's suggestion, we used a major portion of Norman Clare's translation, which Asit Chowdhury of Chhayabani Pictures Private Limited kindly made available to us.

The Indian words and allusions in the scripts can be categorized in the following way:

Relationships

The village community in a typical Bengal village is closely knit within a network of economic or social relationships, and often appears as an extension of the family, with people addressing one another in terms common within the family circuit. The terms of address used in the trilogy are often familial terms used for people who do not actually belong to the family, while in other cases they define familial relationships. *Thakur-mashai* is a general term of respect for a Brahmin and a priest; *Ma-thakrun* is the feminine form, for any older Brahmin woman. *Dada-thakur*, or its more colloquial form, *Da-thakur*, would be a term of address for a Brahmin when addressed by someone belonging to a lower caste. The *kathak-thakur* was a professional narrator or reader of the scriptures. *Thakrun* is a more general mode of address denoting respect towards an elder: feminine of *Thakur*. *Ginni* (wife) is often used as a suffix to a surname to refer to a married woman, as in *Mukhujje-ginni*. Incidentally, *Chatujje* and *Mukhujje* are popular, colloquial distortions (anglicized as Chatterjee and Mukherjee) of Chattopadhyay and Mukhopadhyay, common Brahmin family

names. *Chakkotti* is, similarly, a colloquial distortion of Chakravarty, another Brahmin family name. *Mashai* would be a common suffix to a man's surname, to denote respect. *Thakur-po* and *Thakur-jhi* are brother-in-law and sister-in-law respectively, specifically one's husband's brother and sister. *Khuro* and *Khuri* are uncle and aunt respectively, specifically one's father's brother and his wife. *Bou* is wife, but *Bou* and *Bou-ma* are terms of address for both wife and daughter-in-law. *Bara-bou* is the eldest daughter-in-law of the family; her husband, the eldest son of the family, may also address his wife thus. *Sejo-bou* or *Sejo-thakrun* is the wife of the third son of the house. *Bou-than*, an abbreviation of *Bou-thakrun*, is sister-in-law, more specifically one's elder brother's wife. *Notun* is new. The name *Notun-bou*—the new wife—was probably given to Sarbojaya when she came to the village as a new bride, and it stuck to her. *Notun* or its abbreviation, *naw*, is also a prefix to indicate the fourth in seniority among the children of the same parents, and by extension goes for the wife of the male. *Dada*, used by itself or shortened to *-da* as a suffix to a man's name, denotes an elder brother, or by extension any man not actually related but older and close enough. *Didi* and *-di* are the feminine parallels. *Na-di* is a popular abbreviation of *Notun-di*, the fourth in seniority among sisters. *Ranga-di* is an elder sister, usually the fifth or lower in a scale of seniority. *Khoka*—little boy—is often used as a pet name. Apu is called *Khoka* by his father. Any elder can call a child *Khoka*.

Clothes, Decorations for the Body, etc.

The dhoti is the length of white cloth worn by Indian men in place of trousers. The bindi is a small, circular decorative mark on the forehead worn by women. *Alta* is the lac-dye used by Hindu women to colour the edges of their feet.

Entertainments

The jatra is a traditional theatre in the round, popular in eastern India. Originally more operatic, it has now developed into a 'heroic', ranting

style, with loud musical support, and colourful costumes. The Ram-lila is an operatic spectacle, illustrating the life and adventures of Rama, the seventh incarnation of Lord Vishnu, and the hero of the epic Ramayana, and is widely performed all over northern India in September–October. The best known performance takes place in Ramnagar near Benaras, over a whole month, spread over a number of 'sites' specified for specific episodes of the epic story. The Bauls are a class of religious minstrels singing in a special mode in a rich allegorical style, elaborating on subtleties of doctrine in terms of the most mundane symbolism. The shehnai is a wooden wind instrument used to play the classical *ragas*, but more familiar as an almost insep-arable part of a traditional marriage ceremony in Bengal, where the shehnai players play a repertoire of melancholy *ragas* as the ceremony proceeds. The tabla, a pair of small tabors, is used to provide per-cussion accompaniment to string and wind instruments in Indian music, and also with vocal music, set to rhythm. Kabaddi is a game played between two teams of nine ranged on either side of a central line. Each player when his turn comes runs into the other team's area, holding his breath, and before running back tries to touch as many of the other team as possible to throw them out of the game. The members of the other team meanwhile try to encircle and grab him and prevent him getting back till his breath gives out and he is put out of the game. The bioscope-wallah was a roving peepshow oper-ator showing slides of exotic places.

Religion, Rites, Rituals, etc.

Puja is the act of worship, and would usually stand for an elaborate ceremony with the chanting of holy verses and an intricate ritual. It would also refer more specifically to the most important religious fes-tival in Bengal: the worship in autumn of Durga as a ten-handed god-dess defeating and killing the buffalo demon. Mahashtami, the eighth lunar day of the season, is the third day of worship; Dussera, the tenth lunar day, is the last day of the festival, when the image of the

deity is immersed in a river or lake. In north India, the Dussera is celebrated by setting fire to enormous effigies of Ravana.

The rite of the sacred thread marks the beginning of a second life for a Brahmin: a more formal Brahminhood, and the right to wear the sacred thread, slung over his left shoulder and across his body in a loosely hanging loop. A Brahmin boy goes through the rite between the ages of seven and fifteen; Kshatriyas and Vaishyas at a somewhat later age.

As a Brahmin, Harihar is often called upon to take a family under his religious tutelage through an initiation rite in which he assumes the role of guru, or preceptor, and imparts religious instructions.

Lord Shiva, also called Vishwanathji ('Lord of the World'), one of the three principal gods of the Hindu pantheon, is among other things a devoted and loving husband. Young, unmarried girls worship Shiva in the hope of getting a husband like him. Mahakal is one of the many names for Shiva, especially in the role of the divine destroyer and embodiment of Time. The Chadak puja is also dedicated to Shiva, but is primarily celebrated by the lower castes with spectacular demonstrations of physical skills and endurance.

Ganesha, elephant-headed son of Shiva, is worshipped throughout the year as protector of the home. His image swaying in the wind would be an ill omen, a withdrawal of protection.

The rite of the holy pond is a popular, folk ceremony for young virgins praying for a good match and a happy married life.

In traditional Bengali homes, a conch shell is blown to herald in the evening, and on all auspicious occasions and religious ceremonies.

The mark of the sindur, or vermilion, in the parting of a woman's hair and on the forehead is the sign of a married woman. A widow would wipe off the mark at her husband's death. Brahmin men would also wear the mark of the sindur on their foreheads as an auspicious symbol of their devotion, and especially when offering puja.

Eating and cooking in a traditional Brahmin household are enmeshed in a whole system of taboos: a woman cooking should not be touched; a person while eating should not touch anybody; a hand that has touched food is at once rendered unclean and would defile anything that it touches.

The *shraddha*, literally 'offerings in reverence to the dead', is a rite that the closest relatives of a dead person have to perform at the end of a period of *ashaucha* ('unclean state') when they do not shave, do not wear shoes, do not eat meat or fish, and do not have sex. The *shraddha* is basically an occasion for offerings of flowers, food, etc., to the memory of the dead.

The Telis are one of the richer lower castes in the Bengal caste hierarchy, traditionally engaged in manufacturing and selling oil.

The namaskar is the common greeting exchanged when people meet, often accompanied by the gesture of palms pressed together and raised to the chest.

The hulu is a sound made by rapidly raising and lowering the tongue within the narrowly pursed lips, often by several people together, as an auspicious sound for a religious rite or ceremony, and also as a signal in rural or tribal communities.

Places

A large part of *Aparajito* takes place on the ghats of Benaras, the holy city of Kashi for most Bengalis. The ghat is a mooring place, or a series of steps leading to a tank or river where people can bathe or wash clothes. The Benaras ghats, as one can see in the film, offer a kind of a ground for congregation for gymnasts, minstrels, the *kathaks*, and devout women and seekers for salvation, in the presence of the holy river.

Khulna is a district in east Bengal, now in Bangladesh. Bishtupur is a colloquial variant of Bishnupur, a small town in Bengal. In fact, there are several towns of that name.

The text that the grocer-schoolmaster dictates to his students for a spelling test in *Pather Panchali* is a quotation from *Sitar Banabas* (1860), a retelling of a part of the Ramayana story by Ishwarchandra Vidyasagar (1820–91), educationist and social reformer. In the excerpt chosen, Lakshmana shows Rama and Sita a series of paintings illustrating episodes from their past, and evokes memories associated with the different places. Janasthan is a district and the Prasraban a mountain on the banks of the river Godavari.

Dhruva was a mythical prince famous for his unassailable devotion to Lord Hari, or Vishnu. The Sudarshan Chakra is Lord Vishnu's weapon, a whirling sharp-edged wheel that cuts his opponents down and returns to the divine owner.

The navaratna or nine gems are the pearl, ruby, chrysoberyl, zircon, diamond, red coral, beryl, emerald and sapphire. The nine leading courtiers of the legendary King Vikramaditya (fourth century A.D.) were called 'the nine gems' for their learning, wisdom and mastery of arts and letters.

In *Apur Sansar*, Apu quotes from *Sadhabar Ekadashi* (1866), a satire by Deenabandhu Mitra (1830–73). The line about Mainak is part of a speech by the drunken Nimchand, the virtual hero of the play, an intellectual and an inveterate drinker. Accosted by a sergeant towards the close of Act II, Nimchand, dead drunk, confronts the British policeman with a series of quotations from *Macbeth*, *Othello* and *Paradise Lost*, before offering a mythological parallel for his state. Mainak is a mountain to the south of mount Kailasha. The mountains are supposed to have had wings in those days, and when an angry Indra, irritated by the flying mountains, hacked their wings down, Mainak alone hid under the ocean and escaped the wrath of the great god. Nimchand compares himself to Mainak, hiding with his cumbrous wings in a sea of alcohol.

There are references to two poems by Rabindranath Tagore (1861–1941), both from one of his earliest collections of poems, *Sonar Tari* ('The Golden Boat', 1894). 'Take me back . . .' are lines from *Basundhara* ('The Universe'), written in 1893, and the lines that Apu recites on the boat on his way to Pulu's village are from *Niruddesh Jatra* ('Destination Unknown'). In *Aparajito*, Apu recites a poem by Satyendranath Dutt (1882–1922), when the Inspector visits the school.

Saratchandra Chatterjee (1876–1938) was a widely read Bengali novelist known for his insights into lower-middle-class domesticity, and especially into suffering womankind.

In *Pather Panchali*, Indir tells Durga a story about rakshasas and rakshasis, ogres and ogresses, who threaten their prey with the ominous 'haun, maun, khaun', similar to 'fee, fi, fo, fum'.

Cuisine, Plants, Fruits, etc.

Musoor and *mung* are kinds of lentil. Khichdi is a dish of rice and lentils cooked in spices and fat. *Badi* is lentil paste made into little conical mounds, dried in the sun, and later fried and added to curries.

Ghee is clarified butter used widely as a cooking medium all over India. Pulao is a spiced dish of rice boiled in clarified butter, with raisins and, often, meat. Kalia is a rich curry of fish or meat. Korma is a highly spiced, grilled curry of meat, fish or eggs.

Payesh is a sweet cream made of rice boiled in milk and flavoured with spices, also often made with treacle. *Chandrapuli* is a sweet made of dried milk and grated coconut, in the shape of a crescent moon. Pedha is a sweet made of thickened milk.

Paan is betel nuts, catechu, lime, etc., folded in a betel leaf in the shape of a small, conical cup, chewed as a digestive at the end of a meal. Habitual paan chewers often add tobacco to the ingredients, and do not restrict themselves to the after-meals routine. Paan masala

is a collective description for the ground spices put in a paan, but often taken without the paan. The hookah is a tobacco-pipe with a long tube drawing smoke from a detachable earthen container (the chillum), loaded with tobacco and charcoal, through a water-filled coconut shell underneath it. The chillum is often used without the hookah.

The tulsi or the basil is a plant with auspicious associations for a Hindu household. The lamp that the housewife lights and places in a niche below the tulsi plant is a symbol of the continuation of life in the ancestral home. The plant is usually grown on a high earthen structure in the porch or the central courtyard of a traditional Indian house. The *kash* is a species of tall grass with white flowers, used to make mats. The *karamcha* is a variety of sour fruit turning crimson as it ripens. The *kul* is a kind of bitter-sweet plum. *Yam* leaves are eaten by the poor in Bengal.

The Bengali Calendar

Aparajito opens with a caption: 'Benaras 1327', dated by the Bengali calendar; 1327 is equivalent to 1920 by the Christian calendar. Baishakh is the first month of the Bengali calendar, from mid-April to mid-May, when it is summer in Bengal. Magh is the tenth month of the Bengali calendar, from mid-January to mid-February, when it is winter in Bengal. Bhadra is the fifth month, from mid-August to mid-September.

The Bengal Currency

The anna, no longer in use, was one-sixteenth of a rupee. The old paisa was one-fourth of an anna or one-sixty-fourth of a rupee. The current decimal coinage in India retains the paisa, but makes it one-hundredth of a rupee. The cowrie, the small shell of the gastropod *Cypraea moneta*, was used as money till relatively recently.

There are still one or two points on which clarification may be necessary for the foreign reader. It will be noticed that in the village of Nishchindipur almost all the characters address each other by familial appellations; even Nanda-babu, in *Aparajito*, calls Sarbojaya 'Bou-than'. While it remains common in urban communities, such a relationship belongs peculiarly to the village, where members of the same caste consider themselves one large family.

It may be interesting to remember that the traditional relationship between an elder brother's wife ('Bou-than') and a younger brother has always been flirtatious, with an undercurrent of a not unpleasant tension. There is, of course, a rational social explanation for the relationship: a younger brother was often closer to the elder brother's wife in age than anyone else, and would frequently be the only man in the family with whom she could have an easy, informal friendship. Incidentally, it is this tension that forms the central theme of Ray's later film, *Charulata*.

Religion has always been an invisible force in the daily existence of the village. Its shadow falls on every parting, every reunion; on birth and death, happiness and sorrow, hopes and desires. The earthen lamp at the foot of the tulsi plant, the image of Ganesha on the wall, are the tangible symbols of its presence. But the intangible makes itself felt in the many daily rituals—in Sarbojaya's reluctance to be touched by her son when she is cooking, in the hurried prayers of Durga at the 'holy pond', in Harihar's reminder in his letters that whatever God ordains can only be beneficial. The sound of the conch shells in the evening, the wedding in the Mukherjee household, the autumnal return of Durga the goddess, carry their religious significance into each home. Even away from the village, religion remains a way of life and a livelihood for Harihar. At the moment of his death, he asks for the holy water of the Ganga to be poured into his mouth. In *Apur Sansar*, Aparna must marry before the night is out, for once the auspicious hour passes, she can never marry again. It is only Apu, that offspring of a new age, the poet-rationalist, who

rebels against his own traditional environment. Yet he too, faced with his mother's death, stops in the act of taking off his shoes, and gives in to his grief. Till the last rites are done, he must remain unshod.

The nuances are many, and no translation can do justice to all of them. I could only translate the words and gestures. The viewer of the films must bring with him his own response to the total experience. Only then will the words and gestures reflect the emerging consciousness of a different generation whose legacy we still carry in our own.

Shampa Banerjee

A Note on the Illustrations

As well as production stills from Mr Ray's collection, several shot directly from the completed film are reproduced here. Most of the latter come from the collection of Nemai Ghosh, regular and exclusive stills photographer of Ray's films for more than a decade now.

Ray has more than once recounted how the idea of making a film from *Pather Panchali*, the first part of a bildungsroman trilogy by Bibhutibhushan Bandyopadhyay, came to him when he was illustrating a children's version of a part of the novel. A 'commercial' artist working for an advertising agency, Ray had just begun illustrating books (mainly for children) and designing covers for an enterprising and imaginative publishing house, Signet Press, and its director, the late D. K. Gupta, 'mad about films'. Once he had made up his mind, he filled up a sketchbook with a running series of wash drawings, 'with great care, in the manner of comics'; now deposited in the Cinémathèque at Paris, it is the only scenario the film ever had. 'I never wrote a complete screenplay for *Pather Panchali*, and I had all the time to *draw* it,' says Ray. We drew on Shyam Benegal's photocopy of the *Pather Panchali* sketchbook for several reproductions. If one looks closely, one finds quite a few scenes that did not eventually go into the film.

A busier filmmaker by the time he came to make the two later films of the trilogy, Ray did not have the time or the inclination to

work in the old manner. He chose the *Aparajito* and *Apur Sansar* sketches for this book himself from his later sketchbooks, which were more in the nature of working notebooks than scenarios, with a character here or a setting there vividly realized in lively lines.

Samik Bandyopadhyay

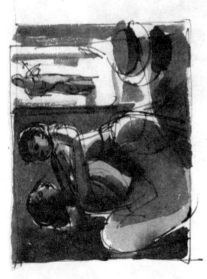

PATHER PANCHALI

The Song of the Road, 1955

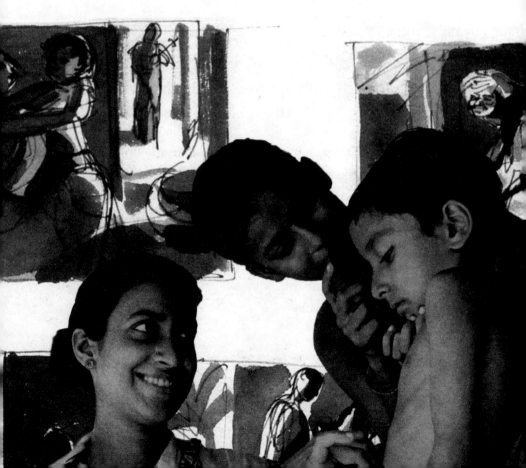

CREDITS

Direction and script	Satyajit Ray
Story	Bibhutibhushan Bandyopadhyay
Camera	Subrata Mitra
Art Direction	Bansi Chandragupta
Editing	Dulal Dutta
Sound	Bhupen Ghosh
Music	Ravi Shankar
Music recording	Satyen Chatterjee
Produced by	Government of West Bengal

Bengali / 115 minutes / Black and white / 1955

CAST

Artistes	*Characters*
Kanu Bandyopadhyay	Harihar
Karuna Bandyopadhyay	Sarbojaya
Chunibala Devi	Indir
Uma Dasgupta	Durga
Subir Bandyopadhyay	Apu
Runki Bandyopadhyay	Little Durga
Reba Devi	Sejo-thakrun
Aparna Devi	Nilmoni's wife
Tulsi Chakravarty	Prasanna
Rama Gangopadhyay	Ranu
Haren Bandyopadbyay	The sweet-seller

1

It is early morning in the village of Nishchindipur. Sejo-thakrun, widowed matriarch of a wealthy landowner's undivided household, stands by the sacred tulsi plant on the terrace roof of a large, old-fashioned, brick-built house. She folds her hands in a swift prayer, then turning around at a sudden noise, looks out towards the sprawling orchard by the house. A little girl rushes away in the distance.

SEJO-THAKRUN: Just look at her! Hey, girl! Won't she leave a single fruit on the trees?

Little Durga, daughter of Harihar Ray, an impoverished Brahmin, runs down a bamboo grove carrying the stolen fruit in the folds of her sari. She stops to hide behind a shrub as her mother, Sarbojaya, walks by, carrying a pitcher, a bucket, and a length of rope, on her way to the village well. When her mother is out of the way, Durga skips down a path through the bamboo grove, walks quickly past the date palms and creepers, now past a cow tied to a tree, up to a dilapidated brick wall covered with more creepers. Through a worn, wooden door in the wall, Durga enters the courtyard of the house, moving past the tulsi plant in the centre, to the section of the house where her old aunt Indir stays. Durga climbs on to the raised mud veranda and peeps into Indir's room.

DURGA (*in a whisper*): Aunty!

There is no reply. Moving away from the torn gunny curtains at the door, Durga takes a guava from the folds of her sari. She lifts the lid of a shallow earthen bowl kept on the veranda outside, and hiding the guava under a bunch of bananas, covers the bowl with a broken palm-leaf fan. Now she comes down the steps at the side of the veranda, holding the lid of the bowl in her hand. She goes to the kitchen, a separate construction at the back of the courtyard, where, from a small brass pot on the veranda, she pours some milk into the lid. She carries the milk down the courtyard again, past the cowshed, around the main section of the house, to a corner of the wall where a pumpkin creeper climbs. A large earthen jar stands on the ground. Durga smiles as she removes the cover and puts her hand into the jar. Magically from its depths she brings out fluffy little kittens, holding them by the skin at the back of the neck, and sets them down by the milk.

Sarbojaya walks towards a walled area with a lofty door bearing an ornamental lion on its arch. Inside, there is a spacious courtyard with a well. As she goes towards the well, Sarbojaya can hear the strident voice of Sejo-thakrun, who stands on her terrace nearby, vigorously wringing out the washing before spreading it on the line. In a neighbouring house, a woman similarly occupied leans out of a window, avidly listening to Sejo-thakrun's tirade.

SEJO-THAKRUN: The orchard wasn't a gift! It was bought with good money! Haven't I said, over and over again, put up a fence! If you want to bring the fruits home, put up a fence! Now you'll learn. Aren't there thieves enough in this village?

NEIGHBOUR: What s the matter?

SEJO-THAKRUN: What do you think? That daughter of Hari Thakur-po's! Not a single fruit is left on the trees because of that wretched girl. The moment I'm not looking she plucks them off!

NEIGHBOUR: What has she taken now?

SEJO-THAKRUN: I saw her take the guavas. But who knows what else she may have taken? I can't keep watch on every tree.

NEIGHBOUR: Why don't you speak to them?

SEJO-THAKRUN: Who should I speak to? And who is there to listen to me?

Sejo-thakrun speaks pointedly, looking towards the well, where Sarbojaya stands pulling up her bucket. She stops and turns towards the voice, and listens to the stream of accusations with a rising sense of anger and shame.

SEJO-THAKRUN: She isn't *my* daughter. If her own mother is not concerned, what difference does it make if you or I say anything about it? She'll realize for herself how things are after a while, when there'll be a scandal in the village. It's all due to bad upbringing. At this age they'll learn whatever they are taught. O Naren's mother! Swarna hasn't come; why don't you tie up the calf?

Sejo-thakrun has had her say for the moment; there are other urgent household matters she must see to. But Sarbojaya, the target of all her harsh words, turns away towards the well thoughtfully, disturbed by the injustice of Sejo-thakrun's words. For the orchard had once belonged to the Rays, and was snatched away from them when a cousin of Harihar's died, on the flimsy excuse of an unrecorded debt. Breaking into her thoughts, the kind words of Nilmoni's wife, an old family friend, bring a tired smile to Sarbojaya's lips.

NILMONI'S WIFE: Shall I carry the pitcher for you?

SARBOJAYA: No, it's all right.

NILMONI'S WIFE: Why not? Let me take it. Will you be able to carry it, really?

SARBOJAYA: Yes. I'll manage.

Nilmoni's wife, who has heard at least a part of Sejo-thakrun's mono-
logue, is aware of Sarbojaya's reaction. She also knows that Sarbojaya
is pregnant for a second time. When Sarbojaya leaves, Nilmoni's wife
throws an angry glance towards Sejo-thakrun's roof.

Indir sits eating on her veranda. She kneads the rice in a brass bowl
to a pulp with her gnarled hand, then puts a ball of it in her toothless
mouth. Little Durga sits behind her, leaning against one of the
wooden posts that support the thatched roof. She silently and hun-
grily watches the old woman's hand as it moves from the bowl to the
mouth and down to the bowl again. Indir, unaware of her presence,
finishes her meal, and licks first her fingers and then the bowl with
great satisfaction. Turning around to pick up the small brass tumbler
of water, she discovers Durga and smiles apologetically.

INDIR: Oh dear! I forgot to keep some for you!

Durga only smiles in reply, bending over her fingers as she plays with
a length of thread that she winds and unwinds. Indir washes her
hands, shakes them dry and turns to the earthen bowl which holds
the bananas. Hidden below the bananas is a surprise—the guava that
Durga has stolen for her. Indir picks it up, pleased, then turns it
around in her hand, smiling, nodding and muttering appreciatively.

Sarbojaya comes into the courtyard, carrying the pitcher and looking
around angrily for her errant daughter. As she calls out to Durga, the
smile fades from the old woman's face, and both she and the child
look guiltily towards the voice. Sarbojaya stops near the veranda, and
Indir quickly hides the fruit the moment she turns away again, going
towards the kitchen.

SARBOJAYA: Durga! Come here.

INDIR: She isn't doing any harm. Why don't you let her be?

SARBOJAYA: No. Why should she sit there when you are having a
 meal? Get up from there!

INDIR (*gently coaxing*): Go, your mother's calling you. Be a good girl. Go, dear, go—

Durga reluctantly gets off the veranda and moves towards the kitchen. Sarbojaya, looking harassed and tired, sits on the veranda in front of the kitchen.

SARBOJAYA: What did you take from Sejo-khuri's orchard? Well, what was it? Tell me! What are you hiding in your sari? Show it to me at once!

Durga takes out more fruits from the folds of her sari. Indir watches the scene from her veranda with a conciliatory smile on her lips. But she soon stops smiling, and clamps her toothless mouth shut crossly.

SARBOJAYA: Go and return them to Sejo-khuri! And remember to sweep the yard when you come back!

She gives a tired sigh as Durga moves away. Indir rinses her mouth noisily, then pours the remaining water from a brass jug on a lime sapling growing at the foot of her veranda. She puts away the jug, wipes her hands and goes into the courtyard, where a torn rug lies on the ground. Indir picks it up and starts shaking the dust out of it. Sarbojaya, who is still on the kitchen veranda, looks annoyed and quickly covers her nose with the end of her sari.

SARBOJAYA: Thakur-jhi! Thakur-jhi! (*Indir looks up innocently.*) Do you realize you're ruining that girl?

INDIR (*smiling*): What's the matter ?

SARBOJAYA: Need I tell you what the matter is? Where do you think all those fruits go?

INDIR (*still smiling*): What fruits ?

SARBOJAYA: The ones Durga picks and brings to you. You know nothing about them, of course!

7

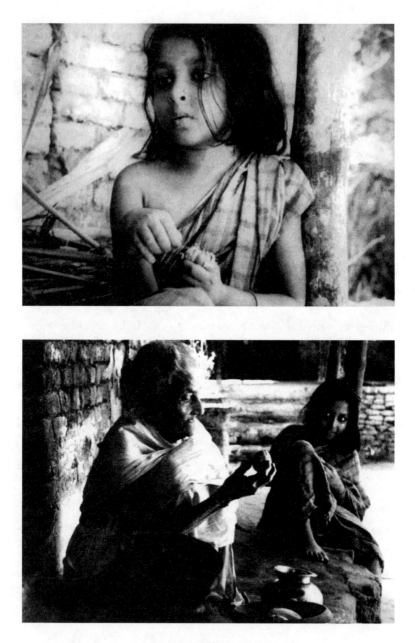

Above. Little Durga, daughter of Harihar Ray.
Below. Indir discovers a surprise—a guava that little Durga has stolen for her.

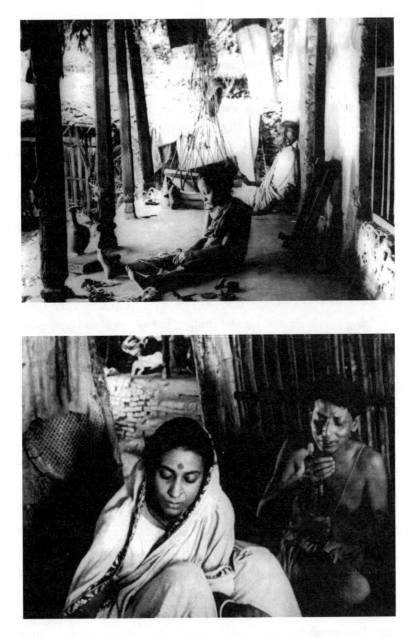

Above. Indir rocks the rope swing, singing a lullaby, as Durga sits at the other end of the verandah, with her playthings.
Below. Harihar discusses his new plans with Sarbojaya.

Indir decides on a timely retreat, and starts shuffling across the yard with the rug as Sarbojaya picks up a palm-leaf fan to cool herself. But the old woman's silence angers her all the more, and she continues shouting till Indir reaches her own veranda.

INDIR (*moving away*): She is just a child—

SARBOJAYA: She may be a child, but are you a child as well? Don't you have any sense? Who do you think you are? Just because we give you a place to stay, you think you can get away with anything! I'm quite aware what you are like.

INDIR: What a lot of nonsense you talk.

SARBOJAYA: Should I spell it out? Haven't you been stealing from my kitchen? Salt, chillies and oil. Haven't you been removing them quietly? Shall I open your box and show you? Well?

Indir stops, turns around, makes a face, then turns right back again, walking resolutely on, till she reaches her veranda and enters her room. Sarbojaya's voice grows fainter in the distance as the bells of the village sweet-seller are heard passing by the house.

SARBOJAYA: Why don't you say something? You can't carry on in this way so long as you're staying with us. I'm warning you, Thakur-jhi. You'd better start looking for another home. I've borne enough. For eight years I have suffered you. But I won't suffer you any longer, Thakur-jhi. That is my last word. You spoil my daughter, and all the blame falls on me! I won't allow this to continue, Thakur-jhi!

Indir grimaces through her torn curtain at the unseen Sarbojaya, mumbles soundless curses, and drops the rug on the floor. She squats on the floor of the room, and takes out a torn, knotted sari from an old box. An unsuspecting kitten, sitting outside the room, suddenly vanishes from view as a small bundle falls on it with a thump. The bundle contains all the worldly belongings of Indir, apart from a

worn-out rush mat, which soon follows it before Indir herself emerges from the room.

INDIR: At my age one can take just so much and no more!

Indir climbs down the steps of the veranda. As she picks up her mat and bundle, she throws the kitten violently off the veranda, snorting at it in disgust. Sarbojaya, who is undoing her hair, turns to see Indir marching off towards the outer door. She calls out to the old woman, does not get a reply, and turns away angrily.

SARBOJAYA: Thakur-jhi! Where are you off to?

Indir opens the door with a loud clatter, and comes out of the house. Durga, who is coming back home, sees Indir walking away, and rushing up to her, pulls at the mat in an effort to bring her back. Sarbojaya, who hears Durga calling out to the old woman, rises and goes near the cowshed to look out over the broken wall at the back.

DURGA: Aunty—!

SARBOJAYA: Durga—!

INDIR (*jerking the mat away*): Let go!

SARBOJAYA: Durga—come away!

Durga watches unhappily as Indir moves away, then walks towards the house, turning back to take a last look at her old companion. Inside the house, Sarbojaya stands waiting for her daughter.

SARBOJAYA: Have you given them back? (*Durga nods.*) Now what did I tell you to do ?

Durga walks up the courtyard, picks up a broom, and clasping it securely with both her small hands, starts sweeping the ground.

Night. Durga lies asleep with a kitten by her side. A tin box with her playthings lies open beside her on the far side of the bed. In the darkness outside, Harihar paces up and down on the veranda, wearing an anxious expression and smoking a hookah. The walls, doors and

windows behind him reflect the muted light of a hurricane lamp. Harihar stops and peers into the darkness of the courtyard, then continues walking, the sound of his wooden slippers sharply breaking the silence of the night. At one end of the courtyard, barely visible in the darkness, is the labour room, a makeshift structure, where a light is seen flickering behind a gunny curtain as someone enters the room. Inside the labour room, Sejo-thakrun puts a paan in her mouth. Nilmoni's wife, with characteristic compassion, sits caressing Sarbojaya's forehead; her face is twisted with pain.

It is a clear, sunny morning, the day after. Durga is bringing Indir back home. She pulls at Indir's mat, then runs on ahead and beckons to her, hurrying the old woman along. At the door of the house they are stopped by a woman on her way out, carrying a pitcher.

WOMAN (*smiling*): There you are! Where have you been all these days, Aunty?

INDIR (*smiling back*): I was staying at Raju's. This morning, on my way to the pond, I heard from Shailo that Hari has—I was already on my way here, when she came looking for me.

Durga manages to pull the mat away from the old woman, and goes into the house carrying the old bundle and the little brass tumbler. Nilmoni's wife, standing in the courtyard, turns around towards Indir's voice with a smile.

INDIR: And so we met on the road.

WOMAN: Go on, hurry and see what a lovely nephew you have!

Indir trails behind Durga into the courtyard. Durga dumps Indir's belongings on the floor of her room. The baby can be heard crying in the distance.

INDIR: Where is he? Where's the little boy?

NILMONI'S WIFE: So, Aunty—you've come back at last!

INDIR: Where is he ?

Sarbojaya lies on the floor of the labour room, with the baby beside her. She looks up, but her face is unrelenting. A woman sitting by her looks up and smiles as Indir appears at the door, wearing a toothless grin on her wizened face. Little Durga's face now appears by hers. She too smiles, revealing gaps in her teeth.

INDIR: Why don't you remove the cover, dear, so that I can see his face?

Sarbojaya looks at her child. Then with great reluctance lifts one corner of the cover from the baby's face. Indir puts an arm around Durga, and still smiling, bends forward to wipe a tear.

INDIR: A lovely baby—a lovely baby.

Another day. Indir sits rocking the rope swing that serves as a cradle for the baby, singing a lullaby. Durga sits at the other end of the same veranda, outside Sarbojaya's room, with a tin box between her legs. She is counting her marbles. Sarbojaya is cooking in the kitchen. Harihar comes to her, coughing to announce his presence, to take some charcoal for his hookah. Sarbojaya fills the little container with burning charcoal. Harihar fits it back on his hookah and blows on it as they talk.

HARIHAR: What are you cooking?

SARBOJAYA: Can't you see? Pulao, korma, kalia—

HARIHAR (*laughs*): Why don't you cook all that one day? Will you? Or don't you remember how to?

SARBOJAYA: I don't remember.

HARIHAR (*mysteriously*): Then it can't be done. (*Sarbojaya does not respond.*) I was thinking of celebrating in a big way the day the boy takes his first mouthful of rice.

SARBOJAYA: And how can you be thinking of doing that?

HARIHAR: Why not? After all, I am getting a job with Rai-khuro from next month.

13

Harihar has finally got what he wanted: his wife turns away from the cooking to look up at him, surprised and pleased.

SARBOJAYA: Really!

HARIHAR: I met Nilmoni-khuro today. He said that Rai-khuro has promised.

SARBOJAYA: Have they said anything about the salary?

HARIHAR: I am not worrying about that. I'm not going to spend the rest of my life collecting rent for him. He can't make me his bonded slave. Once I get a job . . . then there are a few households of disciples as well . . . altogether we can settle our affairs a little better at home. Besides, there are good times and bad times.

SARBOJAYA (*in a reverie*): Things are going well. The boy came in the month of Magh, and in Baisakh you get your job.

HARIHAR: That's what made me think of the celebration. Maybe we'll have to spend a bit. But it'll be worth it. And people will praise your cooking. That's something too! Eh? What do you say?

SARBOJAYA: Listen, do you think they will pay you regularly?

HARIHAR: Why shouldn't they ? Rai-khuro is a good man.

SARBOJAYA: How can you tell who is a good man and who isn't? Don't I know how they have been cheating you all the time, just because you are too simple and good-natured?

HARIHAR (*annoyed*): What? When did you see anything like that?

SARBOJAYA: Didn't I? They grabbed our orchard in front of our eyes!

HARIHAR: Oh that! They said that Haren-da had borrowed three hundred rupees from them when he was alive. So they took the orchard as repayment of the loan.

SARBOJAYA: Do you think we would have anything to worry about if the orchard were still ours? Mangoes, coconuts—they pick sackfuls of fruit from our doorstep. And if Durga takes one guava, they'll have a hundred bitter things to say.

HARIHAR: Don't you see, I'll have nothing to do with them. They will look after their money-lending business, and I will see to my writing.

SARBOJAYA: And who will know your true worth in a place as backward as this?

HARIHAR: Why don't you listen to some of my plans? Let me tell you what I am working on now. (*Excited*) New verses, new plays! Just wait till people hear about them. The proprietors of the jatra troupes will come in droves! Don't you see, they want new stuff. But that's difficult to find. Original plays don't grow on trees. Oh yes, I've seen what the new writers of today can give us. All of them live off old material. The same old stuff repeated every time! And if those are accepted, why won't people take purely original work from Harihar Ray of Nishchindipur? What do you think, huh?

SARBOJAYA: Of course they will take them. You are educated. The villagers will respect you. What can be better than that?

Little Durga comes into the kitchen and sits down on Harihar's lap. Sarbojaya turns to her with a smile as she speaks.

SARBOJAYA: You will educate the boy, give him his sacred thread, and teach him to worship the gods. Durga will get a good husband. Two meals a day, and a few clothes once a year. What more does one need?

HARIHAR: Yes. Yes, it'll all happen just the way you want. After all, my ancestors haven't filled up volumes with their writing all in vain. They set a tradition that cannot be ignored. Just wait a year or two. Let me pay off the debts, repair the house and settle down a bit. Then you won't have to cook spinach every day. (*To Durga*) What do you say?

Sarbojaya looks on happily as Harihar laughs.

Indir leans against the wall on Sarbojaya's veranda, her eyes shut, rocking the cradle as she softly sings a lullaby. The years pass.

2

It is another morning six years later. Sarbojaya comes back home carrying some firewood. Going past a window she sees a huddled shape on the bed. It is Apu, her son. She tries to shake him awake, then gives up and goes around the corner of the house, calling out for Durga. Durga, now quite a grown-up young girl, stands with a calf near a tree in front of the door to the courtyard. A woman sits milking a cow which looks emaciated. She rises and hands a small pot of milk to Durga, as Sarbojaya enters the house.

SARBOJAYA: What is this? Apu! Won't you get up? Apu! Won't you go to school? Get up, Apu! Get up, dear, Apu! (*She moves away from the window.*) Durga—! Durga! Will you go and get Apu out of the bed? He must go to school and he's still fast asleep.

WOMAN: The pot didn't fill, do you hear? Haven't you been feeding the cow?

Durga goes into the courtyard carrying the pot of milk. As she goes towards the kitchen past the tulsi plant, Sarbojaya is seen walking towards the courtyard door carrying a bucket. Indir emerges from her room, carrying her torn quilt. She shakes the dust off it and spreads it on the ground in the sun. Durga goes to the room where Apu lies asleep and shakes him. But he huddles under the sheet, refusing to get up.

DURGA: Apu! Hey, Apu, get up! Hey, Apu! Apu!

Durga sits on the bed, leans forward, and suddenly gives a knowing smile. She cautiously stretches open a tear in the sheet and one sleeping eye is revealed. With her hands she forces the eye to open, and pushes aside the sheet. Apu tries to hide under the sheet again

as his sister tickles him. He has to give in finally, and sits up on the bed, grinning at her.

Now Apu comes down the steps of the pond at the back of the house, and standing at the edge, scrubs his teeth clean with some ash.

Now Durga combs his hair and Sarbojaya tucks in the folds of his dhoti at the waist, smiling up at him.

Now he tilts up a large brass bowl of milk, till it hides his face and some of the milk trickles down the side of his mouth. Durga wipes his mouth with a chequered towel and Apu is ready for school.

It is late in the summer and the rain clouds hang heavy in the sky. Durga takes Apu down a narrow path across a large, empty field. Chakravarty, a Brahmin from the village, bald and elderly, stops to look at the children as he goes past them in the other direction.

3

The village school sits in the grocer's shop. Prasanna, the grocer, who is also the teacher, sits on a high ledge in the shop, along with the rest of his ware, and carries on his business while he instructs his pupils. He is a pot-bellied man, of an appearance awesome to the children. He is giving them a dictation as he weighs out some salt in a packet on an old-fashioned pair of scales. Puti, a young girl, stands at the entrance of the shop, waiting to be served. Prasanna alternates between serving his customers with a smile and glaring at the boys, who sit on the floor in front of him. The passage he is dictating is complicated and there are many long words in it. A boy stands in one corner of the classroom holding his ears. Some others quietly play noughts and crosses on their slates.

PRASANNA: 'Here stands in the heart of Janasthan . . . here stands in the heart of Janasthan!' (*He glares at the boys.*) Harey! Harey! Why

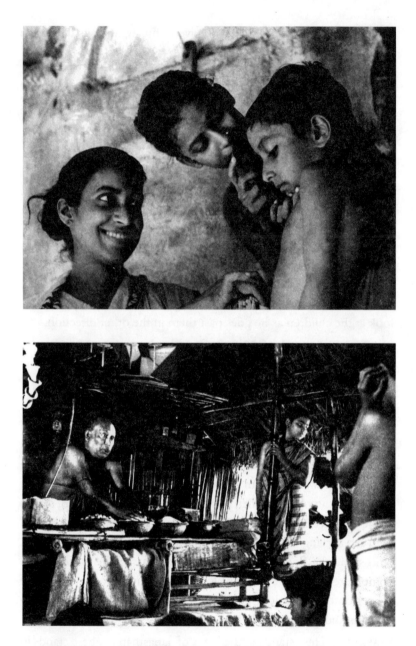

Above. Apu gets ready for school.
Below. The pot-bellied grocer, Prasanna, is also the schoolteacher, sitting on a high
ledge in the shop, combining his daily business with teaching.

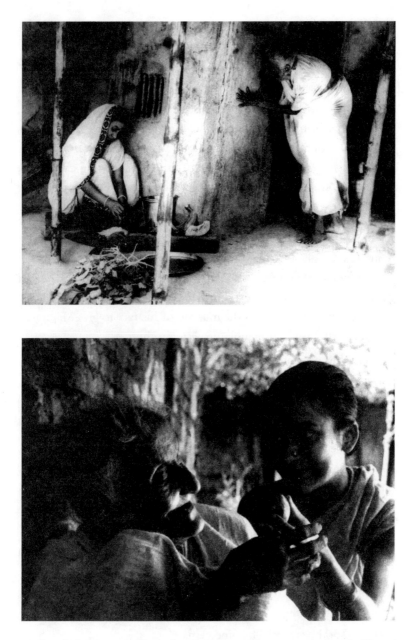

Above. Indir takes a stealthy look at Sarbojaya grating coconut before shuffling into the kitchen. *Below.* Indir's face lights up as Durga, now grown up, holds out a guava for her.

have you got up again? How much time will you waste just wet-
ting that rag to wipe your slate with? Huh? Sit down! 'Here stands
in the heart of Janasthan . . .' Well, Puti, what do you want now?

PUTI: One paisa worth puffed rice.

PRASANNA: Puffed rice? A paisa worth? Here, give me the paisa . . .
'The great mount Prasraban . . . the great mount Prasraban! Its
lofty summit . . . its lofty summit . . . (*Puti collects her puffed rice.
Prasanna yawns.*) is crowned by . . . the ever-moving clouds . . .
which ceaseless gales . . . which ceaseless gales . . .'

Badyi Majumdar, a dried up little man of indeterminate age and a
toothless grin, comes up to the shop, carrying his umbrella and
coughing loudly. Prasanna now has to divide his attention between
the boys and Majumdar, who carries on a conversation undeterred
by Prasanna's lack of interest. Prasanna continues to glare at the boys,
and then swiftly rearranges the muscles of his face to give Majumdar
a half-hearted smile, pretending to listen to him.

BADYI: How are you, Prasanna?

PRASANNA: '. . . which ceaseless gales . . .' Oh welcome, welcome,
Majumdar-mashai!

BADYI (*stepping over a hole in the road*): Dear me! It's a trap to kill
people!

PRASANNA: '. . . urge down . . . the paths of the sky . . .'

BADYI (*to a man sunning himself outside the shop*): Namaskar, Chatujje-
mashai. Everything all right with you?

PRASANNA: '. . . the paths of the sky.' Welcome, welcome!

BADYI: You've spread quite a net, eh? How many fish have you
caught?

PRASANNA (*smiles*): There were eight of them. Now a new one has
joined recently.

BADYI: Good heavens! The nine gems!

PRASANNA (*glaring at the boys*): What's that? Apurba! Why are you grinning? . . .

BADYI (*to the man outside the shop*): Take my grandson, just eight years old . . .

PRASANNA (*addressing Apu*): . . . Is this a playhouse? (*He scratches his back with a cane.*)

BADYI: . . . just wait and see. Finally he too will be carrying the plough, that's all.

PRASANNA (*smiling at Badyi*): Well, well. What were you saying, Majumdar-mashai?

BADYI: Tell me, brother, have you seen a good *jatra* lately?

PRASANNA: Jatra? Jatra—once the Trailokyatarini group . . . (*Badyi chuckles gaily, shaking his head. Prasanna turns to the boys.*) Hey! Gupey! What are you up to?

BADYI: Oh no, no. Do you know, brother, the Nawabganj folks are getting a good group of singers?

PRASANNA: Phatke! I'll break every bone in your body! (*Smiles at Badyi.*)

BADYI: They think they are one up on Nishchindipur. (*Prasanna laughs politely and scratches his stomach.*) But they don't know Badyi Majumdar yet. I'll get the best group of players here, such as no one has ever seen before. (*Prasanna fidgets. Badyi suddenly spots Chakravarty outside the shop.*) Chakkotti! (*To Prasanna*) Pass me your bottle of hair oil, brother. I'll oil my hair and then take a dip.

PRASANNA (*dictating*): 'The foothills being covered with . . .'

BADYI (*leaning towards Prasanna*): Brother! I haven't taken into account your subscription this time. But you'll pay up when we need it, won't you?

PRASANNA (*transforming a murderous look at the boys into a melting smile*): Certainly! Certainly!

BADYI: My friend (*Prasanna transfixes the boys with another murderous look.*), see that you don't forget Badyi Majumdar! (*Laughs.*)

PRASANNA (*laughs*): No, no.

Outside the shop, Chakravarty is seen passing by, carrying his fishing rod. Majumdar calls out to him, hands back the bottle of hair oil to Prasanna, rubbing some oil into his hair, then rushes out, only to appear again, to give Prasanna another juicy bit of news. Chakravarty turns back and comes towards the shop.

BADYI: Hey! Chakkotti! Wait! (*Giving back the bottle*) Here, hold it. The drummer is coming from Kalna, Prasanna. When his hands touch the drum, it'll sound like thunder rolling from the sky!

PRASANNA (*politely*): I see, I see.

BADYI (*rushing away again*): Hey, Chakkotti! What about your subscription?

PRASANNA: Satey! Bring your slate here. Bring it at once! Phatik! Get that slate away from him. Get that slate!

Puti, who has been idly standing and watching the classroom all this while, looks scared. Prasanna snatches the slate away violently from Phatik, takes one look at the slate and starts bellowing with rage.

PRASANNA: What have you written? What have you written here? Get up! Get up and come here, you wretch!

One of the boys pulls up the offender by his ear. Apu, still a newcomer in the class, cautiously turns round and watches Satey being led away. The cane, stuck in a tin of salt, is pulled out with one swift stroke, spraying grains of salt around. Apu watches petrified as Prasanna lifts the cane high.

PRASANNA: Show me your palm! Show me your palm! I said, show me your palm!

The cane falls with a sharp crack, once, twice. Puti shuts her eyes tightly and runs out of the shop. The cane descends again. A white

bird flutters over a pond. On the other side of the pond, far away, Puti runs home. Apu watches, his eyes wide with fear.

Sarbojaya is grating coconut, sitting on the kitchen veranda. Indir comes stealthily up the steps, looks at Sarbojaya, who is some way from and has her back to the kitchen door, then shuffles into the kitchen quietly. But she is not quiet enough, and Sarbojaya, hearing a suspicious noise, peers in through the window.

SARBOJAYA: What's going on there? What are you up to? Thakur-jhi! What is it you're taking away? (*She resumes grating as Indir comes out.*) What have you been doing in the kitchen?

INDIR (*guiltily*): Nothing.

SARBOJAYA: What do you mean, nothing? I saw you quite clearly, taking something from the shelf!

INDIR: I didn't have any chillies, so I took a few.

SARBOJAYA: Show me.

INDIR: Here.

SARBOJAYA: Why can't you ask me? Haven't I told you I dislike your pottering around in my kitchen?

Outside the house, Durga plays hopscotch alone. On her veranda, Indir sits pouring something out of a brass bowl into an earthen one. Her game over, Durga steals up to her from behind and holds up a guava under her nose. Indir is startled, then pleased. She smiles at the fruit, nods her head with affectionate indulgence, and takes it from Durga. Durga has just produced another fruit for the old woman when Sarbojaya is heard calling, her voice severe with disapproval.

SARBOJAYA: When you are free, come here. You'll have to chop the spinach. (*Durga comes to the kitchen veranda.*) Sit down. At your age, girls do so much work at home cooking, cutting the vegetables, washing the dishes—they even help with all the religious ceremonies. You can't just run around like this all day forever. If

Ranu-di is really your ideal, why don't you learn from her? You have no temperature today, have you? (*Durga, chopping the spinach, shakes her head.*) Let me see. (*She touches Durga's forehead.*) Remember to take the juice of the *tulsi* leaf in the evening.

Harihar has brought Apu home from school. They go towards their bedroom. But once he has left his slate inside, Apu rushes out again, jumps on to the kitchen veranda to the consternation of his mother, and leans over her. Durga is no longer there.

HARIHAR: Go and tell your mother of your visit to Puti's home.

SARBOJAYA: So you are back! Hey! Don't touch me! Don't touch me! (*Smiles.*) There, now you have gone and touched me!

APU: Ma—I'm hungry.

SARBOJAYA: Already? Why, didn't you have some puffed rice?

APU: Yes.

SARBOJAYA: Well then?

DURGA: Apu! Come here!

The corner of the house where Durga used to keep her kittens once long ago. Apu comes and squats by his sister, who leans forward and whispers conspiratorially, pointing with one hand towards the bedroom windows.

SARBOJAYA: There's roasted rice in the big bowl. Ask Durga to give you some.

Harihar is coming down the steps of his veranda, holding his hookah. On her patch of ground below her veranda, Indir is sitting on her haunches. She smiles apologetically, asking Harihar to help her up. Harihar helps her on to the veranda. From the kitchen, where she sits grinding spices, Sarbojaya looks up angrily towards them. Indir's words have reached her ears.

INDIR: Huh! O Hari! Please hold my hand and help me up, dear.

HARIHAR: What's the matter?

INDIR: My back has become really stiff. (*She sits on her veranda.*)

HARIHAR: How are you feeling these days?

INDIR: Ah well. (*Laughs.*) Who would care for an old woman?

HARIHAR: Why? What's the matter?

INDIR: Just look at this. (*She pokes her head through a hole in her torn shawl.*) See? (*Laughs.*)

HARIHAR (*laughing*): What's that?

INDIR: It's a shawl. I wrap it round my shoulders in the evenings.

HARIHAR: All right. This year, during the pujas, I'll buy you a new shawl.

INDIR (*delighted*): Will you really?

HARIHAR: Yes, yes I will.

Harihar has reached the kitchen. He wants some charcoal for his hookah.

HARIHAR (*to Sarbojaya*): Can I have some cinders, please?

Sarbojaya gets them from the kitchen, grumbling. Harihar sits down on the veranda.

SARBOJAYA: How can I go on supplying you with cinders forever? Do you think you have laid up a pile of logs for me? (*Sitting down to work again*) Did you tell them? How long will you keep your mouth shut?

HARIHAR (*yawns*): Rai-khuro is in trouble over his land.

SARBOJAYA: So what?

HARIHAR (*laughs*): If I go and ask for my salary now, I'll probably lose my job!

SARBOJAYA: So what if you lose it? Is it so difficult to get another job? All you get is eight rupees a month, and that too he doesn't pay you three months running. What kind of a job is this?

HARIHAR (*smiles*): It's never happened before.

SARBOJAYA: So just because it hasn't happened before, you won't worry about it? Have you taken a look at the state of the household, what food the children get to eat, what clothes they have to wear?

Harihar turns away from her and looks out silently into the courtyard.

Apu goes in search of his sister's secret store of mustard oil. It is kept in a coconut shell, on the topmost shelf in the bedroom. Apu clambers on to the bookshelf, then jumps off with the coconut shell in his hand.

Sarbojaya can be heard talking to Harihar in the kitchen.

SARBOJAYA: Durga has had fever for the past few days. There's no medicine, not even a proper diet. The boy has been going to school in torn clothes. It makes me feel terrible.

Apu moves to the window which overlooks the spot where Durga sits waiting.

APU: Here.

He hands Durga the coconut shell. She pours a bit of oil into another coconut shell in which she keeps tamarind paste. It is a little treat for the two children, who love the sweet and sour tang of tamarind, ripe and dried in the sun, the colour of dark clay.

Sarbojaya is heard in the background.

SARBOJAYA: We can forget about repairing the house, but how do we repay the debts? Those five rupees from Sejo-khuri—it's been six months now. Who knows when she'll say something rude. For god's sake, do something about it.

The spices have been ground. Sarbojaya washes the grinding stone.

In the corner near the cowshed, Durga takes a lick at her sticky finger. Apu hops off the window sill.

DURGA: Sit down.

Apu settles down beside his sister and watches greedily as Durga takes another lick, making a clucking sound with her tongue, relishing the strong sour taste. She thinks about it for a second, then nods her approval.

DURGA: You won't tell mother?

Apu shakes his head silently. Durga offers a sticky finger for him to lick. Apu imitates his sister and makes a clucking noise. Durga slaps him lightly in reproof and looks fierce.

DURGA: Idiot! Mother will hear you.

Apu lifts his face and gives her an apologetic smile. Durga's fingers have left streaks of tamarind paste on his cheek. He rubs his face against his arm. Durga tries some more of the paste, smiling at Apu. Apu returns the smile as she feeds him. The shared secret leaves its sharp pleasurable taste between them. But the sweet-seller's bells are heard in the distance and the spell is broken. Durga stops with her fingers halfway to her mouth. She frowns and rises, going to the gap in the wall, from where Chinibas the sweet-seller can be seen coming down the village road. Two large containers hang suspended by ropes from a narrow bar balanced on his shoulders. Durga turns back to Apu, her eyes sparkling.

DURGA (*whispering*): Uncle Chinibas!

The bells come closer. Durga and Apu stand outside the house, their faces showing an anxious longing. Chinibas is a jolly, rotund, bull-necked man with a heavy drawling speech.

CHINIBAS: Do you want anything, child?

Durga licks her lips, but does not reply. Chinibas smiles and rattles off a mouth-watering list of the sweets he is carrying today. Durga has been thinking furiously, a slight frown creasing her forehead. Now she moistens her lips again, and speaks in a hushed whisper to Apu without taking her eyes off the sweet-seller.

DURGA: Hey! Go and tell Father.

APU: You go.

DURGA (*pushing him angrily*): Go on!

Harihar is smoking his hookah standing in the middle of the court-
yard, when Apu walks up to him and whispers in his ear. But Sarbo-
jaya, sitting in the kitchen, has seen him, and heard the sweet-seller's
bells.

SARBOJAYA: He's asking for money, isn't he? Don't you give him any.
It's such a bad habit!

Harihar speaks gently to Apu, trying to soften his disappointment,
then sends him off.

Outside the house, Chinibas stands waiting.

CHINIBAS: Don't you want anything?

Apu has still not come back. But Durga knows the answer already.
She shakes her head slowly, looking unhappy. As Chinibas goes away,
his bells ringing merrily, Apu walks up to Durga.

DURGA: Hey—let's go with him!

She pulls him along, and they break into a run, following Chinibas
down the village path. A dog which was sitting curled up nearby
rushes off after the children. Down the edge of the pond they go,
their reflection moving on the water with them: Chinibas, followed
by the dog, and the children. A gentle wind blows over the pond,
forming ripples. The containers balanced on Chinibas's plump shoul-
ders bob up and down as he walks, his bell rings, and a flock of cack-
ling ducks herald his entry into an arched doorway. The courtyard
inside is full of the noise and bustle of children playing kabaddi. They
all crowd around Chinibas, greeting him enthusiastically. Apu
and Durga remain at the entrance of the courtyard. The house is
large and imposing, the ancestral property of the Mukherjees,
Sejo-thakrun's family. Durga smiles, looking at the other children,

then her smile disappears and she withdraws into the shadows as Sejo-thakrun's voice is heard.

SEJO-THAKRUN: Hey! What's happening here? Get along with all of you! Off you go. (*To Chinibas, imperiously*) Well? What have you brought today?

Carrying a large brass plate, Ranu comes out of the house. A little older than Durga, she is a pretty young girl with a pleasant smile.

RANU: Mother has asked for sweets worth two annas.

SEJO-THAKRUN (*responding to Chinibas's list of sweets*): Show me the *chandrapuli* you have brought.

A GIRL: Hey! Durga will be in my team!

DURGA: Apu, want to play with us? Come on—all right then, you go home. I'll be back soon. Come, Puti.

A BOY: Apu is left out, Apu is left out of the game!

Apu turns away, annoyed, as the boy holds up a spinning top on his palm, right under Apu's nose.

RANU: Durga, want to have a sweet?

SEJO-THAKRUN (*pulling her aside roughly*): Haven't I told you not to give them sweets? They have their own home, don't they? Why don't they buy their own sweets and eat them? (*Glaring at Durga*) I can't bear to see such shameless greed. (*To Chinibas*) Well, show me . . .

The boy with the top has left Apu alone and now climbs up to the terrace of the house. Other children follow him, including Durga. On the terrace sits another young girl, Tunu, stringing together a collection of beads with great concentration. Durga goes and sits near her.

A GIRL: Hey, Tunu! Won't you play with us?

DURGA: What are you doing, Tunu? How lovely! Who gave them to you?

TUNU: Father.

DURGA Let me string some beads.

TUNU: No.

DURGA: Please!

TUNU: No.

RANU: Hey, Durga!

Durga turns to see Ranu coming towards her, holding one arm behind her back. She bends over Durga.

RANU: Open your mouth.

She puts a sweet in her mouth, and moves away as Sejo-thakrun's voice is heard.

SEJO-THAKRUN: Children, come and take your sweets! Come Sunil! Come Khuku!

Apu still stands at the entrance to the courtyard. Chinibas, his transactions over, hoists the bar on his shoulders and makes his way through the arched doorway, out of the house.

4

It is evening now. The rain clouds gather again, as Apu and Durga bring their cow home from the field. Durga takes the cow into the shed as darkness settles in the empty courtyard. Sarbojaya comes with an earthen lamp to the tulsi plant. The sound of conch shells floats in the evening air, marking the end of another day. Outside the house the shadows deepen on the water of the pond; the banana grove beyond looks black against the sky.

The night is resonant with the noise of crickets. Apu and Harihar sit on the veranda in the light of the hurricane lamp. Harihar has a small wooden table in front of him, and glasses on his nose. His lips move silently as he reads to himself what he has just written. Apu sits by him, writing something on his slate with deep concentration. In the

dim light, Sarbojaya can be seen moving around in the room behind. Durga sits on Indir's veranda playing with some pebbles. Near her, Indir struggles with the knot of a bundle, grumbling to herself.

INDIR: How many times have I said buy me a shawl, I need it in the evenings. I am old, after all.

SARBOJAYA: Durga, come here at once!

Sarbojaya comes out of the room as Durga reaches the veranda. She slaps Durga and draws her down to the floor. Apu grins. Durga sticks out her tongue at him. Sarbojaya starts combing Durga's hair, pulling at the knots. On her own veranda, Indir tries to thread a needle, holding it near a flame.

SARBOJAYA: When do you think you will do your hair ? Sit down.

DURGA (after a pause): Mother—can you make a plait with four strands?

SARBOJAYA: Uh! Don't move your head.

DURGA: Ranu-di knows how to.

SARBOJAYA: Look at the state your hair is in. No oil, nothing. And you want a plait with four strands.

DURGA: Mother, did you know, they are coming to see Ranu-di.

APU: Who are coming?

Ranu will be inspected by a prospective groom's family. But no one explains that to Apu. Harihar turns a page. Indir still struggles with the needle. The whistle of a distant train breaks the stillness of the night. Apu looks up from his slate once more, this time to listen to the fading noise of the train.

APU: Didi—

DURGA (smiles): Yes?

APU: Have you ever seen a railway train?

DURGA: Yes.

SARBOJAYA (pulling at her hair): Lying again?

APU: Do you know where the railway track is?

DURGA: Ye . . . s!

APU: Where?

DURGA: Across the Sonadanga meadow, across the paddy fields, and you are there.

APU: Shall we go there one day?

HARIHAR: Let me see what you have written. (*Apu hands him the slate.*) Lovely! Now write—(*dramatically*) 'A ghost! Help!'

Harihar smiles at Apu as he hands back the slate, then picks up his pen again. Sarbojaya has almost finished plaiting Durga's hair.

5

It is another day. Sarbojaya is trying to feed Apu his midday meal. A dog sits in the courtyard, looking expectantly. Apu sits on the kitchen veranda with his back to his mother, holding a homemade bow and arrow, aiming now at the dog, now at an unknown enemy. Once in a while he takes a mouthful of rice from his mother's outstretched hand.

SARBOJAYA: Here—Were you good at your lessons today? (*Apu nods.*) You are so young—don't the other boys tease you?

Apu draws the string of his bow, lets the arrow fly, and with his mouth full, jumps off the kitchen veranda to chase after it.

SARBOJAYA: Hey! Apu! Come back!

But Apu has had enough. So has his mother. Annoyed and exasperated, she goes into the courtyard for a last try. She follows him around as he releases his arrow once again and runs away after it.

SARBOJAYA: Here—Be a good boy, finish your meal. Mustn't waste it. Apu! Come here! Won't you finish your food? All right, don't.

Sarbojaya walks away in disgust. Moving aside the washing that hangs from a line stretched across the courtyard, she goes grumbling to the kitchen, the dog following her. She empties the plate in front of the dog. In the courtyard, Apu aims his arrow again, then rushes off after it.

SARBOJAYA: It's not as if it's a grand meal. Just a little rice, and every day he fusses over it. How will you survive? But you haven't come to this world to survive, have you? *(Turning to Apu again)* Now, are you going to rinse your mouth or aren't you?

The arrow has fallen somewhere near the courtyard door. Apu runs up to the door just as it is pushed violently open from outside, and Sejo-thakrun appears, in a rage, framed by the doorway. Sarbojaya turns at the noise.

SARBOJAYA: Durga!

Pushing aside the washing, Sejo-thakrun confronts Sarbojaya, with two young girls by her side.

SEJO-THAKRUN: Where's Durga? Where is that girl?

GIRL: Shall I bring out her tin box, Aunty?

SEJO-THAKRUN: Go! A fine way to bring up your daughter!

SARBOJAYA *(in desperation)*: Why don't you tell me what's wrong?

SEJO-THAKRUN: Robbery. That's what's wrong. A necklace of beads that belongs to Tunu here—your daughter has stolen it!

SARBOJAYA *(in shocked disbelief)*: Stolen it!

The girl comes back with a tin box. Sejo-thakrun snatches it away and starts digging into it.

SEJO-THAKRUN: Huh! Surprised, are you? She's no innocent. A regular thief! My brother-in-law brought the necklace from the town only the other day. It seems Tunu showed it to your daughter.

Apu, who had retreated to one of the verandas, spots Durga as she comes near the house, about to enter it through a broken part of the wall. He shakes his head, frantically trying to warn her away. But Durga has heard the tin box being thrown on the ground. They have not found the necklace there. She waits at the wall, listening intently.

SEJO-THAKRUN: And today, in broad daylight, with a courtyard full of people, with the children playing around, she just walks off with it! She has had her eyes on that necklace right from the beginning. Or else why should she be asking to see it every day?

SARBOJAYA (*cold with anger and humiliation*): You won't find it in that box. She hasn't come back home yet. And what makes you so sure that it is she who has taken it?

GIRL: Durga-di had . . .

SEJO-THAKRUN: You keep quiet! (*To Sarbojaya*) If she hasn't taken it, do you mean to say that we have hidden it ourselves?

SARBOJAYA: Why should I say anything like that? The necklace could have fallen off while they were playing—

SEJO-THAKRUN: No. It did not fall off. We've searched high and low for it. I didn't come to tell you about it without looking for it first.

But Sarbojaya has now seen Apu, who is still sending silent messages to his sister. She turns to where Durga is hiding and calls out to her. Durga steps into the courtyard and comes through the washing to join the group.

SARBOJAYA: Did you take Tunu's necklace? (*Durga shakes her head.*)

SEJO-THAKRUN (*enraged, grabs at Durga's arm*): You didn't take it? You wretched girl!

SARBOJAYA: Did you have to strike her?

SEJO-THAKRUN: She is a liar!

Sarbojaya separates Sejo-thakrun and Durga, then pulls Durga's fists open. Fruits roll out on the ground. Indir comes into the courtyard,

dragging a large, dry palm leaf, and is bewildered by the scene she witnesses.

SARBOJAYA: Let me see!

SEJO-THAKRUN: And from which of your orchards have those come? Eh? Pick them up, Tepi.

INDIR: What's the matter?

No one replies. Sejo-thakrun still waits grimly for retribution. One of the girls with her starts picking up the fruits. Sarbojaya checks out for more fruits, untying a knot at the end of Durga's sari.

INDIR: What's up? O Sejo-bou! O Bou! What's the matter? O Bou! What's wrong?

No one looks at Indir. Tired of being ignored, she makes a sound of intense disgust, and walks away. Standing next to Durga, Sarbojaya looks once more at Sejo-thakrun.

SARBOJAYA: You know very well that we don't own any orchard. I know quite well myself that she shouldn't be picking the fruits of someone else's garden! But that doesn't mean that she would steal something that was bought with money. How can you say that, Sejo-khuri? (*Turning away*) You don't have your name written on every fruit. She is only a child. What does it matter if she takes a few—

SEJO-THAKRUN: Oh! So now you are getting sarcastic, are you? I didn't have my name written on my money either. But you took it from me all right! I can't let that money remain with you any longer. You'd better keep it ready for me. Come, Tepi. (*Turning back again*) And if you can get that necklace out of her, kindly return it.

Sejo-thakrun comes out of Sarbojaya's door with the two girls. Drawn by the raised voices, a woman stops near the door, looking curious.

WOMAN: What's happened?

SEJO-THAKRUN (*loud and clear*): The fruits from my trees are grabbed by that girl the moment they touch the ground. I came to complain about it, and her mother started talking back! What can one do! She says my fruits don't have my name written on them! So what if a child picks them? Like mother, like daughter! A bunch of thieves!

Inside the house, Sarbojaya turns her face away slowly, breathless with anger. Her eyes fall on the cause of her humiliation. Durga sits on the ground, collecting all her junk and putting them back in the box.

SARBOJAYA: Durga! (*Durga looks up scared.*) Get up! Get up, I say! So you won't?

Durga leans back, looking up at her mother with dumb, frightened eyes. Sarbojaya's hand grasps Durga's hair and pulls her to her feet. For a moment their faces are close together, one twisted with intense anger, the other with pain. Indir, sitting on the ground near her own veranda, looks up in alarm, then rises and hobbles towards them. Holding on to a post of their veranda, Apu watches them, his eyes wide with fear. Pushing the old woman aside, Sarbojaya drags Durga by the hair, down the courtyard, past the tin box still lying on the ground, through the curtains of washing, towards the door at the end of the courtyard. Durga slips away from her hold and sits back. Apu watches in shocked silence. Indir starts moving towards them again. But Sarbojaya, gripped by unbearable shame and anger, pulls her daughter to the door and pushes her out. Durga falls down, drags herself up again and moves away. Sarbojaya shuts the door, and falling against it, slowly slumps down to the ground, sobbing uncontrollably. The storm is over, and a stillness descends on the courtyard. Apu stays near the veranda. Indir looks at the weeping figure near the door, then quietly starts picking up Durga's scattered playthings. Tired and spent, Sarbojaya sits leaning against the door. Apu emerges from his corner, and sending his mother a cautious glance, goes across the

courtyard to the kitchen, where he rinses his mouth with water from a brass pot.

The day wears on. Indir takes the dried clothes off the line. Apu's voice can be heard in the distance, reading his lessons aloud. At the door, Sarbojaya lifts her head and wipes her eyes.

SARBOJAYA: Apu!

Apu, who has been holding up the book to cover his face as he reads, now shuts it and looks at his mother.

SARBOJAYA: Durga's food is lying ready. Go and fetch her.

Apu gets up with a smile, and runs out of the door, carrying his bow and arrow.

6

Night. In the flickering light of an earthen lamp, a huge shadow moves against the wall, shapeless and witchlike. It is Indir, telling the children a story of demons and kings. Durga lies with her head on Indir's lap, looking up at her with rapt attention. Apu leans against his sister, listening intently. Indir tells her story with a great deal of drama, waving her arms and changing her voice to suit the characters.

INDIR: Just then—a rakshasi appeared! Haun, maun, khaun! I smell the blood of a human being! Who lies awake in my temple? Nilkamal sleeps and Lalkamal lies awake. Then again in the second hour of the night, the rakshasi appeared once more. Haun, maun, khaun! I smell the blood of a human being! Who lies awake in my temple?

HARIHAR: Durga—! Durga—!

INDIR: Nilkamal lies awake and . . .

HARIHAR: Open the door, dear!

DURGA (*to Indir*): I'll be back.

INDIR: All right.

Sarbojaya sits in the kitchen, resting her face on her arm, looking worried and thoughtful. Behind her, Durga comes in by the door, smiling, carrying a large fish. Sarbojaya is unimpressed. On the bedroom veranda, Harihar sits washing his feet. Durga goes back to Indir.

HARIHAR: Go and tell her I am home.

SARBOJAYA (*to Durga*): Keep it there.

HARIHAR: Well? Where are you?

SARBOJAYA: Why don't you say what you have got to say?

HARIHAR: Come here. I have a great deal to tell you.

INDIR: Then the rakshasi came . . .

SARBOJAYA (*as she leaves the kitchen*): Durga ! Keep an eye on the milk!

Harihar wipes his hands dry and smiles at Sarbojaya.

SARBOJAYA: Well?

HARIHAR (*laughs*): Whatever people might say, Rai-khuro isn't a bad sort. Here, my salary for three months—three times eight, twenty-four rupees. Count them. Let me quickly finish my evening prayers. I have a lot more to tell you.

In the kitchen, Harihar begins his meal after making a ritual offering of the rice to the deities. Sarbojaya fans Harihar with a palm-leaf fan.

HARIHAR: I went to collect taxes at Dasghara today. I met someone there. Someone I've never met before. He looked important. All of a sudden he touches my feet! Whatever for? 'Da-thakur,' he said, 'you don't know me, but your father used to know me well. He would do us the honour of being present at our home for religious festivals and ceremonies.' 'What is your name?' I asked him. He said, 'Mahesh Biswas.' 'Well, what do you want?' 'I have something to ask you,' he said. 'What is it?' 'Next month all of us in the family want to be initiated. It would be wonderful if you could perform the ceremony.' Quite rich, this fellow!

SARBOJAYA: Did you agree?

HARIHAR (*smiling knowingly*): Are you mad? If I agree so readily, he'll think, 'Ah! The priest is in a bad way.'

SARBOJAYA: So what if he does ? We *are* in a bad way.

HARIHAR: There are other complications. Listen, if people know about it, there will be a scandal.

SARBOJAYA: Who's going to know?

HARIHAR: There's no telling. Maybe you yourself will let it out. (*The fan stops moving in protest.*) You never know with women.

SARBOJAYA: As if I have nothing better to do than tell people about who you're going to initiate.

HARIHAR: Aha—why are you getting angry? The job's not running away. And anyway, it's in his own interest. I'll talk to him after the puja festivals are over. Otherwise I'll lose my prestige. Don't you understand? These two months you'll have to manage on my salary. A set of new clothes for Apu and Durga, and a shawl for Didi—all that can come out of this money.

SARBOJAYA: We'll have to pay back Sejo-khuri somehow, by tomorrow.

HARIHAR: All right. Pay her from this money. The rest of the debts can be paid back after these two months.

SARBOJAYA: And what about getting the house repaired?

HARIHAR: That too can wait till after the pujas. The house has managed to survive the rains. I'll go and fetch the carpenter some time this month. He can take a look and give me an estimate.

SARBOJAYA: For god's sake, do something about the kitchen first.

HARIHAR: We'll get the kitchen repaired, and the cowshed. The walls will be fixed, the roofing will be seen to. Everything will get done. Don't you worry.

Sarbojaya looks outside the kitchen, as the children run up the bed-
room veranda. They rush into their room and fall on the bed. Durga
opens the window on the far side of the bed, then lies back.

APU: Hey! How many days are left for the pujas?

DURGA: Only twenty-one days.

APU (*blowing out the lamp*): Hey, Didi!

DURGA: Hmm?

APU: Did you take Tunu-di's necklace?

DURGA: Don't be silly.

APU: Who took it then?

DURGA: I don't know. Go to sleep.

In the next room, Harihar lies down on the bed after a last prayer for
the day. Through a door at the side, Sarbojaya can be seen sitting with
some sewing in the light of an earthen lamp.

HARIHAR (*smiles*): I have a new play in my head. I'll write it down the
 moment I have some time.

SARBOJAYA: Listen—

HARIHAR: Hmm?

SARBOJAYA: Weren't you in Kashi for a long time?

HARIHAR: Hmm.

SARBOJAYA: Does everyone know you there?

HARIHAR: Uhuh. Some people certainly do.

SARBOJAYA: And what's the name of that ghat? You know, where the
 kathak-thakurs sit?

HARIHAR: Dashashwamedh Ghat.

SARBOJAYA: Isn't it possible to make a good living there? Isn't it?

HARIHAR: I suppose so.

SARBOJAYA: Why don't we go there then?

HARIHAR: No. That cannot be.

SARBOJAYA: Why not?

HARIHAR: How can it be? I left Kashi to come back to the home of my ancestors. And now you want me to go back there? No. That can't be done.

SARBOJAYA: Of course it can. It can be done if you want to do it. You spent eight years there, leaving me with my parents. Didn't even write me a letter.

HARIHAR: But I didn't know you then. If I had, do you think I'd have gone away at all?

SARBOJAYA: Huh! As if your knowing me has made any difference.

Harihar is almost asleep. Sarbojaya sits alone with her sewing in the light of the lamp. She is still talking to Harihar. But her mind is far away, among the ghosts of her lost hopes and forgotten dreams.

SARBOJAYA: This isn't just your home, it is mine too. But what kind of a home is it? It's like living in the jungle. When darkness falls, the jackals prowl outside the door. There's no one with whom one can talk, share one's thoughts. When you aren't at home, really, I feel so scared! (*Sighs.*) You won't understand all this. You eat and sleep and live your own life. You don't even care if you don't get your salary. I had a lot of dreams once. A great many things that I wanted to do.

But there is no response. Harihar is fast asleep. Sarbojaya sighs and goes back to her sewing, alone in her little world, illuminated by the flame of the lamp. On her veranda, Indir sits in the darkness, leaning against the wall, singing softly to herself in a voice that is tired and rusty with age, yet full of a deep longing. When will her journey end?

INDIR: A poor beggar am I, O Lord,
　　My hands are empty.
　　Take me along with you.
　　Lord, the day is done, evening falls,
　　Ferry me across the river.

41

7

Durga and her friends are having a picnic. It is a bright day, and the children are hard at work in a clearing in the middle of a patch of jungle, among the long grass and tangled bushes and trees that spread their branches in every direction. Durga is squatting on the ground, blowing furiously on a wood fire. A girl sits cutting vegetables under a tree. There is a big vessel on the fire. Another girl brings the rice in a brass pot.

DURGA: Hey Apu! Hurry up with the wood. The fire's not hot enough. (*To the girl with the rice*) Have you washed it well? Put it here.

GIRL CUTTING VEGETABLES: What a blunt edge!

Indir walks down the village path, wearing a new shawl. There are children playing around noisily. A girl stops to speak to Indir.

GIRL: Is it Granny's wedding today?

INDIR: Get along with you! Where is your mother?

GIRL: There, at the pond.

Apu, carrying dry twigs in his arms, runs through the bamboo grove to where Durga is sitting. All the girls are busy preparing for the picnic.

DURGA: Hey Umi, why don't you join us? We're having a picnic! (*To Apu*) So many? Put them down. Where's the chopper?

APU: There it is.

DURGA (*to a boy sitting on a tree*): Hey! Get down at once! And go and wash the banana leaves. Huh! Sitting and swinging his legs.

Indir walks down the village path towards the pond, where a woman sits washing pots and pans.

WOMAN: Where did you get the shawl, Aunty?

INDIR (*laughs*): Raju gave it to me. He bought it at the fair at Nawab-
 ganj. It cost nine and a half annas!

WOMAN: It looks good on you.

Ranu comes running through the bushes to the picnic spot. She sits
down next to Durga, who looks delighted.

DURGA: How did you get away? Isn't Sejo-khuri at home? (*Ranu shakes
 her head.*) Want to cook?

RANU: What are you cooking?

DURGA: Khichdi.

RANU: Let's see—

DURGA: Take a look—there's rice, there's lentils, potatoes, brinjals,
 cummin seed, chillies, bay leaves, oil . . . Tepi! Didn't you bring
 the salt?

TEPI: You told me you would get the salt. I'd only said I'd get the oil!

DURGA: What do you mean? You said, oil, rice, . . .

TEPI: Hey! Don't you dare lie!

They throw themselves into the quarrel with gusto. The other chil-
dren stand around laughing. Ranu gets up, manages to calm them
down and runs to get the missing salt.

Sarbojaya is taking out brass vessels from a trunk. In the courtyard
outside, thin cotton quilts hang from a line in the sun. Indir comes
into the courtyard, in her new shawl. Sarbojaya notices it and calls
out to her.

SARBOJAYA: Thakur-jhi!

Indir tries to slide past the quilts without replying.

SARBOJAYA: Can't you hear me? Come here.

Indir gives up and reluctantly shuffles up to Sarbojaya, with a concil-
iatory smile on her face.

INDIR: What's the matter?

SARBOJAYA: Where did you get that shawl?

INDIR: Er, Raju—gave it to me.

SARBOJAYA: What do you mean, gave it? (*Indir starts walking off*) Listen to me! He gave it without your asking for it?

INDIR (*walking away*): Why should I ask for it?

Sarbojaya shuts the lid of another tin box with a loud bang, making a face at the cockroaches inside. She rises and walks down her veranda with the box. The end of her sari gets caught in the bird cage hanging from the roof. She wrenches it away angrily. Indir has reached her veranda and is hobbling up the steps. Sarbojaya goes towards the courtyard door.

INDIR: At my age—I feel a bit chilly in the evenings. So all I said was . . .

SARBOJAYA: Very well. If they can clothe you, let them feed you too.

INDIR: I did tell Hari about . . .

SARBOJAYA: Did he say he won't give it to you, that you had to go and beg for it from other people? Don't you feel ashamed of yourself?

Sarbojaya goes out of the door, going round the house to the pond at the back. Indir sits down on the ground where the grains are spread out to dry. She starts pounding something with a mortar and pestle, taking her anger out on it by exerting all the strength in her frail old body.

SARBOJAYA: Can you imagine what that man must be thinking?

INDIR (*shouting*): Can't an old woman have her whims and fancies?

SARBOJAYA: Oh! So you must have your whims and fancies now! You live off me, and then you go and have your whims and fancies! While my children don't get enough to eat twice a day. Have you thought of that? What about their whims and fancies? Would you care whether they have food in their stomach or clothes on

44

their back? Listen Thakur-jhi, as long as you're dependent on me, you shall not go from door to door, begging. Do you understand? If you want to satisfy your whims, you'd better make other arrangements.

INDIR: You don't have to keep me if you don't want to. Why talk about it? Do you think I've nowhere to go?

SARBOJAYA: Very well! Go where they'll keep you. Go today. At once!

Sarbojaya is suddenly caught by a violent fit of coughing. The tin box falls from her hands, spilling its contents across the steps of the pond. She has to sit down to try and control herself. Indir stops pounding and looks up, then comes out of the house, to the pond. For her the quarrel is over and done with, and she is concerned for the younger woman. But Sarbojaya is unwilling to give up the fight. She shakes her head and moves away from Indir's ministering hand, rejecting her sympathy.

INDIR: What's the matter? What's the matter? There, there, there.

SARBOJAYA: You can go where you want to, Thakur-jhi; I can't let you stay here any more.

Indir stands silently behind her as Sarbojaya puts all the things back in the box again.

At the picnic spot, Ranu and Durga sit side by side, eating.

DURGA (smiles): Well done. Your husband will be pleased with your cooking.

RANU: Shut up.

DURGA: How many days now to your wedding?

RANU: I don't know.

DURGA: I'll tell you. Shall I?

RANU (smiles): All right.

DURGA: Two months—and ten days. Isn't that so? (Ranu smiles and nods.) How does it feel?

RANU: The way it does for everyone else.

DURGA: But tell me how!

RANU: You'll know when it happens to you.

DURGA: It won't happen to me.

RANU: Of course it will.

DURGA: I know it won't.

RANU: Oh yes. Your mother's looking for a groom for you.

DURGA: Don't be absurd!

RANU: It's true. You can ask her.

Boys chase one another through the jungle. They run across a clearing, noisily, past Indir, who stands looking forlorn. She is wearing her new shawl, and is once again without a home.

Indir stands at Raju's door. It has been a long and tiring walk, and she is gasping for breath.

INDIR: Raju, are you home? Raju!

RAJU: Who is it?

INDIR: I have come to you just . . .

RAJU: Oh, it's Aunty.

INDIR: . . . for some shelter. If only for these few days—

RAJU: Do you want to stay?

INDIR (*panting*): Only a few days. There's no peace at home. Nothing but complaints.

RAJU: I see. Come in. Hey! Go and tell mother that Aunty Indir has come. And bring a stool, and some water for her to wash her feet.

INDIR: Where else can I go in my old age? So I thought I'll come to you. If you don't look after me, who will?

8

The puja festivals have begun. Drums play loudly. The image of the goddess stands in a haze of fragrant incense smoke. At Sarbojaya's home, Durga, in a new sari, jumps off the veranda and runs out of the house. Apu, who is with his mother, runs after Durga, Sarbojaya following him till she has tucked in the end of his dhoti. Apu wears a new dhoti, and has a shawl wrapped round his thin shoulders, for it is autumn and there is a chill in the air already. Sarbojaya stands at the door, smiling as Apu disappears.

A stream of children rush into Sejo-thakrun's courtyard. Durga runs in through the arched doorway, followed by Apu. The children crowd around Sejo-thakrun, who is distributing sweets. In the sea of out-stretched hands, Durga and Apu too get their share. It is festival time after all, and even Sejo-thakrun is in a generous mood. Outside, near the image of the goddess, children stand watching the drummers, the loud beat of the drums filling the air.

It is night. Apu sits in the front row of an enthralled audience, watching a jatra being performed on a makeshift stage. It is a mytho-logical, with an all male cast. All the actors are heavily made up and wear glittering costumes. The villain of the piece is the Serpent King, who wears black, as opposed to the hero, Kusha, a young man of noble ancestry, who is in white. The young man's wife, Sujata, daugh-ter of the Serpent King, is played by a man.

KUSHA: Beware! Beware, O evil one! O Serpent King! If I hear you speaking thus once more, I'll pull out your tongue and throw you to the dogs and jackals! All for the good of this earth.

SERPENT KING: And I shall kill you! All for the good of this earth.

SUJATA (*grabbing her father's leg*): I pray you, father, do not think such thoughts! Do not bring widowhood upon your daughter with your own hands!

SERPENT KING (*kicking her*): Away, you dissolute serpent woman!

KUSHA: Sujata! Sujata! Why do you forget your place? No longer are you the Serpent King's daughter. You are the wife of a man who traces his lineage from the great Sun! Should you fall at the feet of a low-born, hateful serpent, merely for the sake of my life?

SUJATA: No! I cannot even imagine your death. Father! Kick me as much as you will. Only grant me the vermilion on my forehead, the holy sign of marriage!

SERPENT KING (*giving another hefty kick*): A human can ask for nothing from a serpent. Get away from me, you shameless hussy!

KUSHA: Sujata! Sujata! Come away! Listen to your husband!

SUJATA (*clutching her father's leg once more*): Oh no! Kill me first, Father, and then go and complete the task you have set before yourself.

SERPENT KING: Let go of me !

KUSHA: Leave him! Leave him! If indeed there is a god, the serpent's pride will be destroyed.

SERPENT KING (*shouts*): Mahakal! (*Mahakal appears on stage.*)

MAHAKAL: Yes, Son of the Demon!

SERPENT KING: See how my daughter holds me back. Kill him! Be merciless, take your revenge!

MAHAKAL: Do you remember, O Kusha, brother of Lava, I had taken an oath in the battlefield to crush your head in with a kick? Today I have my chance.

SUJATA: No! No, Mahakal! My brother! My friend! I beg you, do not harm my husband!

SERPENT KING: Do not heed her! Kill him! Kill the evil Kusha! I will deal with my daughter.

MAHAKAL: Come, sinner!

The battle begins, their wooden swords clashing in rhythm. Kusha, who was unarmed, is suddenly provided with a sword by his wife, who is now being held back by her father.

SUJATA: Let me go, Father!

MAHAKAL (*letting out a devilish laugh*): Today I shall slake my thirst for revenge!

SUJATA: Take this, my husband, and protect yourself.

KUSHA: See, O Demon! Now the victorious trumpet will sound!

SERPENT KING: Someone give me a weapon! A weapon!

A woman and a man suddenly appear from the wings. They are plainly dressed, but carry ornamental swords in their hands, which they proceed to hand over to the Serpent King and Sujata.

WOMAN: Take this, O King, and join the battle!

MAN: Take this weapon, sister, and save your husband!

They all attack each other vigorously as the music swells.

9

Apu kneels in front of the mirror, next day, trying to wedge a tinsel moustache under his nose. It keeps falling off as he concentrates on fixing a crown made of the same stuff on his head. Sarbojaya comes into the house after a dip in the pond.

SARBOJAYA: Durga! Durga! Will you see where the calf has gone?

APU: Mother! Help me tie this thing.

SARBOJAYA: Wait! Looks like I'm here only to carry out your orders.

Durga comes past the wall of the house, calling out to Apu. Apu stands stiffly as Sarbojaya ties the crown to his head. She pushes him away, the crown flops on his nose. Apu fixes it in place as he moves away.

DURGA: Apu! Want to go and look for Aunty?

SARBOJAYA: Don't you go looking for Aunty now. Go and find the calf instead.

DURGA (*laughs*): What's that? (*She frowns suddenly.*) Where did you get the tinsel?

In the courtyard, Apu stands looking guilty, with the crown still perched on his head. He watches uneasily as Durga rushes past him, towards the bedroom. On the floor of the room Durga's little tin box lies open. Scissors, beads, bits of tinsel, shells, all her precious possessions lie scattered around. Durga takes one look, then rushes out, chasing after Apu. Apu runs out of the house, then in through the gap in the wall, followed by Durga. He manages to dodge his sister for a while. But Durga outwits him and he is caught. She pulls him down on the ground outside the house, and slaps him hard.

DURGA (*holding Apu down*): So? So you'll . . .

Through the gap in the wall, Sarbojaya sees the battle begin. She comes out of the house and pulls the children apart, slapping the dust off Apu.

SARBOJAYA: What's this? Durga? Durga! What are you up to? You're hitting him again?

DURGA: Why has he taken things out of my box?

SARBOJAYA: Why shouldn't he? Your box indeed. What's so precious about your box?

DURGA: He has taken away all my tinsel!

SARBOJAYA: Shut up! Go and fetch the calf.

Apu stands looking at Durga with eyes full of tears and reproach. The moment Sarbojaya leaves, Durga ties the end of her sari around her waist, and in a low voice, so that her mother does not hear her, has her last word on the subject.

DURGA: Ass! All dressed up like a prince!

Durga runs around the corner of the house, then peering round the wall, sticks her tongue out at Apu viciously. She then makes a gesture of eternal enmity, touching her chin with her thumb. Apu has had enough. He runs after his sister, who rushes round the corner, past the back of the house, into a path in the jungle. They come out into the paddy fields, where, under an open sky, Durga runs down a narrow path, with Apu in hot pursuit.

Indir is coming back home. Through the cracks of the courtyard door, her feet can be seen approaching Sarbojaya's house. She carries a stick now for support. Sarbojaya, who has been sitting inside the kitchen, having her midday meal, turns round at the noise of the door being pushed open. Indir hobbles up to the kitchen veranda. She looks tired and ill.

INDIR: Bou! Are you there, Bou!

SARBOJAYA: What brings you back?

INDIR (*with a pleading smile*): I haven't been feeling too well. So, I thought if I could spend my last few days—in my ancestral home—

SARBOJAYA: A fat lot you care about your ancestral home! You may as well leave, or there'll be trouble, I warn you!

INDIR: All right, all right—

Indir drags herself to her part of the house, and putting her bundle on the veranda, sits down at its edge, panting with the effort. She wipes the perspiration off her face with a tired gesture.

SARBOJAYA: What are you up to now?

INDIR: Let me just get back my breath.

Somewhere in the open field, Durga sits alone, chewing a stick of sugarcane. She sees Apu in the distance, and jumping off her perch, quickly moves away. Apu follows his sister.

Indir still sits on her veranda, wiping her face, and gasping for breath.

SARBOJAYA: Thakur-jhi! Have you fallen asleep?

INDIR: Will you—give me some water?

SARBOJAYA: Why don't you pour some yourself? You have your tumbler with you.

Sarbojaya sits eating inside the kitchen. On the veranda outside stands a large brass pitcher. Indir struggles up to the kitchen and gives Sarbojaya a last appealing smile. Sarbojaya turns, removes the lid of the pitcher and goes back to her meal. Indir's smile fades away. She silently turns to the pitcher, drinking some of the water and splashing some on her head before she moves out in the sun again. She pours the last of the water in her tumbler on the plant in front of her veranda, then starts picking up her belongings. In the kitchen, Sarbojaya sits with her back to the door, staring in front of her, her face hard and unrelenting. Indir turns to take a final look at her veranda, then drags herself down the courtyard again. Indir was out of the door. Sarbojaya lifts a bowl to her mouth mechanically.

Far away, in a field of tall, white *kaash* flowers, where telegraph poles stand towering against the sky, Durga wanders alone. The low hum of the telegraph wires fills the afternoon air. Durga looks up, then lowers her head again, listens to the hum of the wires, then moves away, looking for the source of the strange noise. In the distance, Apu wades through a patch of water, as he comes towards Durga. Durga has tracked the sound to a telegraph pole. She rests her ear against it and listens to the hum, then moves away just as Apu comes near. Apu has heard the noise too. He looks upwards, then walking up to a pole, rests his ear against it, before running after Durga. Hiding in the tall grass, Durga runs deeper into the field. Apu suddenly finds himself alone in this dense jungle.

APU: Didi!

A stick of sugarcane comes flying through the air and hits Apu. He picks it up with a smile, then goes up to Durga, who sits hidden among the tall grass, picking burrs from her sari.

DURGA: Sit down. (*Frowns.*) Eat it!

Apu plunges his teeth into the stick of sugarcane.

APU: Where are we?

Durga does not look up, but turns out her lower lip to signify 'who knows'. Apu points to a pylon.

APU: What's that? (*Durga makes the same gesture.*) If Mother . . .

Durga suddenly reacts sharply, clamping her hand over Apu's mouth to silence him. She listens hard, then silently mouths, 'a train!' Quickly jumping to their feet, the children look around in the sun. Then, turning back, they suddenly see the top of an engine, and clouds of smoke above the sea of white flowers. Apu and Durga run across the field. The train is still far away. Stumbling on the uneven ground, Durga falls down and scrambles up again, but Apu has rushed ahead, away from her. The train chugs into view as Apu runs towards it. The engine rushes past, the wheels of the train moving rapidly with a grating noise. Apu climbs up the embankment and stands looking at its receding shape. A long trail of grey smoke hangs low over the white *kaash* flowers.

Apu and Durga are returning home through a path in the bamboo grove. Durga has the calf on a leash. Away on their path, beneath a cluster of bamboos, Indir sits gasping for breath. Durga tickles Apu, and the two children roll down the sloping sides of the bamboo grove laughing helplessly. They run up the slope again. But Apu remembers the calf and has to climb down once more to pull it up after him.

Standing on the slope, Durga suddenly breaks into a smile. Then turning to caution Apu with a gesture, she goes down the other side, and creeps up to Indir, who sits with her tired old head sunk between

her knees. The children wait for her to wake up, but Indir does not stir. And when Durga puts her hand on the old woman's knee to shake her awake, she rolls over, her head hitting the ground with a thud. Leaning over her lifeless body, Durga whispers, 'Aunty!' Then, scared and shocked, she turns away, accidentally dislodging Indir's tumbler, which is sent rolling down a slope into a patch of water.

The evening mist gathers on Indir's still face.

The pall bearers carry Indir away.

Sitting with her brother on Indir's lonely veranda, Durga wipes a tear.

The funeral over, Harihar sits on the steps of the pond behind the house, staring into the water. Sarbojaya stands silently near him. Indir's song hovers over the house like the memory of a grief that will soon be forgotten.

INDIR'S SONG: Lord, the day is done, evening falls,
Ferry me across the river.
You are the host of the crossing
They tell me.
I send my prayers to you.
You take across those
Who have not a cowrie to spare.
A poor beggar am I, O Lord,
My hands are empty.
Take me along with you.

10

It is another day. The bioscope-wallah has come to the village. He stands with his magic box, shaking a rattle and loudly reciting in a sing-song voice his extraordinary bill of fare. Children rush in from all directions. Apu and Durga lean out of a hole in their wall and

eagerly watch the bioscope-wallah and the children with money who
have gathered around him.

BIOSCOPE-WALLAH: Come, come, come, come! Come and see Delhi!
See the Qutub in Delhi! See the Taj in Agra! See Kalighat in
Calcutta!

Harihar is preparing to go away somewhere. He now sits on the
veranda at home, doing his last minute packing. Sarbojaya hands him
a small bundle, then stands with the end of her sari drawn over her
head.

SARBOJAYA: When are you coming back?

HARIHAR: It'll take about seven days. I think I'll go to Bishtupur once.
It's a big town. If I can get a monthly contract, then we can sit
back and relax.

Harihar goes into the nearest room and takes down the umbrella
from the wall. He folds his hands in prayer in front of the little image
of Lord Ganesha, the elephant-headed son of Lord Shiva, and pro-
tector of the home, before he comes out of the room. Now Sarbo-
jaya hands him a tin box. Other odd bits Harihar picks up himself.
As he goes down the courtyard, towards the door, Sarbojaya stands
watching him silently.

HARIHAR: All right, I am off.

SARBOJAYA: Goodbye.

Watching Harihar starting on his journey, Sarbojaya's mind is filled
with strange forebodings. Scared and lonely once more, she bows her
head in a silent prayer for his safety.

Harihar walks down the road, stopping to bow his head in reverence
as he goes past the temples. Durga has seen her father in the distance.

DURGA: Hey Apu! There's Father. Run and get some money from
him.

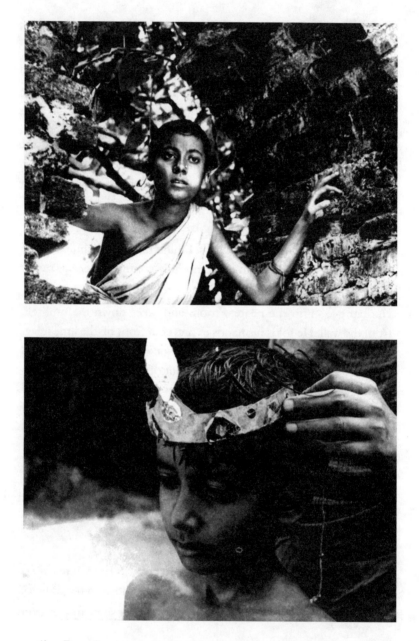

Above. Durga listens intently as Sejo-thakrun carries out the search for the lost necklace. *Below*. Sarbojaya ties the tinsel crown around Apu's head.

Above. Harihar prepares to leave.
Below. Durga steals in by the door with a large fish.

Harihar bends low to hear his son's appeal. At the wall, Durga watches anxiously as Apu points to the bioscope-wallah. Harihar gives in to Apu's pleadings, and Durga comes out on the road, smiling, running to meet Apu halfway. Together they rush up to the bioscope-wallah, peering into the holes of his magic box, which holds the wonders of the world. Harihar stops to watch his children, smiling affectionately.

BIOSCOPE-WALLAH: See the temples of Mathura!
 See the harbour of Bombay!

11

Harihar has been away for some time now. In the courtyard, below the tulsi plant, the dog lies sleeping. On the kitchen veranda, on a brass plate, Sarbojaya has put some *badi* to dry. Bottles of pickle stand sunning in the courtyard. Durga comes into the house carrying a kitten in her arms, and goes towards the bedroom veranda. Sarbojaya, who is sitting in the kitchen shaping out more *badi* on a brass plate, calls out to her daughter.

SARBOJAYA: Durga! Come here.

DURGA: Mother, I want to make some *badi* too.

SARBOJAYA: You can do that later. Do something for me first. (*She gives Durga some coins.*) Go and buy some treacle. I want to make some *payesh* for Apu.

DURGA: Shall I go now?

SARBOJAYA: Yes, right now. He has been asking for *payesh* every day.

Durga drops the kitten and goes away from the kitchen. Apu comes charging down the path to the house, through the shrubs and bushes, holding his bow and arrow and waving a letter over his head. He leaps across the threshold and runs around the courtyard wildly, refusing to listen to Sarbojaya, who runs after him.

APU: Letter! Letter! Letter! Letter! Letter! Letter!

SARBOJAYA: Whose letter is it, Apu? Let me see! Apu, let me see!

Apu throws the letter at the foot of the tulsi plant. It is a postcard from Harihar, written in a formal style. Sarbojaya reads the letter.

HARIHAR'S VOICE: I arrived at Dasghara yesterday. I have had an interview with Mahesh Biswas. The unfortunate man was bereaved of two of his children on last Mahashtami day. Under the circumstances, I deemed it fit not to mention the initiation ceremony. I am leaving for Bishnupur today. Do not be anxious. I shall collect the money required for the repair of the house and return presently. Do not be anxious. Whatever God ordains can only be for our good. Give Apu and Durga my blessings and my love.

A mendicant comes walking round the walls of the house.

MENDICANT (*singing*): Have pity on me, O generous one.
 If I can reach the Mother's blessed feet,
 I shall place them on the lotus seat of
 my heart . . .
 Mother! Give me alms, Mother!

He comes to the open door, from where Sarbojaya can be seen sitting on the steps of her veranda, looking disappointed and worried. Apu stands near her wondering why a letter from his father should depress Sarbojaya so. Lost in her own thoughts, Sarbojaya does not hear the call of the mendicant. When he repeats his call, Durga comes to the door and gives him some rice.

MENDICANT: Bless you, little mother, may you marry a king!

12

In the night, when the children are asleep, Sarbojaya stays awake with her fears. She turns to the bed where the children lie, kisses Apu, pulls a sheet up to cover him, then, picking up the lamp, goes to another room where she puts it down on the floor. She then takes out old

brass utensils from a big box. There are plates, tumblers and bowls. One of the plates has a lotus carved in the centre, and bears the legend: Be happy.

Next morning, wrapping a shawl around her shoulders, Sarbojaya goes out of the house carrying some of the utensils with her.

Now she comes back home down the same path. The morning mist has floated away, and Sarbojaya has brought home rice enough to last another few days.

13

Ranu is getting married. The rich Mukherjees have put on a big show for the occasion. A band has come from the town, and is making an awful din. The village children stand gazing in admiration at the gaudily dressed musicians. A priest makes his way through the crowd and takes a close look at the band, peering into their faces, his own face puckered in a frown. Apu jostles his way through the closed ranks and appears in the front row. Badyi Majumdar nods his head in appreciation as he listens to the cacophony. He swings his head to the beat of the music, then turns to whisper into a friend's ear. The noise is so loud that it takes some time to get the message across. The friend turns to another man, who listens and nods in agreement.

Inside the Mukherjee home the village women are busy preparing for the wedding feast. Under the strict supervision of Sejo-thakrun, the women sit cutting fish and chopping vegetables in enormous quantities. Among them, on one side, sits Sarbojaya hard at work, with the end of her sari drawn over her head. In another room Ranu is being dressed up for the ceremony. A woman paints a line of red *alta* on the edges of Ranu's feet. Durga and her friends stand inside the room, looking at Ranu, and smiling their encouragement. Durga is suddenly looking older. Her eyes, lined with kohl, have something

wistful about them. She wears a bindi on her forehead and her hair is neatly combed and drawn back from her face.

Ranu sits in her bridal clothes at the marriage ceremony, her face decorated with sandalwood paste. The priest places her hand in that of the bridegroom, as he chants from the holy text. Durga sits watching the ceremony, a lock of hair falling on her face, her eyes brimming with unshed tears. The priest places a garland on the hands of the bride and bridegroom.

14

One day has followed another, and months have flown by since Harihar left home to seek his fortune. In Sarbojaya's home, Nilmoni's wife looks at the empty pots in the kitchen, shaking her head in despair. Sarbojaya sits on the veranda outside, sobbing. She is drained of all hope, all her reserves of strength.

NILMONI'S WIFE: What do you think you are doing? How long are you going to carry on like this? We see each other every day. Couldn't you just tell me once? Are we strangers to you?

SARBOJAYA: What can I do? Every day I think there'll be some news from him. This has never happened before. It's been five months. Not a single letter, not a word . . .

NILMONI'S WIFE: I'll take Durga with me and send something with her for today. Here, keep this. (*She takes out some money.*) Take it, don't be childish.

SARBOJAYA: I can't!

NILMONI'S WIFE: Then I'll leave it here. (*Sarbojaya holds her back.*)

SARBOJAYA: I can't, Na-di! Na-di, I beg of you, I still have the brass vessels I received on my wedding!

When Nilmoni's wife leaves, Sarbojaya hides her face in her hands and gives in to another bout of weeping. Drained of tears at last, she

lifts her face again, only to hear Apu's joyous voice in the distance. Apu is running down the path in front of their house, holding a letter high above his head. Sarbojaya quickly dries her eyes and comes down the kitchen veranda just as Apu enters the house and runs around the courtyard madly.

APU: Letter! Letter! Letter! Letter! Letter!

SARBOJAYA: Apu!

APU (*reading aloud*): Shrimati Sarbojaya Devi!

Sarbojaya snatches the letter away from him and stands reading it.

HARIHAR'S VOICE: I have been unable to write to you in the past four months. You must be anxious. However, there is good news. I have at last found some means of earning money. I shall return home soon. It seems our luck has turned at last. Whatever God ordains can only be for our good.

The lines of sorrow fade away from Sarbojaya's face as she turns to smile at her son.

The water in the village pond ripples in the gentle breeze, and the large flat leaves of the water lily flutter gaily.

Water insects dart across the surface of the pond, busily exploring a flower, a leaf, a stem, a broken branch of a tree, as the ripples spread in wide circles.

In the courtyard of Sarbojaya's house, the dog spends the quiet afternoon *teasing* a kitten.

Sarbojaya lies half-asleep on the veranda in front of the bedroom, fanning herself with a palm-leaf fan.

Durga stands in front of a small mirror, putting kohl in her eyes, and a bindi on her forehead.

It is the festival of the Holy Pond. Durga has had an early bath and is wearing a clean sari, with her wet hair spread over her shoulder. Carrying a small brass pot, some flowers and a sapling, Durga goes down the courtyard, past the cowshed, to her special corner near the wall, where she has already dug a little pit. The monsoon wind blows and there is a sound of thunder rolling far away in the sky. Durga plants her sapling, and starts her prayer, dropping the flowers near the sapling.

DURGA: Holy pond and garland of flowers,
　　　Who sends her prayers under the noon-day sun?
　　　It is Leelavati, a maiden pure,
　　　I have my brother, I'm the blessed one.

Apu walks idly, under the threatening sky. The tall palm trees sway in the breeze. In the fields far away people run for shelter. Apu breaks into a run as the sky darkens above him and thunder rolls. Durga too has heard the thunder. She rushes through her prayers, longing to be out under the sky when the great gusts of wind bend the branches of the trees and a curtain of rain moves across the fields bringing with it the sweet smell of wet earth.

DURGA: My husband, a son I'll give to thee,
　　　May the waters of the Ganga cover me.
　　　To Haro Parvati I pray,
　　　Lend me some good sense every day.

She pours some water into the pit, folds her hands hastily, then rushes away to greet the storm.

As Durga runs out of the house, Sarbojaya wakes up at the sound of the door being opened.

　SARBOJAYA: Durga!

Apu runs up to the side of the house and throws his school books and slate on the bed through the window. A gale swirls around the

yard as Apu runs out into the fields again. In the village pond the wind blows over the water hyacinths, curling their leaves. Sarbojaya takes the drying clothes off the line and looks anxiously towards the door.

SARBOJAYA: Durga!

But Durga and Apu are far away, racing across a great big field, where the clouds hang low, heavy with rain, and the thunder rolls majestically.

The first drop of rain falls on Chakravarty's shining bald head. Holding his fishing rod steady with one hand, Chakravarty unfurls an umbrella over his head. The raindrops fall splashing down on the water of the pond.

Now the rain is coming down in a steady stream. Wrapping his thin arms around his drenched body, Apu runs for shelter. A solitary *kul* tree stands in the middle of the field, spreading its branches. Apu rushes under its sagging branches and stands shivering, calling out to his sister, his voice drowned by the sound of the rain.

In the village the ditches and ponds are filling up fast with the rain water. Deep puddles have formed around Sarbojaya's house. Running through the rain, the dog comes shivering into the house. He climbs up a veranda and stands shaking the water off his body.

Apu stands shivering under the *kul* tree, calling out to Durga. But Durga, her restless spirit moving with the wind and the rain, bends her head low, her hair streaming in front of her, and swings around over and over again in a wild dance. She lifts her face to the sky, shutting her eyes, and receives in silent ecstasy the torrential rain that falls over her. Cold and wet, hugging himself against the rain, Apu watches his sister, smiling through his chattering teeth as she sticks her tongue out and shakes her head defiantly. The smile flickers, for

it is cold with the east wind driving the spray under the branches of the *kul* tree. Finally, Apu stands looking miserable, waiting for Durga to finish her wild game with the rain, her hair streaming, her head bent low, as she turns round and round, till the noise of the storm and the rain grows louder and more menacing. Now she starts running through the open field, the rain hammering down on her, her palms pressed against her ears to shut out the persistent drumming of the rain. She runs to Apu under the tree and pulls him up with her to a higher perch, holding him close and covering him with the end of her wet sari. The noise of the rain merges with the roaring sound of thunder. Apu covers his ears. Even Durga has had enough of the rain. To keep their courage up, she starts chanting an old rhyme that will magically take the rain away.

DURGA: By the leaf of the lime and fruit of the *karamcha* tree,
 Rain, away with thee!

Sarbojaya walks past the overflowing pond towards her house in the pouring rain, carrying a large yam leaf. A coconut, blown off the tree in the storm, lies on the ground. She looks around to see if anybody is near, then snatches up the fruit and rushes away towards the house.

The rain lashes the leaves of the *kul* tree. The wind hisses and moans around the children. Durga hugs her brother and chants her rhyme in right earnest, stopping to sneeze every now and then.

15

Durga lies in bed with a fever. The village doctor, a thin old man, looks grave as he listens to his stethoscope.

DOCTOR: Show me your tongue, my dear.

Durga sticks out her tongue, and smiles at Apu, who sits at the foot of the bed. Sarbojaya stands with Nilmoni's wife near the bed, their heads covered with the ends of their saris, a look of concern on their

face. Nilmoni, portly and good-natured, stands near the door of the room, with a shawl wrapped around him and holding an umbrella.

NILMONI: Have you heard from Hari, Bou-ma?

SARBOJAYA: He has written. He is coming back this month.

NILMONI: I don't know why he must move around so much.

DOCTOR (*to the women*): Do you have some sago at home?

NILMONI'S WIFE (*to Sarbojaya, who stands silent*): If you don't have any, I'll send you some. Just send Apu across to me.

DOCTOR: Then give her some sago. And if the fever goes up, put a piece of wet cloth on her forehead. (*To Durga*) There's nothing to worry about, my dear. (*To the women*) Don't let her catch a chill. Come on, Nilmoni, let's go.

As the grown-ups leave the room, Apu comes and sits beside his sister, near the window. Durga smiles up at him. Outside the room, Nilmoni can be heard talking to the doctor as they move away.

NILMONI: How did you find her, Doctor?

DURGA: Hey, listen!

APU: What is it?

DURGA: When I'm well, we'll go and look at the train again. All right?

APU (*smiles*): Yes.

Another day. The merry tinkle of the sweet-seller's bells is heard as he goes past the house. Durga, still confined to bed, turns away from the sound, looking wistful.

Night. Sarbojaya sits up holding a piece of wet cloth against Durga's heated forehead. In the dim glow of the earthen lamp, Sarbojaya looks tired and sleepy. Apu sleeps beside Durga, near the window. The monsoon winds are blowing outside the house, slowly whipping up into a strong gale. Resting her head on her arm, Sarbojaya sits dozing beside her daughter. The wind beats against the house, making

the door of the room creak ominously. Sarbojaya wakes with a start. She looks at the windows, which are protected only by sheets of gunny stretched across their frame. The fierce wind pushes against the curtains, making them bulge inwards, straining against the ropes that hold them.

As the night wears on, the violence of the storm increases. Gusts of wind drive streams of water through the cracks and openings. Durga tosses restlessly on the bed. The door shakes as the wind batters against it, its latch ready to snap.

The rain gets heavier and heavier. Lightning flashes and the hurricane pounds against the walls of the house.

In the flickering light of the lamp, the little image of Ganesha, the protector of the home, sways unsteadily against the wall.

One of the curtains is blown partly loose from the window frame and lets in a flood of water. Sarbojaya kneels on the bed and secures the curtain, tying it back to the frame.

But now the latch of the door has finally given way.

In the howling wind, Sarbojaya pushes up a large tin trunk against the door.

Durga, awake and frightened, moves restlessly on the bed. The noise of the storm surges around her in a rising wave, and she covers her ears with her hands, crying out for her mother. Only Apu sleeps soundly through it all.

Sarbojaya bends over the bed and covers Apu with a sheet. Durga stretches her arms towards her mother. Helpless and panic-stricken, Sarbojaya bends over and draws Durga's face against her own,

holding her in a close embrace and murmuring words of comfort, her voice muted by the storm.

Against the wall, Lord Ganesha shakes violently in repeated flashes of lightning.

The night has passed, and so has the storm. In the grey morning, Apu stands knocking on Nilmoni's door.

NILMONI'S WIFE: Coming! (*She opens the door.*) What's the matter?

APU: Didi is not well. Mother asked me to fetch you.

NILMONI'S WIFE: Oh! All right. Binu! Sweep the courtyard, will you?
 I'll be back in a minute. (*To Apu*) Let's go.

The storm has left its mark on the house. The roof of Sarbojaya's kitchen has caved in. A low wooden seat, the oven, kitchen utensils, a dead frog, all lie exposed to the sky. Nilmoni's wife and Apu wade through the water in the courtyard. The cowshed has lost its roof, and part of Sarbojaya's veranda has been washed away.

Inside the room, Sarbojaya sits unnaturally still, her loose locks falling down her back, staring with unseeing eyes in front of her, holding Durga's lifeless head on her lap. Nilmoni's wife looks at Sarbojaya's still figure, then, placing her hand gently on Apu's head coaxes him out of the room.

NILMONI'S WIFE: My dear, go and fetch your uncle. Tell him that
 Aunty is asking for him.

APU: Is Didi sleeping?

NILMONI'S WIFE: Yes. Go, darling. Go, there's a good boy.

Nilmoni's wife picks up Durga's hand, but no pulse beats there any more. The earthen lamp still burns, unnoticed in the light of day. Nilmoni's wife stands silently looking at Sarbojaya, then comes forward, sits down in front of her, and rests Sarbojaya's head on her

own shoulder, stroking her hair in an unspoken gesture of compassion, sharing her silent grief.

16

Apu stands near the pond, cleaning his teeth. He rubs his teeth with his finger, slowly, with a far-away look in his eyes, then stops altogether, and stands staring into the distance.

At the well, Sarbojaya, her hair uncombed, her sari in shreds, fills her pitcher with water from the bucket.

Apu comes into the courtyard after a dip in the pond. The house is still littered with the ravages of the storm. He wades through the mud in the courtyard, where broken branches, leaves and roof thatching lie rotting. He goes into one of the rooms, combs his hair and comes out with a shawl wrapped around him. He picks up the empty oil bottle from the veranda and steps down into the courtyard. Stopping for a moment, he looks up at the sky. But the sky is still overcast, and Apu goes back for an umbrella.

Now he goes down a narrow path between fields, alone, a little figure with a man-size umbrella.

17

With the roof of the kitchen gone, Sarbojaya cooks on Indir's veranda, which has somehow escaped too much damage in the storm. A pot is on the fire. Sarbojaya sits in front of it, looking dazed. Nilmoni's wife has sent her daughter with a basket of vegetables.

NILMONI'S DAUGHTER: Aunty! Aunty! (*There is no reply.*) Mother has sent these for you. I'm putting the basket here.

Sarbojaya does not look at her. The girl, scared of the still, silent figure on the veranda, puts the basket down and backs away, then quickly walks out of the house.

Harihar comes down the path leading to the house. He calls out for his children. Sarbojaya starts, the single bangle slides down the arm on which she rests her face. She removes her arm and sits up listening, still staring blankly in front of her. Harihar looks into the bedroom from outside, then turns the corner and pauses in front of the house. A tree has crashed through the wall on one side. Harihar looks at the ruins of his home sadly.

HARIHAR: Couldn't it wait a little longer?

The house looks deserted. The roofless cowshed stands like a skeleton in a scene of devastation. Coming into the empty, silent courtyard, Harihar is suddenly afraid. He calls out to his children once more, his voice hoarse with fear.

HARIHAR: Khoka! Durga!

Behind him, Sarbojaya appears from Indir's veranda, her head covered with the end of her sari. She goes silently past her husband towards the bedroom, puts down a jug of water on the veranda, and goes into the room. Immensely relieved, Harihar picks up his luggage and follows her up the steps.

HARIHAR: Oh! You're home.

SARBOJAYA: Come.

Harihar stands on the veranda, looking at the devastation around him. Sarbojaya comes out of the room with a small brass pot with a long spout, and pours the water from the jug into it. She goes back to the room again as Harihar turns towards the room, putting his luggage on the veranda.

HARIHAR: How are you? They've gone out, have they?

He takes off his shirt and wipes his face. Sarbojaya comes out of the room with a low wooden seat and a towel, then goes inside again to bring a pair of wooden slippers, which she places near the seat. Now she starts moving down the steps again, as silently as she had come. But Harihar stops her. He squats on the veranda and starts opening one of the bundles he has brought with him.

HARIHAR: Where are you going? Won't you see what I have brought?

Sarbojaya stands motionless on the stairs. Harihar, smiling happily, takes out his purchases one by one. Sarbojaya holds on to her silence like a shield against the grief that is about to overwhelm her. She barely turns her head, refusing to look at the gifts Harihar has brought home.

HARIHAR: Wouldn't I have come earlier if I could? My luck changed when I arrived at Ranaghat. It was worth all the running around I had to do before. Here, from the Chadak fair— (*He holds up a rolling pin and board.*) Take a look. It's made of the wood of the jackfruit tree! And you'd asked me for a picture of the goddess Laxmi, here it is. See how I have framed it in glass. (*He picks up a sari.*) And for Durga there's a—here, take a look at this one. See if you like the sari. Come on, look at it! Why should you worry any more? I have come back home . . .

Sarbojaya takes the sari. All her pent-up grief wells out as she clutches the sari in her hands. The music swells and carries her cry with it in a sweep. She slumps down, weeping bitterly, uncontrollably, and with utter abandon.

Sarbojaya collapses at her husband's feet, offering him the entire burden of her helpless sorrow, her admission of defeat. Harihar bends over her, bewildered, rises in confusion, then falls back again, resting his head against Sarbojaya's shaking shoulders.

HARIHAR: Durga! Durga Ma—!

Holding the big umbrella and the bottle now filled with oil, Apu stops behind the house, a lonely little figure, and listens to his father's agonized cries.

In the night, while Sarbojaya sleeps, Harihar lies awake, staring at the ceiling. A railway train moves on the tracks far away, its rhythmic sound travelling across the field in the silence of the night.

18

Morning. Harihar sits on the veranda with his glasses on his nose, dusting and sorting out sheaves of paper. In another part of the house, Nilmoni's wife helps Sarbojaya to pack their meagre family belongings.

HARIHAR: Khoka, please go and fetch whatever is on the shelves and put them on the big bench outside.

SARBOJAYA: To tell you the truth, Na-di, in this one year I've lost all attachment to the ancestral home. We've managed to survive somehow because of you and Thakur-po. I don't know what I would have done without you.

NILMONI'S WIFE: What are you saying? And what good did our being here do? We couldn't keep you here, could we?

SARBOJAYA: That's not your fault, Na-di. It's our fate. After all, there are other people who live in Nishchindipur, live happily here.

NILMONI'S WIFE: Well, I hope you settle down happily in your new home. What else can I say?

Sarbojaya and Nilmoni's wife both cover their heads with the end of their saris as Sejo-thakrun's voice is heard.

SEJO-THAKRUN: Where are you, Notun-bou?

Sejo-thakrun comes up to where the two women are sitting, carrying a basket of mangoes, and sits down near them, out of breath from the effort.

SARBOJAYA: Please let me put a seat there for you.

SEJO-THAKRUN: You don't have to bring me a seat. The mangoes fell the other day in the storm. So I thought I'll bring them for you— to take with you on your journey.

SARBOJAYA: You needn't have taken the trouble to bring them yourself.

SEJO-THAKRUN: What's wrong with that? After all I have never given you anything. So what are a few mangoes? You are leaving tomorrow?

SARBOJAYA: Yes. You are probably angry with me. I didn't tell you anything.

SEJO-THAKRUN: Oh no. Why should I be angry with you, Bou? I am pleased, very pleased to hear that you are leaving. It isn't worth it, digging one's stakes in at one spot and staying there year after year, Notun-bou! It makes a person mean. I know. It has happened to me. (*She puts a* paan *in her mouth elaborately, but she is close to tears.*) Let's see if I too can get away to Chandranath for a while. I must talk to my brother-in-law about it.

Now the village elders have come to visit Harihar. Among them are Badyi Majumdar and Chakravarty. Badyi looks older, infirm. Harihar and Apu shift a tin trunk from the big wooden bench to make room for everyone. Nilmoni sits at the back with his hookah. While they talk, Harihar continues with his work, and Apu runs up and down the veranda, now carrying things, now putting something away.

HARIHAR: Chakkotti-mashai, come in. Please sit down.

AN OLD MAN: Why are you getting so formal with us? It's all right!

Above. Returning home, Harihar silently gazes at the devastation around him. *Below.* All her pent-up grief wells out as Sarbojaya collapses at her husband's feet, sobbing uncontrollably.

BADYI (*out of breath*): I've been in bed for a month and a half following an attack of indigestion. I've been feeling so weak that I couldn't come. Now Chakkotti tells me that you are going away to Kashi!

HARIHAR: Yes. We're leaving tomorrow. Early morning.

BADYI: Oh? Leaving tomorrow?

HARIHAR: Yes.

BADYI: Oh. But Harihar—do you think you're doing the right thing? You are Rajkeshto's son, and a grandson of Tarkalankar-mashai. This home of yours has given shelter to three generations. There are still some of us older people left in the village. You should have discussed it with us. Eh?

Badyi Majumdar looks at the others for approval. All the old men make suitable noises. Only Harihar continues with his work.

HARIHAR: What is there to discuss, Majumdar-khuro? You can see for yourself what a state the house is in. I can't afford to repair it now. All of you are there; I'm sure you would have helped me to pay for the repairs. But how long can this state of affairs go on? It's been a long time. Yes, almost fifteen years. I had hoped to pay back your loans, and I haven't been able to do even that. Let me see if I can manage it after selling some of our belongings. I've not been able to do any of the things I had hoped to do. I used to do a bit of writing. Just look at these sheets. White ants all over them. I had hopes of educating the boy. (*He shakes his head despondently.*) It came to nothing. (*Sighs.*) And the girl— (*He shakes his head again.*) She gave me the slip. (*He pauses, as if shaking off Durga's ghost.*) So, it is right for me to leave, Majumdar-khuro. There are times when you have to give up even your ancestral home. Once there, if nothing else, I can sit at the ghat and read from the holy books . . .

The bookshelves in the room have been emptied. While Harihar talks outside, Apu stands in front of the shelf where Durga used to keep

her secret store of oil for her tamarind pickle. He climbs the lower shelves to reach the top ones where large spider's webs spread against the wall. Apu's hand touches a coconut shell. He pulls it down and drops it on the floor, turning to look at it. Outside the men can be heard talking.

HARIHAR: . . . or narrate old mythological tales and earn a living.

BADYI: Hmm. You're leaving. But you'll be back sometime?

HARIHAR: There'll be no coming back for me.

The coconut shell lies on the floor of the room. A spider comes out of it as a bead necklace falls out. Apu picks up the necklace and stares at it silently. Then he turns and runs to the window. He jumps out of the window, climbs over a broken wall, and runs towards the pond at the back of the house.

Apu throws the necklace into the pond.

It lands in the water with a plop, and is lost beneath a floating carpet of leaves. Apu remains staring at the water where he has thrown the necklace as the leaves close in again, almost, but not quite, covering the gap left by it.

19

Harihar Ray has left his ancestral home. The house, with its collapsed roofs, has an abandoned, ravaged look. The dog sits curled up in the empty courtyard.

Between the broken bricks of the veranda, a snake moves slowly, sinuously. It comes out and glides towards the bedroom door. It crosses the threshold and disappears into the room.

In the gathering darkness, a bullock cart goes jogging down the road, a hurricane lantern swinging at the back.

Under the matted roofing of the cart sit Apu, Sarbojaya and Harihar. Sarbojaya holds the end of her sari to her mouth.

After a while she bows her head and weeps silently. Harihar looks at her, then turns away with a sigh. He looks in front of him, at the path that he is leaving behind. In the fading light his face looks sorrowful, but resigned and strangely calm, as the bullock cart carries them away.

सुबह, दोपहर, शाम, तिमाहीना —

APARAJITO

The Unvanquished, 1956

CREDITS

Direction, production and script	Satyajit Ray
Story	Bibhutibhushan Bandyopadhyay
Camera	Subrata Mitra
Art Direction	Bansi Chandragupta
Editing	Dulal Dutta
Sound	Durgadas Mitra
Music	Ravi Shankar
Produced by	Epic Films (Private) Ltd

Bengali / 113 minutes / Black and white / 1956

CAST

Artistes	*Characters*
Kanu Bandyopadhyay	Harihar
Karuna Bandyopadhyay	Sarbojaya
Smaran Kumar Ghosal	Apu
Pinaki Sengupta	Younger Apu
Ramaniranjan Sengupta	Bhabataran
Charuprakash Ghosh	Nanda-babu
Shanti Gupta	Mukhujje-ginni
Ranibala	Teli-ginni
Sudipta Roy	Nirupama
Ajay Mitra	Shibnath
Subodh Ganguly	The Headmaster

<center>1</center>

A train rumbles across a bridge. Through the window, steel girders flash past, revealing brief glimpses of a wide river, the holy Ganga.

TITLE: VARANASI. YEAR 1327 [BENGALI CALENDAR]

Dawn over the city of Varanasi. Near the ghat, an old man stands on a flat roof, scattering grain. A flock of pigeons flutter over the roofs of buildings, the air reverberating with the noise of their wings. There are pigeons everywhere, on the carved temple walls, on the thatch covering of sunshades on the ghat steps, over the water at the edge of the river. They come flapping their wings at the call of the old man, and settle down on the roof where he stands. There are people everywhere too. An old widow sits praying under a torn sunshade. Men and women bathe in the river. The *kathak thakurs* recite holy verses, surrounded by devotees. The temple bells ring in the morning air. In the river, boats lie moored in the shallows. Fishing nets rest against the walls of the ghat.

Harihar carries the holy water of the river in a little brass pot, up the steps of the ghat. He stops to collect his glasses from another *kathak* who sits under a neighbouring sunshade on the steps, smears some *sindur* on his forehead from the coconut shell that the *kathak* offers him, then goes up the steps again. He enters one of the narrow meandering lanes of the city, sprinkling the holy water on the deities placed

<center>81</center>

on either side of the lane. He turns into a narrower lane and enters a door on the right. It is an old-fashioned brick house. The rooms, in two storeys, are built around a small courtyard. The Rays live on the ground floor. Sarbojaya is washing the courtyard, sweeping the water away with a broom. Harihar hangs his shawl on the clothesline.

SARBOJAYA: Did you see the monkey outside?

HARIHAR: What? Did a monkey get into the house?

SARBOJAYA: Not *that* monkey. Your precious son.

HARIHAR (*laughs*): Oh, I see.

SARBOJAYA: I boiled some milk for him, and he vanished without drinking it. And the boys in this neighbourhood . . .

She grumbles as she sweeps the courtyard, her voice indistinct against the noise of the broom and the water running from a tap.

SARBOJAYA: This is a crowded township. How can I keep an eye on him here? Isn't there a school nearby? I can stop worrying for at least a little while then.

Sarbojaya has finished cleaning the courtyard. Now she sits washing dishes at the tap. Harihar, wearing fresh clothes, comes out of a room. He goes in once more, to take his umbrella, before going towards the front door.

SARBOJAYA: Are you going out? There's some milk for you.

HARIHAR: For me? You just said that the milk was for Khoka.

SARBOJAYA: You too will have some from now on.

HARIHAR (*smiles*): Is that so?

SARBOJAYA: It's in the kitchen in the small bowl.

Squatting on the floor of the kitchen, Harihar drinks the milk from a bowl. He smiles, pleased, then comes out of the kitchen, taking another sip from the bowl.

HARIHAR: Ah! The milk tastes good.

SARBOJAYA: Won't you go to market?

HARIHAR: Yes, of course. Tell me what I should get.

SARBOJAYA: I'll tell you, but—

HARIHAR: But? Thinking of the money, are you? I don't have to pay in cash.

SARBOJAYA: What do you mean? Will he give you credit?

HARIHAR (*smiles*): Do you think I provide all those herbal medicines for free? Tell me what I have to bring.

SARBOJAYA: All right then, bring some mustard oil, and some kerosene too. And spices. And see if you can get some *mung dal*— *mung* or *masoor*, whatever you can get. I want to make Apu some khichdi. He had some at the ghat the other day, and has been asking for it ever since.

HARIHAR: Anything else?

SARBOJAYA: That's enough for today. Oh yes, can you get some good paan masala?

HARIHAR: What brand?

SARBOJAYA: I don't know the name. The woman upstairs had given me some. It tastes nice.

HARIHAR: Find out the name. I'll bring it tomorrow.

He fills some water in the bowl from the tap, drinks, and puts it down near Sarbojaya, before turning to leave.

HARIHAR: I discovered a sweetmeat seller whom I knew before. He says he has rheumatism. Here's some medicine I am taking for him.

SARBOJAYA: Really?

HARIHAR: If you like, I can get some cream from him. Cream from Kashi! You know how famous that is?

SARBOJAYA: I know.

HARIHAR: Should I get some?

SARBOJAYA: Let the medicine work first.

Harihar laughs before going out by the door.

Two little girls run down the stairs behind Sarbojaya, followed by a woman.

WOMAN: Hey, Gayatri! Gayatri! Listen!

Two more women come down the stairs, one of them carrying a baby in her arms. They are on their way to the river. The second woman stops to talk to Sarbojaya in Hindi.

SECOND WOMAN: Aren't you going to bathe in the Ganga? (*Sarbojaya smiles and shakes her head.*) If you don't, you won't get your salvation.

Another member of the family, a man, comes down the stairs as the women go towards the door. He speaks in broken Bengali as he follows the women.

MAN: They have just arrived. Let them settle down first. They will bathe in the Ganga, pay their homage to Vishwanathji—they must settle down first—all in good time.

Apu peeps out from behind the wall of a house. A drawing of a dog adorns the wall. Behind another wall, which carries the picture of a rabbit, hides another boy. Apu is playing with his friends in the lanes near his home. The boys run up and down the narrow, winding paths, past walls decorated with drawings of various animals. The lanes are so narrow that a passing cow can block the way, and the boys must crawl under her spreading belly, and out on the other side.

Sarbojaya has just finished cleaning the dishes. As she is putting them away, Apu rushes in by the front door. He rushes up to the tap, drinks from it, and is running out again as Sarbojaya calls him. She brings him a bowl of milk.

APU (*in Hindi*): Water!

SARBOJAYA: Apu! Wait! Don't you ever feel hungry? Running around all morning like this? Have you eaten anything outside? (*Apu nods.*) What did you eat?

APU (*showing off his Hindi*): A sweet made from milk.

SARBOJAYA: Did you really eat it?

APU (*rushing out again*): And a *pedha* as well!

Sarbojaya is going to the tap again to wash the bowl, when a noise on the stairs makes her stop and cover her head with the end of her sari. Nanda-babu comes down the stairs; he too is on his way to the ghat. Nanda-babu lives alone in a room on the terrace roof of the house. He is fat and suspiciously over-friendly.

NANDA-BABU: Is Ray-mashai at home?

SARBOJAYA: No.

NANDA-BABU: Oh—I had brought a calendar for him. Last night I was late coming home, so I couldn't give it to him. Shall I put it in his room?

SARBOJAYA: Yes.

NANDA-BABU: All right. We bring one out every year. You'll find all the important holy days in it. And all the holy festivals are marked in red. You won't have any problem at all.

Harihar sits under a sunshade with a thatch covering, surrounded by women, mostly widows. He is explaining verses from the holy text by translating them from the Sanskrit. A brass plate lies in front of him with just a few coins on it. Apu wanders around nearby, playing by himself with a paper toy—a little windmill that spins in the breeze.

HARIHAR: O Lord of the world, those who have faith in you are the blessed ones. Those who worship you are the holy ones. Those who praise you . . .

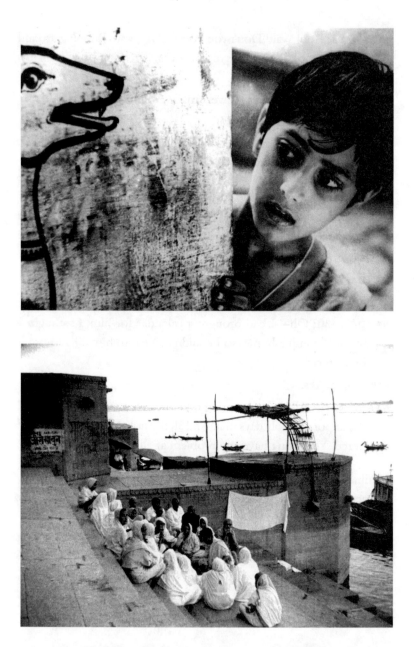

Above. The hide and seek game: Apu peeps out from behind a wall.
Below. At the ghat, reciting from the scriptures.

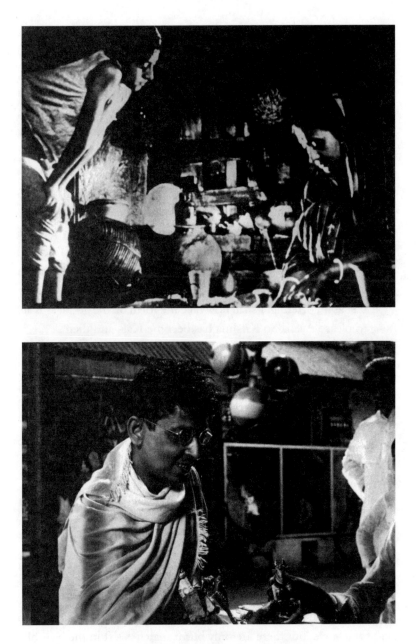

Above. Apu watches his mother making tea.
Below. Harihar buys toys at the marketplace.

Apu runs down a parapet holding his little windmill, walks past temple pillars, and rushes down the steps of the ghat, his windmill spinning merrily. Nearby, another *kathak* sits under his sunshade, describing Lord Krishna's amorous exploits. He tells the story with a lot of drama, breaking into song now and then. Apu goes past him, down to the river, where he hops on to one of the boats. After exploring the boat, Apu goes for a walk along the river bank.

KATHAK: Look at that! She weeps with her head on Krishna's chest! Wait till I call my brother. Then Jatila, very quietly, walks up to her brother Ayan. She takes him with her to her hiding place and says: 'My dear brother, just take a look at that! See what your wife is up to! There she weeps resting her head on Krishna's chest! Oh! But where—?' You see, what has happened in the mean while—Krishna tells Radha, 'Get a *jaba* flower and place it at my feet as an offering. I shall now take the form of the goddess Kali, to please Ayan.' So Krishna has become Kali, and then . . .

The *kathak's* words grow faint in the distance. Apu walks past an open-air gymnasium. He stops to watch one of the men who is doing his morning exercises. The man stops to speak to Apu. He is holding a heavy club.

MAN: Little boy, want to swing a club? (*Apu shakes his head.*) Why not?
APU: No.
MAN: Then let me swing it.
The man swings the club without any apparent effort. Apu watches the performance with a rapt expression on his face.

Now evening falls over the river. In the fading light the city stands at the edge of the river, stretched along its banks.

Sarbojaya is pouring kerosene into a stove in the kitchen. She tries to light the stove, but there are only burnt matches left in the box. She calls out to Apu, then stops and covers her head with the end of her

sari as Nanda-babu comes into the house, carrying a tabla, and with a cigarette hanging from his lips. Sarbojaya waits in the kitchen till he has gone up the stairs, then goes across the courtyard into the bedroom. But there are no matchboxes on the bedroom shelf either.

SARBOJAYA: Apu! Apu! Come here. What's the name of the man who lives on the top floor?

APU: Nanda-babu.

SARBOJAYA: Go to him, and tell him that mother has used up all the matches. Wait! Tell him that mother has used up all the matches and father isn't home yet. So she has asked for two matchsticks. Listen! Just get two matchsticks, all right?

Apu runs off before his mother has really finished, up the flights of stairs, straight on to the terrace. He pauses at the door of Nanda-babu's room. Nanda-babu can be heard humming a tune inside. The door is half-open, and Apu can see Nanda-babu taking off his shirt, humming all the time. He picks up a paper packet and takes out a bottle. Apu gently pushes the door open.

APU: Nanda-babu—

NANDA-BABU: Who is it?

He quickly hides the bottle behind him.

NANDA-BABU: Who is it?

APU: It's me.

NANDA-BABU: Who's me? It's Khoka! Come in, come in. What do you want?

APU (faintly): Matches.

NANDA-BABU: What will you do with matches?

APU: Mother wants them.

NANDA-BABU: Oh! Mother wants them. All right, wait.

He puts the bottle on a table and takes a box of matches from a new carton, then points at the bottle self-consciously.

NANDA-BABU: That is my medicine. I'm ill, you see. So the doctor has asked me to take that every evening. Here—

APU: Only two matchsticks.

NANDA-BABU: What? Why only two? Take the whole box. I have more of them. Here, take it. (*Apu turns to go.*) Tell your mother that Nanda-babu has said that she need not return it. All right?

Apu nods, and goes out of the room. Nanda-babu starts humming again.

On the steps of the ghat Harihar sits reciting from the holy texts. When he finishes, the women sitting around him put their contribution on the brass plate in front of him. The coins are mostly single paisas. Harihar goes to the edge of the river to wash his face. The *kathak* who was earlier telling the story of Krishna to a gathering of women now approaches Harihar as he comes up the steps.

KATHAK: You have a fine voice. Namaskar! You are a singer too, it seems.

HARIHAR: I used to be.

KATHAK: Do you live close by?

HARIHAR: Why?

KATHAK: I was just wondering where I could have some tea. The weather's gone chilly suddenly, and my throat is sore. Here, see how I've been carrying the tea leaves tied to the end of my wrapper.

HARIHAR: All right. Why don't you come along? My home is quite near, in Ganesh Mohalla.

KATHAK: You don't mind?

HARIHAR: Oh, no.

KATHAK: My name is Kalicharan Bandyopadbyay. I'm from Sathkhire.

Making tea is a rare and exciting experience for Sarbojaya. Apu sits in the kitchen watching her stir the tea in a small brass pot with the

handle of a ladle. She smiles at Apu, then picks up the pot with a piece of cloth wrapped around it, and pours the tea into glasses.

SARBOJAYA: God knows whether it's all right.

APU: I want some too, Ma.

SARBOJAYA: Later. Go and give them the tea first. Then come and take the sweets. Careful. Don't drop it.

Apu carries the glasses on a brass plate to where Harihar and Kalicharan sit on the bed. Sarbojaya waits behind the door, frowning with worry, waiting for the verdict.

HARIHAR: There you are.

KALICHARAN: That's nice. Your son's very helpful!

Kalicharan takes a sip of the tea.

KALICHARAN: This is good tea.

Sarbojaya smiles in relief.

Kalicharan is leaving. Harihar comes out into the courtyard with him.

KALICHARAN: Where's your son? He is a good boy.

HARIHAR: Khoka!

KALICHARAN: There you are. Come. On Tuesday I'll take you to a feast at the palace of Teota. You'll come with me, won't you?

HARIHAR: Of course he will.

KALICHARAN: Every year they have a feast at the palace and they send me an invitation. You won't mind if I take your son with me, would you?

HARIHAR: No, no.

KALICHARAN: I don't mind telling you, my friend, I have collected about four hundred rupees somehow, starving myself most of the time. If I can manage to save another hundred or so, I can get myself a bride from a decent family. I think you can't be happy without a family of your own. Don't you agree? All right.

Goodbye. (*He takes a few steps, then turns back.*) Oh! Hari-babu! You
wouldn't know of any girl—

HARIHAR: I'm afraid not.

KALICHARAN: Oh. All right then.

2

It is late autumn, the time for various religious festivals. Sarbojaya
goes to the Vishwanath temple one day, with Apu, and with the non-
Bengali neighbours from the first floor.

Inside the temple, Sarbojaya stands enthralled among a crowd of
devotees, watching the priests perform a ritual in front of the image
of the god. The priests sing to the god, ringing little bells, and rocking
to and fro in a trance.

Fireworks leave a shower of sparks in the sky. Above the noise of
drums can be heard the shouts of children playing with crackers.
Inside the house, Sarbojaya lights little earthen lamps as part of the
Dussera celebrations. Harihar comes in by the front door. He moves
slowly, dragging his feet, looking ill.

SARBOJAYA: The Pandeys have all gone to see the Ramlila perform-
ance. Can't you take Apu too? He has never seen it. Will you take
him?

HARIHAR (*haltingly*): Would you—hold these?

SARBOJAYA: What's the matter?

Sarbojaya quickly rises to her feet and takes the packets that her hus-
band carries in his hands. She goes after him anxiously as he struggles
across the courtyard into the bedroom. He sits down on the bed,
gasping for breath.

SARBOJAYA: What's the matter? (*Touching his forehead*) Your body is
burning with fever! How long have you been like this?

HARIHAR (*panting*): I went to the market, then—to the sweet-seller's—for the cream—then to the ghat for my evening prayers. Then, as I was climbing those steps . . .

SARBOJAYA: Let it be. You lie down now. Apu has just gone out to buy some crackers. You lie down.

HARIHAR: What do you need him for?

SARBOJAYA: Don't you need a doctor?

HARIHAR: No. Don't bother.

SARBOJAYA: Indeed! Well, I am not going to listen to you.

HARIHAR: Please listen to me. In that tin box there are some herbal medicines. Give me one dose.

APU: Mother!

HARIHAR: Mix it well with the juice of ginger and some honey. Let me try it today. Maybe it'll work. If I'm not well by tomorrow, we'll see about it.

SARBOJAYA: Apu, come and sit near your father. He is ill.

HARIHAR: Come. Sit down. Did you buy the crackers?

Apu, who had been standing at the door, now comes and gives his father a long list of all the crackers he has bought.

HARIHAR: The fireworks here aren't as good as they are at Nishchindipur, are they?

APU: No.

HARIHAR: Were you watching the fireworks from the terrace?

APU: Yes. (*A voice calls for Apu from outside the house.*)

HARIHAR: Who is that calling you?

APU: Shambhu.

HARIHAR: Who is Shambhu?

APU: He lives in Kukurgali. He is not a Bengali.

HARIHAR: Oh. Is he your friend? (*Apu nods.*) Is he the one who teaches you English?

APU: Yes.

HARIHAR: All right. Tell me, what's the English for 'Apu bhalo chheley'?

APU: (*in English*): Apu is a good boy.

SHAMBHU: Apu—!

HARIHAR: Why don't you call him in?

APU: He is going to set off the crackers now.

HARIHAR: Do you want to go with him?

APU: Yes.

HARIHAR: All right. Go.

Harihar has been lying in his bed with his eyes shut. He looks up as Sarbojaya comes in with the medicine.

SARBOJAYA: How are you feeling now?

HARIHAR: Better. Much better.

SARBOJAYA (*giving him the medicine*): Here—you gave me such a scare! You must have caught a chill. You've been running around too much. You must take it easy now. You're earning enough.

She is moving away when Harihar calls her back.

HARIHAR: Come here—

SARBOJAYA: What is it?

HARIHAR: Why don't you come and sit here for a while?

SARBOJAYA: There's work to be done. I have to make Apu's bed. You will be sleeping on the cot tonight.

HARIHAR: That sweet-seller told me about a house today.

SARBOJAYA: Really?

HARIHAR: Yes. Near the Man Mandir. On the first floor, two rooms, facing the south. The rent is seven rupees. There are markets and schools nearby. Khoka too won't have any problem.

SARBOJAYA: We'll talk about it later. You get well first. (*She turns to go.*)

HARIHAR: What is the boy doing?

SARBOJAYA: Can't you hear him?

Apu sits on the other side of the window, next to Harihar's bed. He is playing by himself and humming a tune. Harihar looks at him through the window, and laughs silently.

Next morning. A monkey sits near the tap in the courtyard, drinking water from it. Sarbojaya tries to shoo it off.

SARBOJAYA: Oh! Look at that! Get out! Go!

But the monkey is in no mood to leave. He snaps and growls at her. Sarbojaya jumps back, screaming in fright. When the monkey has finally gone, Sarbojaya comes back to the tap, looking around cautiously. She is washing the tap clean as Harihar appears behind her, dressed to go out.

HARIHAR: But for the monkeys, Kashi would have been a good place.

SARBOJAYA: Yes, wouldn't it? What's this? You're going out!

HARIHAR: Don't I have to go to the ghat?

SARBOJAYA (pleading): You had such high fever last night. Couldn't you stay back today?

HARIHAR: I'm all right today. The medicine has worked.

SARBOJAYA: You are again going to climb up and down all those steps—

But Harihar does go to the ghat. After bathing in the river, he climbs the steps of the ghat till he hears someone calling out to him. The Kathak who sits next to him holds out his glasses. Harihar goes down the steps again and picks up his glasses. But this time it is harder going up the steps. He pauses for breath at a landing, holding on to a pole to steady himself. The early morning crowd of devotees throng the entrance to the lane through which Harihar must pass, the women throwing flowers at the temple windows on either side, invoking the

gods. It is one of them who first notices Harihar faltering as he moves forward, and then collapsing on the ground. A man rushes up to him, calling for help.

Men from the ghat bring Harihar home, down the narrow winding lanes.

Now a doctor examines Harihar as he lies in bed. Sarbojaya and Pandey, the man from the first floor, stand near the bed. Apu and Pandey's wife are also in the room. Through the window Nanda-babu looks in curiously as he stands brushing his teeth.

PANDEY (*in Hindi*): I didn't hear anything in the night. We came back late from the Ramlila performance. We didn't hear anything in the morning either. My wife was going to the ghat for a dip when she heard that he had fallen down unconscious on the steps.

NANDA-BABU: I hope he hasn't hurt himself.

PANDEY: He must have done so. They are stone steps.

DOCTOR: For one thing, he seems to have a cold in his chest—

PANDEY: Yes—

DOCTOR: The room is damp. The windows and doors should be kept closed so that he is not exposed to the cold.

PANDEY: All right.

DOCTOR: And someone should come with me. I'll prescribe the medicines.

PANDEY: I'll go with you myself.

DOCTOR (*to Sarbojaya*): And if you have some mustard oil and camphor at home, heat them and massage his chest and back with the solution. It will help him.

PANDEY: All right. We'll do that. (*As the doctor goes out with him*) How do you find him, Doctor?

PANDEY'S WIFE: If you need anything, let me know. Don't feel shy. All right? Goodbye.

Pandey's wife goes past Sarbojaya towards the door. Sarbojaya gives her a bleak smile, then turns to her husband with a worried look on her face. She moves closer and buttons up his shirt.

Apu spends his days wandering out of doors. Now he sits and watches with keen interest an elaborate process of irrigation: a pair of bullocks help to draw a large leather bag up a well; it comes up heavy with water and is emptied into a canal.

Harihar lies asleep on the bed near the window.

Outside the room, at the foot of the stairs, two kittens play with a wooden toy. Down the stairs comes Nanda-babu, his feet shod in shining new pumps.

Sarbojaya, working in the kitchen, hears his footsteps and draws the end of her sari over her head.

Nanda-babu looks at Harihar through the window. He calls out softly to Harihar, who does not respond. Nanda-babu moves away from the window and goes stealthily to the kitchen. He takes off his shoes before entering the kitchen, where Sarbojaya sits cooking.

NANDA-BABU (*whispers*): Bou-than !

Sarbojaya sits up, suddenly alert and suspicious. Nanda-babu comes closer, cautiously extending a hand towards Sarbojaya, his fingers trembling with excitement.

NANDA-BABU: Bou-than, are you making paan?

Sarbojaya rises to her feet and confronts Nanda-babu in one sharp movement, clutching a curved kitchen knife in her hand.

SARBOJAYA: Get out! I m telling you, get out at once!

NANDA-BABU: All right, all right—I'm going!

Nanda-babu beats a hasty retreat. Sarbojaya leans back against the wall of the kitchen, deeply upset by the experience.

It is night. The priests chant their prayers in the Vishwanath temple.

Sarbojaya sits by Harihar's bed; he lies in a semi-conscious state, groaning weakly as she massages his chest.

Dawn. Sarbojaya rests her tired head on her arm. A muffled sound wakes her. It is Harihar. A strange sound comes from his throat.

SARBOJAYA: Did you say something? Do you want some water?

HARIHAR: Ganga . . .

She fetches a small brass pot from the other room, and shakes Apu awake.

SARBOJAYA: Apu! Apu! Apu, get up, dear, get up. Go to the ghat and get a pot of water. Here—here's the pot. You must run back. Wait! Wrap this around you.

Sarbojaya puts a shawl around Apu, who goes sleepily out of the room.

Apu goes down the lane towards the river. In the room, Harihar again tries to speak, a rattling sound coming from his throat.

HARIHAR: Kho—ka! Kho—ka!

SARBOJAYA: He is coming. He'll be here any moment.

The temple bells are ringing as Apu runs down the steps of the ghat and fills the pot with water. A lone wrestler swings a club in the distance. The bathers have yet to arrive.

Apu comes up the lane again, carrying the pot of holy water.

Harihar groans aloud and Sarbojaya, frightened and alone, looks around impatiently for her son. Apu comes into the room.

SARBOJAYA (to Apu): Come, come here—here, Khoka is back. Khoka is here—

Apu helps Sarbojaya to raise Harihar so that he may drink the holy water. But as the water is being poured into his mouth, Harihar's head falls back limply.

A flock of pigeons rise into the morning air, covering the sky with their outstretched wings.

At the ghat Apu is guided through the rituals a son must perform to put to rest the spirit of his dead father.

Sarbojaya now earns a living as a cook in a prosperous Brahmin household. An old man, Bhabataran Chatterjee, sits talking to Sarbojaya in the kitchen. Apu comes in.

SARBOJAYA: This is Apu. (*To Apu*) Pay your respects to your grand-uncle.

Apu bends down to touch the old man's feet and receive his blessings.

BHABATARAN: How old is he?

SARBOJAYA: He completed his tenth year in the month of Magh.

BHABATARAN: When did you give him the sacred thread?

SARBOJAYA: After coming to Kashi.

BHABATARAN: Will you come with me?

Apu picks up his books and bag and runs towards a door on the left.

SARBOJAYA: I can't make up my mind, Uncle. I hadn't thought of leaving here earlier. And I didn't even know that you were coming.

BHABATARAN: I've come here this time as I always do. I had no means of knowing that you were so badly off.

SARBOJAYA: You had written that you were coming.

BHABATARAN: What are these people like?

SARBOJAYA: They are good people. (*Smiles faintly.*) I hear they are happy with my work. They'll be going to Dewanpur. Apparently they want to take me with them. So I can't make up my mind.

BHABATARAN: You think it over. I am here for a few more days. If you come and stay with me, the house gets lived in, and you won't have any problems either. Think about it.

Sarbojaya sits in the kitchen, brooding.

Apu stands behind a large, old-fashioned armchair, plucking out grey hair from the head of Mukhujje-mashai, the head of the household, who sits dozing in the chair. He wakes up with a start and a grimace as Apu plucks a hair.

MUKHUJJE-MASHAI: That's enough. Hey! Come here. Go to that table, pull out that drawer. Not that one, the one next to it. There is a leather wallet there. Bring it to me. (*He gives Apu a coin as a tip and waves him off.*) Go!

The man goes back to sleep. Apu comes out of the room looking at the coin on his palm, then breaks into a run.

He runs out of the house, down the driveway, towards the big iron gates. He comes out through a wicket gate.

A wedding procession goes down the road in front of the house. Apu weaves his way through the crowd and goes towards a temple, stopping near a spreading tree outside to buy a handful of peanuts.

Inside the temple grounds, a courtyard stretches in front of the main building, ending in a raised marble veranda with ornate pillars supporting a roof. The place is full of monkeys climbing the walls, swinging from one pillar to the other, chattering busily. Here a little baby monkey sits sucking its mother's breast; there another one hangs from the chain of the temple bell.

Smiling to himself, Apu comes across the courtyard and stands below the veranda calling out to the monkeys and doling out his little store of peanuts. Monkeys leap off the parapet, clamber down the pillars

and pick up their share from the floor and from Apu's hand. The temple bells start ringing loudly. Apu, munching peanuts, looks up at the monkeys swinging from the chains to which the bells are tied.

3

A plump woman lies on a bed with a carved headboard. She is Mukhujje-ginni, Sarbojaya's mistress. Sarbojaya stands at the door of the room, hesitant.

MUKHUJJE-GINNI: Come in—

SARBOJAYA: You sent for me?

MUKHUJJE-GINNI: Yes. You are coming with us, aren't you?

SARBOJAYA: Where?

MUKHUJJE-GINNI: Why! Didn't they tell you? We are going to Dewan-pur next month.

SARBOJAYA: I see.

MUKHUJJE-GINNI: I told you right at the beginning that if I liked your work I'd take you with me. Now I hope you'll agree. Do you have any relatives here?

SARBOJAYA: No.

MUKHUJJE-GINNI: Do you have any where you come from?

SARBOJAYA: I have no one.

MUKHUJJE-GINNI: Then there's no problem. You may as well come with us.

SARBOJAYA: Very well.

MUKHUJJE-GINNI: Oh yes, another thing—Mokshada was telling me that you have lost your appetite. You don't have a fever, I hope? Are you well?

SARBOJAYA: Yes.

MUKHUJJE-GINNI (*smiles*): All right then.

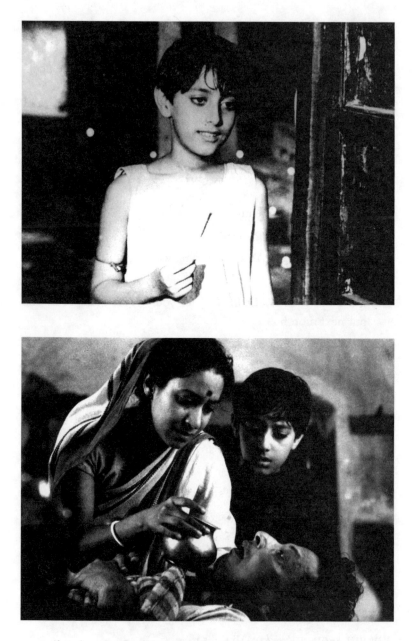

Above. Apu gives his father a long list of all the crakcers he has bought.
Below. Sarbojaya and Apu beside the dying Harihar.

Above & Below. Apu discovers a whole new world.

Sarbojaya comes out of the room on to a spacious balcony, still unsure as to whether she is doing the right thing. She comes down a large staircase, looking thoughtful, and stops when she hears a man's voice calling Apu. Through the iron grills of a window, she sees Apu going into one of the rooms, blowing on a chillum. She is deeply upset. Is that the kind of future that is in store for her son? She frowns as she slowly comes down the stairs again. The whistle of a train breaks into her thoughts.

A train hurtles past noisily. Inside, Sarbojaya and Apu sit by Bhabataran, looking out of the window. The train moves across a bridge, the bridge on the Ganga. The steel girders flash past the window; beyond them lies the river and the holy city of Varanasi. Sarbojaya stares out of the window. The river and the city move away into the distance. Sarbojaya looks thoughtful and sad. It is a long way to the village in the heart of Bengal. The train rushes through unknown countryscapes. Evening falls, clouds gather, and far away the hills darken against the sky.

Sarbojaya has come a long way. Outside the window, the dry, featureless landscape has given way to the mellow green hues of Bengal. The clouds gather over tall palm trees. Villages nestle among fields of paddy. It is morning again. The old man sleeps huddled up in a corner of the compartment. Apu sleeps with his head on his mother's lap. Only Sarbojaya stays awake, staring out of the window, a faraway look in her eyes.

They go from the train into a bullock-cart, trundling down the open road, past a canal with a bamboo foot-bridge, and a boat moving gently on the water. Now they walk down the village path, Sarbojaya and Apu followed by the old uncle.

This is Mansapota, Bhabataran's village. As the men carry the luggage into the house, Sarbojaya stands near one of the raised verandas,

looking around. Here too there are separate structures, with verandas
in front of the rooms, and thatched roofs held by wooden posts,
facing a courtyard in the centre. Her uncle goes to one of the veran-
das and sorts out the bags.

BHABATARAN: Hey! Go and tell them in the other house that Thakur-
mashai is back!

Apu rushes across the courtyard, to the back door. Sarbojaya sits
down on a veranda, and turns towards the sound of a train heard
faintly in the distance. Apu runs back to Sarbojaya, smiling.

APU: Mother! Train!

Apu stands at the back door, where, behind the house, paddy fields
stretch into the distant horizon. Far away, at the edge of the sky, a
train winds its way to some unknown destination. Apu's face grows
solemn as he stands watching the train. His mother comes up behind
him, and putting her hand on his shoulder, rests her chin on his tou-
sled head, smiling.

Evening falls over the paddy fields. In the distance, clouds of smoke
hang over the sky as a train goes chugging along the tracks. Inside
the house, Sarbojaya says her evening prayers at the tulsi plant in the
courtyard. Apu runs out of the house as a young widow comes in by
the door, carrying firewood. She is Nirupama, the eldest daughter of
the Teli's next door. The Telis are a rich, low-caste family who are the
chief patrons of Sarbojaya's uncle. As a Brahmin, the old man sur-
vives on the religious ceremonies he performs in the rich households
of the village. Nirupama puts the firewood down and draws the end
of her sari over her head.

NIRUPAMA: I have made the fire, Aunty. Do you have enough rice,
lentils and other provisions with you?

SARBOJAYA: Yes. I've all that we need. It'll last till tomorrow.

NIRUPAMA: Then I'll go now. I'll be back again tomorrow. Whenever you need anything, just tell me.

SARBOJAYA: You haven't told me your name, my dear.

NIRUPAMA: Nirupama.

At night, Apu and Bhabataran sit eating on the veranda in the light of a lamp. The air is full of the noise of crickets.

BHABATARAN: I am here for another week or so. Will you be able to settle down by then? (*Sarbojaya nods.*) Apu—you come with me tomorrow. You can learn what you have to do as a priest.

Apu looks at his mother, who smiles at him.

4

The next day Bhabataran takes Apu with him to perform a ceremony in the Teli house. An ornate brass lamp stands on the floor, near a low, decorated wooden seat. On the seat stands a little silver throne with a tiny silver canopy on it. There are flowers, a big conch shell, a vessel containing holy water, and, of course, a bell. Apu holds a smooth, black stone, the family god, in his hands. He places it on the throne when the old man tells him. Nirupama sits near the door of the room. Both the old man and Apu wear scarves with the names of gods printed all over them.

BHABATARAN: Place the deity on the throne and put some *tulsi* leaves on him. Now put some flowers on the god . . .

NIRUPAMA: No. Wash them first.

Apu chants a final prayer, prostrates himself in front of the image, then rises to leave.

5

One day, after his priestly functions are over, Apu goes homewards, down a narrow track between paddy fields, carrying a basket containing his priestly collections, and a stone image of the deity. At the end of the fields, Apu crosses a banana grove and stops at the sound of shouting. In the distance, a group of boys, of about the same age as Apu, run across a high path between the fields. As Apu stands watching them with a smile on his lips, they shout and quarrel among themselves, rushing down the slopes of the path. An old woman comes and scolds the boys. Apu turns away, wistfully.

After putting away the basket and the image safely, Apu runs out of the house again. Out under the open sky, the burden of priestly responsibilities falls away from his young sho6Iders, and he runs down the path between the fields, clambers down the slope and rushes on to the bamboo bridge. Standing half-hidden in the banana grove, still wearing the priestly scarf, he watches a group of boys running towards a school building.

That night, in their bedroom, Apu plays silently with a palm-leaf fan in the light of the lantern, looking serious and preoccupied. His mother comes and sits on the bed with some sewing in her hand.

SARBOJAYA: What's the matter with you? You've been sulking since morning. Aren't you well? Then? Are you feeling sad? Are you missing Kashi? (*Apu keeps shaking his head in silence.*) Nishchindipur then? Don't you like Mansapota? Why don't you tell me what's wrong? Have they been rude to you? Have you been doing your job properly? (*Apu nods. Saroojaya sighs in relief.*) They are good people here. If we keep them happy, we won't have to worry about a livelihood. Try and bear it for a few years. After that, if we are lucky, we'll repair our ancestral house in Nishchindipur . . .

APU: Mother!

SARBOJAYA (*sewing*): Yes?

Apu throws the fan aside, moves closer, and puts his chin in his mother's lap.

SARBOJAYA: What is it, dear?

APU (*whispers*): Mother, I want to go to school.

Sarbojaya bends over Apu, and rests her face on his.

SARBOJAYA: Go where?

APU: To school.

SARBOJAYA: Which school?

APU: Nearby, in Arboal. It's a good school.

SARBOJAYA: And how do you know it's a good school?

APU: I've been there. I've seen it.

SARBOJAYA: And what will happen to your work?

APU: My work is in the morning, and the school is in the afternoon.

SARBOJAYA: Will you be able to manage both at the same time?

APU: Yes.

SARBOJAYA: Don't you need money to go to school?

APU: Don't you have any money, Mother? Don't you have any money put away?

Sarbojaya sits up and stares frowning into the distance. Then she turns to her son again and smiles at him.

6

The school building is an L-shaped structure, with the classrooms facing a large playground in front; a gate at one end looks out on a road and an open field beyond. Today is a special day for the school: the Inspector of schools is due to arrive on his periodic visit. The Headmaster is looking after the arrangements for welcoming the Inspector. He goes from room to room, warning the teachers and

students of the imminent presence of this august personality. The Headmaster is a neat little man with his hair parted in the middle, and a small brush of a moustache under his nose. Small, straight and unsmiling, he moves busily up and down the school verandas, looking at a watch on a chain from time to time.

HEADMASTER (*imperiously*): Keshab-babu! Are the palm juice, sweets and everything else ready? Everything under control? (*Keshab nods.*) Only half an hour left! (*He stops at different doors.*) Only half an hour! Half an hour!

The Headmaster bends to pick up a crumpled piece of paper from the ground, then rises, fastidiously lifting the end of his dhoti off the ground, revealing under it his black, striped socks and shining leather pumps. He calls out to another teacher.

HEADMASTER: Jagadish-babu!

The Headmaster silently points to a drawing on the wall. It is a cartoon of himself wielding a cane, with 'Head Sir', written on one side and 'very good' on the other. The Headmaster looks severely at Jagadish, displaying a strong resemblance to his image on the wall. Jagadish bends to examine the wall.

JAGADISH: Oh! I'll do something about it, sir.

While Jagadish sets about repairing the damage, the Headmaster falls into a deeply contemplative mood, which is suddenly interrupted by the arrival of a stray cow in the school yard.

HEADMASTER: Baikuntha—! Baikuntha—!

Shouting for help, he nimbly runs down the stairs of the veranda, skips around the cow, clapping his hands in a dignified manner and shouting at the animal in English.

HEADMASTER: Get out! Get out!

The cow is finally driven out of the school, and just in time too. For soon a phaeton comes rumbling down the road. In it, a suitably

uniformed orderly sits humbly opposite an important-looking man in a white suit, with a rose in the buttonhole, and a pith hat on his head. The Headmaster comes out into the road to greet the honoured guest.

HEADMASTER: Welcome! Welcome!

INSPECTOR: Namaskar.

The Headmaster holds the Inspector's arm and leads him towards the school. In the school, one of the teachers tiptoes down the veranda to check on the progress of the Inspector. He rushes away to inform everybody of his arrival. The school, which was till now unusually silent, suddenly bursts into a hum of activity. But before the guest can enter the gates, the cow decides to take her revenge. She ambles across the Inspector's path, and, to the great embarrassment of the Headmaster, has to be pushed away by the honoured guest himself.

The Inspector enters one of the classes. The teacher and the students rise to greet him.

TEACHER: Come in, come in!

INSPECTOR (*beaming at the students*): Sit down. (*To the teacher*) What are you teaching them?

TEACHER: Bengali just now, sir.

INSPECTOR (*taking a book from the teacher and reading its name*): 'The Foliage of Literature'. What's the meaning of 'foliage'? (*He points at a boy next to Apu*) You tell me.

BOY: Uh—'foliage' means—umm . . .

The Headmaster is tense. The Inspector turns benignly to Apu.

INSPECTOR: Next boy!

APU: 'Foliage' means green leaves, sir.

The Inspector turns a page and offers the book to Apu.

INSPECTOR: Right.

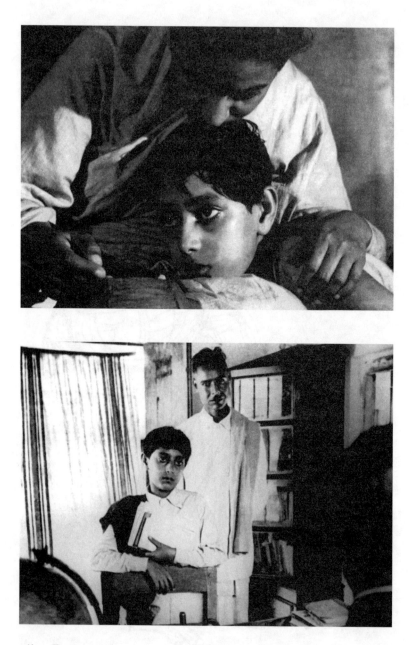

Above. 'Don't you have any money, Mother? Don't you have any money put away?' asks Apu. *Below.* Abinash-babu tells the headmaster : 'He is way ahead of the average student.'

Very
good

APU (*reading*): The Land of Bengal. (*The Inspector nods.*)
Where is the greenest land of all,
Where on tender grass your feet must fall,
Where the golden grain sways in the sun
And the blushing lotus blooms,
It is our Bengal, our very own Bengal,
The greenest land of all.

Where do the thrush and robin sing?
Where are the trees where the fork-tailed
drongos swing?
Where glides the swan with its mate?
Where does the weaver-bird build its nest
And the swallow cries for rain?
In our Bengal, our very own Bengal,
The greenest land of all.

As Apu reads, the Headmaster's frown dissolves into a faint smile of triumph. He turns to look at the Inspector, who is smiling and nodding his head in appreciation.

APU (*reading*): In what land do they speak a tongue
that fills your soul with yearning?
Where do you hear the sweet tones clear
of a *baul* whose heart is singing?

Apu's performance has saved the day. The bell rings; the boys spill out of the school, running off in different directions. The Headmaster sits looking through some papers in his room, with a teacher by his side. Apu, whom the Headmaster has asked to see, comes into the room diffidently.

HEADMASTER: Well, where's the signature? (*The teacher leans forward.*)
Here's the twenty-third. You can remember so many things, but you can't remember to do this? Go and get it signed. (*The teacher leaves.*) Come in, Apurba. (*Smiles.*) Come and sit down. Is your

mother well? (*Apu nods.*) The Inspector was very happy with you. Not that I was any less happy. I've always been keeping watch on your progress. I've also spoken to Abinash-babu about you.

Abinash-babu, who stands behind Apu, smiles.

ABINASH-BABU: He is way ahead of the average student.

HEADMASTER: We expect a great deal from you. On our part, we shall provide you with every facility. But if you really want to be a good student, you'll have to work hard. Especially, you'll have to improve your English. Do you like reading? I'm not talking of textbooks. Things like travelogues, lives of great men, books on science, written in a simple style. If I give you such books, will you read them? (*Apu nods.*)

ABINASH-BABU: Yes, of course. Why shouldn't he? Of course he'll read them.

The Headmaster turns to a cupboard behind his chair and starts taking out dusty volumes which he places on the table. Apu takes each book from him as he describes its contents, and stands clutching them to his chest.

HEADMASTER: Good. In this cupboard I have many such books. If you don't read books like these you cannot broaden your mind. We may live in a remote corner of Bengal, but that does not mean our outlook should be narrow. Now, this book is about the North Pole. If someone wants to know what the aurora borealis is, or how the Eskimos live, he can learn all about it from this book. This is about Livingstone's travels. You can learn about Africa from this one. This is the story of inventions. This contains biographies of famous scientists: Galileo, Archimedes, Newton, Faraday . . .

Apu is a quick learner. The books prove to be a storehouse of magical experiences. At home, Apu sits with a pitcher of water and a small

pot. He dips one end of a rubber tube in the pitcher, sucks at the other end, then siphons the water into the pot.

APU: Mother! Come and watch!

Now, in the light of the lantern, Apu explains to his mother the mystery of a lunar eclipse, with the help of two fruits, one big, the other small. The lantern is the sun. The fruits are the earth and the moon.

APU: This is the sun. This is the earth and this is the moon. Now, the moon goes around the earth. When it comes to this point in its rounds, the shadow of this one falls here. And that is how an eclipse takes place.

Now Apu transports himself into the deepest jungles of the wild African continent. As Sarbojaya comes home from the pond, the door opens with a crash and a Zulu warrior leaps out, yelling 'Africa!' It is Apu, wearing a sort of grass skirt, carrying a toy shield and a spear, with streaks of white on his blackened hands and face. The shield is actually a bamboo winnowing tray on which Apu has drawn a grotesque face. Sarbojaya puts the wet clothes down and goes after Apu. But Apu leaps around in the courtyard and runs out by the backdoor.

SARBOJAYA: Apu—!

APU (*yelling*): Africa! Africa! Africa!

Sarbojaya stands in the courtyard, near the door, watching the Zulu warrior waving his shield and spear, running off into the fields.

Sarbojaya finds Apu asleep with his hand on an exercise book, a pen lying open on the page. He had obviously been reading late into the evening, till he was not able to keep awake any longer. She drags him up.

SARBOJAYA: Apu! What is this! Apu, get up, dear! Get up! It's time to have your meal, get up. Apu! Get up! Wake up!

She manages to drag Apu out of the room. In the empty room the flame of the lantern glows brightly. Time passes.

7

Six years later. The Headmaster sits at his table in the school.

HEADMASTER: Come in, Apurba, come in.

Apu stands at the door of the room, smiling shyly. It is a different Apu, thin, loose-limbed, fine-featured, and sixteen years old. He comes and stands, holding the back of a chair and hanging his head, just as he had done years ago.

HEADMASTER: I have good news for you. You have come second in the district. Sit down.

APU (smiles): It's all right.

HEADMASTER: No, no, sit down, sit down. Now, the point is, you are going to study further, aren't you? If you do, you can get a scholarship of ten rupees. And if you want to study in Calcutta, I can arrange for that too. Have you given this matter any thought?

APU: Yes, sir.

HEADMASTER: You'll go on with your studies?

APU: Yes, sir.

HEADMASTER: Will you study in Calcutta?

APU: Yes.

HEADMASTER: Arts or science?

APU: Science.

HEADMASTER: Good. Do you have any place to stay there? Any relatives?

APU: No, sir.

HEADMASTER: Of course, that should not be any problem. But have you spoken to your mother?

APU: Not yet.

HEADMASTER: Can you get her to agree?

APU: I will try.

That night, Sarbojaya sits on the veranda in the light of the lantern, mixing a herbal medicine with a small pestle in a gallipot. She takes the medicine, washes her hands, and puts away the gallipot as Apu's voice is heard calling. Apu runs up to his mother carrying a globe and sits down by her side.

APU: Mother! Mother!

SARBOJAYA: What took you so long?

APU: Do you know, I've stood second in the district?

SARBOJAYA: Stood what?

APU: Second. That means, there's only one above me.

SARBOJAYA: Really?

APU (*smiles and nods*): And do you know, I might even get a scholar-ship!

SARBOJAYA: What's Kalashi?

APU: Scholarship! The money one gets when one does well in the examination!

SARBOJAYA: How much will you get?

APU: Ten rupees every month.

SARBOJAYA: T-e-n rupee-s!

Sarbojaya is full of admiration for her son's capabilities.

APU: But I'll have to continue my studies. Otherwise they won't give it.

SARBOJAYA: Is that so?

APU: What do you think? They'll give it just like that? I must go and study in Calcutta.

Sarbojaya's smile fades. She looks away from Apu, hurt and upset.

APU: Can you tell me what this is, Mother?

He holds the globe up, near her face. But Sarbojaya does not answer. She frowns and rises, moving away from Apu. Apu suddenly looks lost and uncomfortable.

Sarbojaya goes into the room. In the light of the lantern her face has a thoughtful, sad look. Apu walks into the room behind her, looking at her from the corner of his eyes.

SARBOJAYA (*angrily*): You will go to Calcutta?

APU: Why shouldn't I? That's why the Headmaster called me. He gave me some addresses. He said there would be no problems.

SARBOJAYA: And who is going to pay for it, may I know?

APU: Pay for what? College will be half free. I'll get ten rupees every month, and I'll find myself a job.

SARBOJAYA: And I? Was I just washed up by the river? Once you give up your job as a priest and go away, do you expect them to take care of us still?

APU: Does that mean that I can't study? I must carry on being just a priest?

SARBOJAYA: What's wrong with that? You are the son of a priest. If you won't be a priest, what do you think you'll be? A governor?

APU (*defiant*): Yes. That's what I'll be.

SARBOJAYA: Shut up!

APU (*rudely*): Shut up indeed! You think everything must always be according to your wishes?

SARBOJAYA (*furious*): Yes—a hundred times yes!

APU (*shouts*): No!

Angry and hurt, Sarbojaya slaps Apu. It has not happened in a long time. Apu turns his face away, then puts his hand on his cheek, shocked into silence at last. His mother is equally shocked. She moves

away from him and stands looking apologetic. Apu gets up from the bed and goes out of the house. Sarbojaya stands frozen in her place.

Sarbojaya goes slowly to the front door, looking immensely sorry. But Apu has vanished into the darkness outside.

SARBOJAYA: Apu! Apu!

She goes out of the house, calling out for her son, quickening her pace when she notices Apu sitting below a tree, by the pond.

SARBOJAYA: Apu! There are snakes here! And you'll be bitten by a million mosquitoes. Get up and come back.

APU (*getting up and jerking her hand away*): I'm not coming back!

SARBOJAYA: Come on, don't behave like a child, Apu! You can go to Calcutta. There, I've said it.

APU: But that doesn't mean a thing, for you won't be able to manage here. (*He walks off, Sarbojaya following him.*)

SARBOJAYA: Have I said anything like that? But you must think it all over first.

APU: But why should you hit me?

SARBOJAYA: I'm terribly sorry, dear. I'll never hit you again. Come, I've something to show you. Come.

Apu sits sulking on the bed. Sarbojaya pulls something out of a box from under the bed. She smiles as she sits by him and opens a little cloth purse.

SARBOJAYA: Look!

APU: Whose money is that, Mother?

SARBOJAYA: Don't you remember? I used to work in Kashi? Do you know how much I saved? (*Counts.*) Thirty-two! Thank goodness I saved this money. I'll give you something from this to take with you. You can last out a month on that.

Surprised and delighted, Apu jumps off the bed and comes out on the veranda. He leaps into the courtyard, shouting 'Hurrah!' then turns and runs up the steps of the veranda, picks up his globe and rushes into the room once more. Sarbojaya is kneeling on the floor, putting the money back in the box. Apu comes and squats in front of her.

APU: The Headmaster gave it to me.

SARBOJAYA: What is it?

APU: It's called a globe. It is the earth. Our earth. And can you see these marks? These are the countries. And this blue, all this is the sea. Do you know where Calcutta is, Mother? Here.

Sarbojaya does not really look at the globe. She smiles lovingly at her son in the glow of the lantern.

8

It is the day when Apu leaves for Calcutta. Apu looks at the sundial he has built in the courtyard. It is only a round stone slab, with a stick in the middle, and hours and minutes marked on the stone. The dial, which shows a little after seven in the morning, also bears the legend, 'Sundial made by A. K. Ray'. Hastily buttoning his shirt, Apu goes into the bedroom, past his mother, who sits on the veranda packing his box.

APU: Mother! Seven-thirty.

SARBOJAYA: I've finished, dear. Just take a look at everything once.

APU: It's all right. You take a look.

SARBOJAYA: What do you mean, 'all right'? (*Apu comes out.*) Here, look, here's your tumbler, and here's your bottle of hair oil. Are you looking?

APU (*combing his hair, looking at a hand mirror*): Yes, yes!

ARBOJAYA: And here's your bowl. There are some coconut sweets in the bowl. And here's some spices, look!

APU: Yes.

SARBOJAYA: And this—(*Holding up a bottle*) I had made some ghee at home from the cream. I'm giving it to you. And look at this, under these books are your shirts and vests. And the *d*hoti, I'm putting the dhoti in the bedding.

APU: Yes, put it there.

SARBOJAYA: And in this book there are two postcards. You must write to me the moment you arrive there.

APU (*giving her the comb and the mirror*): Put these away.

SARBOJAYA: And look at this. Here is the wallet. Five from the Telis and twenty-five from me. Keep one rupee on you, you'll have to buy your ticket. And if you can, on your way out, drop in at Nirupama's. They've done so much for you.

Apu, who has been struggling with a pair of old leather shoes, has finally managed to slip them on. He stands up as Sarbojaya shuts the lid of the box.

APU: My globe? (*He goes into the room.*)

SARBOJAYA: You can carry that in your hand. It won't fit into this.

Apu comes out of the room with the globe. Sarbojaya locks the box and gives him the key. Apu touches his mother's feet.

SARBOJAYA: The key.

APU: I'll be on my way then, Mother.

SARBOJAYA: Wait.

She picks up a little bowl with some curd in it, dips her finger into it and puts an auspicious mark on Apu's forehead for a safe journey.

SARBOJAYA: Send me a letter with all the news. Understand? Be careful when you are moving around in the city. Don't eat anything

that you are not used to, or you'll fall ill. If you get a few days off during the puja festival, come straight home. All right?

As she talks, Sarbojaya helps Apu to gather all his luggage, and follows him to the door. She stands at the door looking unhappy. At the end of the path, Apu turns to take a last look. Sarbojaya immediately puts aside her sorrow and smiles brightly at her son. But when Apu is no longer in view, that still, sad look returns. She turns away and sighs before going back into the empty house and its resounding silence.

Apu sits in a railway compartment, looking at his globe. A thin, dark man, blind in one eye, holds aloft a little tin of balm as he talks loudly and rapidly over the noise of the moving train. He brings the tin near Apu, who shakes his head to get rid of him.

VENDOR: Brothers! Have you ever tripped and hurt yourself? If you haven't, there'll certainly be opportunities enough in your life to trip and fall. And that is when this wonderful balm will come to your aid like a benevolent friend!

The train arrives at the Sealdah station. Apu manages to extricate himself from the jostling crowd and steps on to the platform. He moves towards the gate along with the hundreds of people who arrive daily at the great city of Calcutta.

Walking down Harrison Road, Apu searches for the address that the Headmaster has given him. The road is wide and empty. Apu walks down the middle of it, looking at street signs, and moves away with a jerk as an old motorcar comes up behind him, blowing its horn.

Apu takes shelter from a drizzle under a shed, and looks around him to discover a couple of Afghans on one side talking animatedly, and three Chinese on the other side talking and laughing among themselves—his first impression of a city of strange people and strange languages.

Apu crosses the road and stops under a signboard which says, 'The New Royal Press'. He walks hesitantly into the dark interior of the building. In a room alongside an inner courtyard, a stout, elderly man wearing round glasses sits at a table writing intently.

APU: Excuse me! Are you Akhil-babu?

AKHIL-BABU: What do you want?

APU: I have a letter.

AKHIL-BABU: What letter?

APU: Here—it was given by the Headmaster of Arboal School.

AKHIL-BABU (*looking up at last*): Oh. Give it to me. Sit down. Hmm. Paresh has already written about this to me. You've come here to study, have you?

APU: Yes.

AKHIL-BABU: Have you any money with you?

APU: Yes. Mother gave me thirty rupees. Of that ten annas went for the train fare. And twenty-nine rupees and six annas are still left. Can I get a room here?

AKHIL-BABU (*laughs*): I only have that one room. But we'll manage with it.

APU: What will be the rent?

AKHIL-BABU: Tell me, can you work in the press?

APU: Yes.

AKHIL-BABU: At night, after your classes?

APU: Yes.

AKHIL-BABU: All right. Go up those stairs and you'll find the room. It is right in front. I'll follow in a moment.

Apu picks up his luggage from the yard and goes up the stairs. On the terrace, he stops to take off his shoes before entering the room. There is hardly anything in the room. On a shelf near the door there are bundles of paper and bottles of different shapes and sizes.

Between the door and the shelf, Apu finds the switch of the electric light. The solitary bulb glows as he turns the switch on. He looks up at the light, wide-eyed with wonder. Its novelty tempts him to switch the light on and off a few times before he really takes a good look around him.

Now Apu lies on a rush mat on the floor, his face propped on his hand, writing a letter to his mother. His globe is placed neatly on the window sill.

THE LETTER: Dear Mother, I have arrived safely. I have traced Akhil-babu. He has arranged for my stay. I will not have to pay any rent as I will be working in Akhil-babu's press. I have an electric light in my room . . .

9

During the day Apu attends his classes in college. In the evening he works at a treadle press, learning his job. He has to work late into the night. When he remembers to wipe the sweat off his face and look at the big wall clock of the press, it is already past ten at night. In the morning, tired and sleepy, Apu dozes in the classroom. On the black-board behind the lecturer are the names of different figures of speech: Metonymy, Synecdoche.

LECTURER: Synecdoche. Synecdoche is a figure of speech based on association. Here we have an instance of a more comprehensive term used for a less comprehensive one, and vice versa.

The lecturer is a neat man who speaks in English and has a precise and clipped manner. Now he stops in the middle of his lecture to stare reproachfully at Apu, who is fast asleep. His friend Shibnath gives him a nudge to wake him up, and draws his attention to the lec-turer. Apu rises from his seat.

LECTURER: Does this strange word on the blackboard convey any-
thing to you?

SHIBNATH (*whispering*): Tell him it's a figure of speech based on
association!

LECTURER: When I say that Mr Ray has not been wholly attentive to
my lecture, I am using a figure of speech known as euphemism,
which consists in stating a disagreeable fact in an agreeable
manner.

Apu, who has been hanging his head so far, looks up to see the lec-
turer flicking his finger sharply in an unmistakable gesture. Apu picks
up his books and moves towards the door. The boys turn to look at
him as he goes past them.

LECTURER: And Mr Sengupta! I'm sure you'd like to join your friend
outside.

SHIBNATH (*smiling cockily*): Shall I go out, sir?

The lecturer makes the same flicking gesture with his finger. Shibnath
gives a cheeky grin, and walks out of the class in a leisurely manner.
He comes downstairs, stops to drink from a tap, then walks up to
Apu, who stands leaning over the railings of the balcony.

SHIBNATH: Couldn't you find a better place to go to sleep in? Right
in the middle of CCB's class? Are you crying? (*Thumping Apu's
shoulder*) Come on, come on. We have two free periods after this.
Come, let's go for a walk.

Apu and his friend recline on the grass at the river bank. Behind them
steamers move up and down on the Hooghly, and a row of factories
stand belching smoke in the horizon. Apu watches the boats leaving
the small harbour.

SHIBNATH: I say, Apu—

APU: Yes?

SHIBNATH: Don't you wish to go abroad?

APU (*smiles*): You find me a job on a ship.

SHIBNATH: I'm serious. Want to go? Let's go on a trip together. All right? (*Apu does not reply.*) What? Don't you have any ambitions? (*Apu shakes his head.*) What's the matter with you? You'll just go on living here like the frog in the well? You wouldn't go even if you got a chance? (*Apu shakes his head again.*) Why? Why wouldn't you?

APU: Mother will never let me go.

SHIBNATH: Why not?

APU: It takes only three hours to get to Calcutta, and she wasn't letting me come here.

SHIBNATH: Really? How did you manage?

APU: I quarrelled. If I didn't have any ambitions, I would have stayed there. I even had a job there.

SHIBNATH: A job! What job?

APU: That of a priest.

SHIBNATH: I see. Is that your family profession?

APU: Yes.

SHIBNATH: Do you wear the sacred thread?

APU: Yes.

SHIBNATH (*suddenly amused*): And the Brahmin's pigtail?

Apu smiles and shakes his head. Shibnath shows him his watch.

SHIBNATH: Do you realize that we have missed two classes today?

Apu looks at the watch, dismayed. Daylight fades slowly as evening falls across the river. Apu and his friend pick up their books and climb up the incline where they were lying.

SHIBNATH: You know, we made a mistake. We should have told Pranab to answer for us at the roll call. There'd have been no problem at all in PNG's class.

10

At Mansapota, Sarbojaya sits with some sewing on a rush mat under a tree. Far away, across the fields, a train appears against the horizon. Sarbojaya rises quickly, folds the mat, picks up the sewing and goes into the house. She goes into her room and brings out a towel and a low wooden seat. She hangs the towel on the line, removes the gallipot from the window sill, then goes to the front door. She takes a quick look, then goes smiling to draw water from the well at the back. But before she has pulled up the bucket, Apu is heard calling. She turns and smiles, then moves towards the voice. The bucket falls back into the well with a splash, tugging at the rope, which is hooked to a branch. Apu comes into the house, carrying all his belongings, and clutching the globe in his hand. He bends to touch his mother's feet. Sarbojaya has to look up at him as he straightens. She smiles, putting her hand on his shoulder.

SARBOJAYA: Have you grown taller? (*Apu smiles and shakes his head.*) Then you must have become thinner.

APU: Did you get my letter?

SARBOJAYA (*turning away*): I'm not going to speak to you any more.

APU: Why, Mother?

SARBOJAYA: You said your holidays would begin from the seventh. And what date is it today?

Apu sits on the steps of the veranda taking off his shirt.

APU: What could I do, Mother? I had some work.

SARBOJAYA: It wasn't work. Just say that you didn't want to come to your mother.

Apu takes off his shoes and pulls the towel off the line. Then, smiling at his mother and making a suitable noise of protest, he runs out of the house. Sarbojaya looks up, startled. She follows him to the pond,

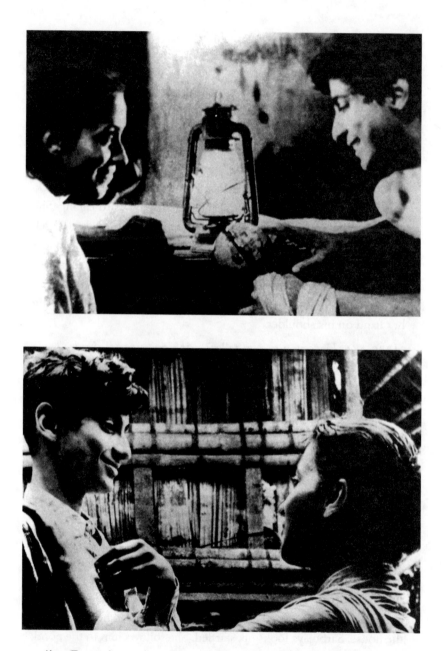

Above. 'Do you know where Calcutta is, Mother?' Sarbojaya smiles lovingly at her son. *Below.* Sarbojaya smiles at Apu, on his first visit to Mansapota from Calcutta, and wonders, 'Have you grown taller?'

remonstrating. But Apu is already in the water. He lifts his head out of the water and turns smiling towards his mother.

SARBOJAYA: What is this! Apu—! Apu! It's evening, you'll catch a cold. Come out of there!

In the light of the lantern, Apu sits at his meal on the veranda. Sarbojaya sits fanning him with a palm-leaf fan.

SARBOJAYA: What do they give you to eat there?

APU: Everything.

SARBOJAYA: What do you mean by everything?

APU: Lentils, rice, fish, vegetables.

SARBOJAYA: Who does the cooking?

APU: There's a cook.

SARBOJAYA: Does he cook well?

APU: Yes.

SARBOJAYA: Better than me? (*Apu goes on eating.*) Better than me?

Apu looks up at her and smiles, shaking his head. Sarbojaya smiles back at him, relieved.

Now Apu lies in bed, reading in the light of the lantern. Sarbojaya comes in and sits on the bed with her sewing.

SARBOJAYA: When you come next time, bring some shell buttons for me. Do you understand? Apu! Put down that book and talk to me!

APU: What shall I talk about?

SARBOJAYA: What have you seen in Calcutta?

APU: I've seen everything.

SARBOJAYA: Tell me about them.

APU: Victoria Memorial, Whiteway Laidlaw, Hogg Market, the zoo, Fort William—

SARBOJAYA: The temple at Kalighat?

APU: Yes. I just went there the other day. The temple at Kalighat, and (*yawns*) Keoratala.

SARBOJAYA: What's there in Keoratala?

APU: (*in English*): Burning ghat!

SARBOJAYA: What?

APU (*laughs*): Cremation ground. (*He turns away from his mother, and settles down to sleep.*)

SARBOJAYA: Are you careful when you are out on the roads?

APU: Yes.

SARBOJAYA: When will you pass all your examinations and take up a job? I'll come and stay with you then, all right? Will you let me stay with you?

APU: Yes.

SARBOJAYA: It's probably not in my fate. Who knows if I will live that long?

APU: Rubbish.

SARBOJAYA: Laughing, are you? What if I am seriously ill? Such things do happen. I'm no longer as strong as I used to be. Every evening I feel feverish and dizzy. And I don't have any appetite at all. I've often thought of telling you. But I never did. You're not going to come to me leaving your studies, are you? (*She stares into the distance.*) Will you arrange for my treatment with the money you will earn? (*Turns to Apu.*) Will you, Apu?

But Apu has fallen asleep. Sarbojaya turns back to her sewing with a sigh.

11

A man beats a drum as he belts out a sort of song in Hindi, describing the performance of a boy acrobat. A crowd of villagers stand watching as the boy walks on his hands, with his legs locked together

above him. Apu watches the show for a while, then walks away. The boy bends backwards, and walks holding his ankles with his hands, his head near his feet. The drummer shouts loudly.

Bored and restless, Apu walks in the sun, near his home, idly kicking at pebbles with his toes.

Sarbojaya sits on the kitchen veranda, making a *paan*, when Apu comes into the house and sits down morosely on the veranda in front of the bedroom.

SARBOJAYA: Did you hear what Niru said? Well?

APU: I did.

SARBOJAYA: You'll go, won't you?

APU: I can't.

SARBOJAYA: Why not? She has asked you over and over again.

APU: I've classes on Monday.

SARBOJAYA: So what? You make too much of it. How does it matter if you are late by two days?

APU: You wouldn't understand. It does matter.

SARBOJAYA: You have so few holidays. Nobody minds if you are a few days late. You arrived here seven days late. And there are no holidays now till the new year. You know they are so happy whenever they see you. You'll go, won't you?

Apu says nothing in reply. He gets up and goes out by the back door. Sarbojaya turns back to what she was doing, looking perturbed.

At night, Apu starts packing his clothes into the tin box. He is stuffing everything into the box anyhow when Sarbojaya comes into the room. She takes over, lifting the box off the bed and putting it on the floor. Apu picks up an almanac from a shelf, and bends over it in the light of the lantern.

SARBOJAYA (*sternly*): Get out of the way.

APU (*apologetically*): There's never any time in the morning for packing. (*He reads.*) Tomorrow the sun will rise at a quarter past six. Wake me up in time.

He puts the book away and gets into bed. Sarbojaya looks up at him in silent reproach, then goes back to her work slowly.

Next morning, at dawn, as she brings the washed vessels back from the pond, Sarbojaya stops to look unhappily at the sky. The sun has just risen. She turns away sadly, and comes into the bedroom to wake Apu. She looks at her sleeping son, then shakes him gently. She withdraws her hand before he can wake up, and retreats from the bed. Backing away slowly, she brushes against the door. The noise is loud enough for Apu to wake up. He takes one look at the window and swings out of the bed.

APU: What is this! Mother! You didn't wake me up all this while? I'm late!

Sarbojaya stands frozen against the door as he goes swiftly past her to the veranda and pulls the towel off the line.

Now Apu sits on the veranda outside, pulling on his shoes. His luggage lies ready beside him. Sarbojaya comes to him carrying food for the way, packed in a bundle. He takes it from her and bends to touch her feet. She gives him the key to the box.

APU: I'm off.

SARBOJAYA: The key. Won't you check that everything's there?

APU: No. There's no time.

Hurt, and full of silent reproach, Sarbojaya does not look up as Apu rushes down the path in front of the house.

He runs down the tracks towards the station, then runs all the way to the platform and settles down to wait, wiping the sweat off his face.

At home, Sarbojaya leans against a wooden post of the veranda and listens to the whistle and rumble of a passing train.

Apu sits near a lamp post, his head lowered. As the train comes puffing into the station, a murmur of voices can be heard from the waiting passengers. Apu lifts his head.

VOICES: Hey! The train's coming in! The train is coming. Here, brother—

Apu rises and turns to collect his luggage as the train enters the station and grinds to a halt. But while the passengers rush into the train, Apu stands alone, his head lowered in thought.

Sarbojaya still stands leaning against the post, looking out towards the path leading to the house. Apu appears at the end of the path, and Sarbojaya runs to the door in a haze of happiness.

SARBOJAYA: Apu!

She follows Apu into the courtyard, her face radiant with a smile. Apu sits down and smiles back at her, unbuttoning the cuffs of his shirt.

APU: I missed the train.

SARBOJAYA: Oh dear. What will you do?

APU: I'll go tomorrow.

He lies down on the veranda with a sigh of relief, his head resting on the bedroll.

SARBOJAYA: But won't it upset your studies?

Apu turns to his mother with a smile and shakes his head. Sarbojaya smiles again, slowly, then leans over her son, her hand caressing his ruffled hair. In the harsh light of the day her face looks strained, with dark rings under her eyes.

SARBOJAYA: Are you hungry? Would you like something to eat?

APU: A little later, Mother.

12

Apu goes back to his daily routine in Calcutta. During the day he attends classes at college. In the evening there is work to do at the press. Once in a while, Apu goes for a walk by the riverside with his friend Shibnath, and watches the ferry leaving from the jetty and the steamers crossing to and fro. Coming into his room one day, he finds a postcard from his mother.

SARBOJAYA's voice (*she sounds tired and ill*): Dear Apu, why don't you write regularly these days? I worry a great deal when I don't hear from you. Do you have a holiday during the Ganesh puja? If you do, then come home once. I haven't seen you for two months. I long to see you. If you don't have enough money, let me know. I shall send you some.

Apu writes back to his mother.

THE LETTER: Dear Mother, I received your letter. There are no holidays for the Ganesh puja in my college. Also, I have my examinations next month. If I don't stay in Calcutta during this time, my studies will suffer. For the examination . . .

At Mansapota, Sarbojaya sits on the bedroom veranda, leaning against the wall, holding Apu's postcard in her hand. She has not been keeping well at all and the rings are darker round her eyes. She looks tearfully at the letter, then lifts her head to look at the bottles of pickle and plates of *badi* lying in the sun beside Apu's abandoned sundial in the courtyard. A fat, prosperous, pleasant-looking woman comes smiling into the house, and bends to touch Sarbojaya's feet. She is from the Teli household next door. Sarbojaya gives her a tired smile, then sits looking into the distance, absorbed in a world of her own, making no effort to respond to her merry chatter.

TELI-GINNI: Every day I think of calling, but I never manage to.

SARBOJAYA: Do sit down.

TELI-GINNI: Have you heard from Apu?

SARBOJAYA: Yes.

TELI-GINNI: He is keeping well?

SARBOJAYA: Yes.

TELI-GINNI: Your son is a real gem, Ma-thakrun. You should get him married now. Once the bride comes home, all your worries will be over. Here you are, alone, and every day I think of coming to you. But where do I find the time, Ma-thakrun? There's always some problem. Yesterday, my son-in-law arrived from Kalna. They have a shop there. His father looks after it, and he too works in the shop. But what difference does that make? No one's ever heard of such goings-on. There are three sons, and grandchildren too. The mother died in the month of Bhadra, and in Magh he brings home a wife again! The boy's . . .

It is evening. Sarbojaya sits on the veranda taking her medicine from the gallipot. A dog crosses the empty courtyard in front.

Another day. Nirupama comes round the corner of the house, looking for Sarbojaya. She is carrying a basket of fresh vegetables. She finds Sarbojaya sitting under a tree outside, her head resting against the rough bark, her eyes shut.

NIRUPAMA: Aunty! Were you sleeping? (*Touches Sarbojaya's forehead.*) Has your fever gone up again?

SARBOJAYA (*looking at the basket*): What shall I do with so much?

NIRUPAMA: Won't you go inside?

SARBOJAYA: In a while. Sit down.

NIRUPAMA: I won't stay now, Aunty. Kumi's cough has got worse again. I'll have to prepare some medicine for her. If I can, I'll come round in the evening. Oh yes—we have written to Thakur-mashai. Even if it means that you'll be angry with us.

SARBOJAYA: Why did you? He is an old man—

NIRUPAMA: Have you written to Apu?

SARBOJAYA (*smiles*): Apu has a holiday today. Today and tomorrow

NIRUPAMA: Is he coming? (*Sarbojaya's smile fades away. She frowns.*) Shall I write to him?

SARBOJAYA (*agitated*): No, no. No! If he comes—he'll come on his own. (*Sighs.*) He has his studies. His examinations are around the corner. It's better that he stays away. You mustn't write to him! (*Nirupama frowns.*) You won't, will you? Tell me! Promise me!

Nirupama rises, looking unhappy. Sarbojaya looks pleadingly at her.

NIRUPAMA: I'm going now, but I'll come again. The others will come too. One of the doors is open. Shall I shut it?

SARBOJAYA: I'll do that later.

NIRUPAMA: All right. I'll leave these on the veranda.

Nirupama leaves. Sarbojaya leans her tired head against the rough bark of the tree, her eyes dark pools against the pallor of her face.

13

Shibnath finds Apu in the lawns of the Victoria Memorial, reclining against a tree, engrossed in a book. He slaps his book down on Apu's leg to draw his attention. Apu looks up. Shibnath comes and sits down near Apu.

SHIBNATH: Well? I never expected to find you here.

APU: Why?

SHIBNATH: Didn't you tell me you were going out of town for these two days? To that village of yours? What's it called? Mansapota?

APU: What's the point? I can't do my studies there. Just feel like sleeping all the time.

SHIBNATH: Won't your mother be angry?

APU: No. I've fixed that.

SHIBNATH (*smiles*): You have?

APU: I've sent her a money order, from the bonus I got from Akhil-babu.

SHIBNATH: Really? (*He takes out a cigarette.*) Aren't you feeling nervous?

APU: A little. I am not quite ready with the Chemistry paper.

SHIBNATH: Want a smoke?

APU (*smiles*): No.

SHIBNATH: Why don't you?

APU (*shakes his head*): No.

Shibnath lights up and blows a cloud of smoke, Apu watches his friend with a smile. Church bells ring in the distance.

The sundial in the empty courtyard at Mansapota, in the shade, as evening falls. The rough, scaly undulations of the bark of a tree. Against it rests the ravaged face of Sarbojaya, her eyes shut. The whistle of a train is heard far away. Sarbojaya opens her eyes and slowly turns to look at the horizon, where, across the fields, a train goes on its way, letting out puffs of smoke against the clear sky. Sarbojaya rises slowly, shakily, to her feet. She rolls up the rush mat and drags herself towards the door of the house. An earthen lamp glows near the tulsi plant. Sarbojaya sits on the veranda, gasping for breath. Through the evening mist a voice floats across to her. It is Apu calling. She looks up towards the door, her face glowing with expectation. She smiles and rises. Slowly, and painfully, Sarbojaya comes down the steps of the veranda. She stumbles and the light scarf around her shoulder drops to the ground and trails behind her. She looks out of the door, in hope, and in despair. There is no one outside. Only the darkness falling swiftly. The waters of the pond glimmering through the trees. The noises of the night, the jackal's cry, the cricket's hum, gather round the lonely house as Sarbojaya looks out of the door. There is nothing out there. Only the dark empty road in front and the fireflies in the shrubs. Sarbojaya sinks down on the

threshold slowly, resting her head against the doorpost. The fireflies dart around as a shroud of darkness covers the path, the trees, the pond.

14

As Apu comes back to the press after classes, Akhil-babu summons him to his room.

AKHIL-BABU: Apu—! There's a letter for you. (*To another man*) Go, put it on the machine. (*To Apu, who reads the letter*) What is it? A letter from your mother?

APU: From Niru-di. Mother is ill.

AKHIL-BABU: Is it something serious?

On the train, Apu sits huddled by the window, looking worried. The vendor selling the wonder balm tosses him a leaflet, but Apu does not look up.

VENDOR: A wonderful balm! When in pain, it comes to your aid like a faithful friend! For cracks and cuts, boils and burns, an infallible cure. And now, here is the Tansen pill . . .

Apu comes down the path around the pond, towards the house. The front door is half-open. He leaves his bedding on the veranda and goes in search of his mother. He walks around the courtyard, then goes out by the back door and comes out near the tree. He calls out to his mother, his voice harsh with fear. But the deathly silence aaround him remains unbroken. No one replies. Coming round to the front door again, Apu stops. Bhabataran stands outside the house looking at Apu. Silently and slowly, he turns away from the boy, and moves towards the door of the house. Apu sits down on the ground, overcome by a strange, unknown fear. He starts taking off his shoes, then clasping his arms around his knees and hiding his face, he breaks into loud, anguished sobs.

APU: Mother! Mother! Mother!

It is night. Apu sits on the veranda in front of the bedroom, hugging his knees, sobbing. The old man sits near him, smoking his hookah.

BHABATARAN: Don't cry, Apu. Parents don't remain with you forever. Whatever had to happen, has happened. Now you had better perform the *shraddha*, and then stay on here. You'll earn enough as a priest.

In the morning, Apu sits near the bedroom door, sorting out his mother's belongings. A storm is brewing and there is rumbling of distant thunder as Bhabataran comes in by the back door. Apu puts all his mother's little possessions on a light quilt and ties it up into a bundle.

BHABATARAN: My boy, where are you off to?

APU: Calcutta.

BHABATARAN: Why Calcutta?

APU: I have my examinations.

BHABATARAN: And your mother's *shraddha*?

APU: I'll take care of that in Calcutta, at Kalighat.

Apu jumps off the veranda, picks up the bundle and looks at Bhabataran. He turns away as the old man raises his hand to bless him. Thunder rolls outside as Apu goes out of the house carrying the bundle and his mother's rush mat.

In the empty courtyard, Bhabataran stands watching as Apu walks away from the house. In his arms, wrapped in a quilt, he carries away his memories. His bare feet leave behind a familiar path as he goes past the pond, past the banana groves, under an overcast sky.

APUR SANSAR

The World of Apu, 1959

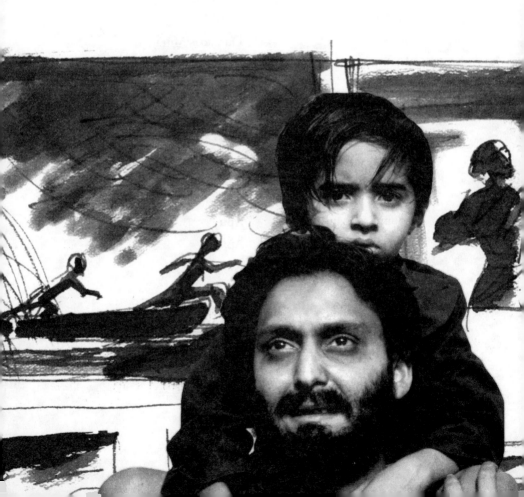

CREDITS

Direction, production and script	Satyajit Ray
Story	Bibhutibhushan Bandyopadhyay
Camera	Subrata Mitra
Art Direction	Bansi Chandragupta
Editing	Dulal Dutta
Sound	Durgadas Mitra
Music	Ravi Shankar
Produced by	Satyajit Ray Productions

Bengali / 106 minutes / Black and white / 1959

CAST

Artistes	*Characters*
Soumitra Chattopadhyay	Apu
Sharmila Tagore	Aparna
Alok Chakravarty	Kajal
Swapan Mukhopadhyay	Pulu
Dhiresh Majumdar	Pulu's Uncle
Shefalika (Putul)	Pulu's Aunt
Abhijit Chattopadbyay	Murari

Prologue

Apu reads a testimonial written in English.

TESTIMONIAL: This is to certify that Apurba Kumar Ray was a student of mine in the Intermediate Science class in the City College, Calcutta. He is sensitive, conscientious and diligent, and is deserving of the fullest sympathy and encouragement.

<div align="right">M. K. Sengupta</div>

APU (*smiles*): I'll be on my way, Sir.

PROF. SENGUPTA: But it would have been better if you completed your graduation.

APU: I know, Sir. But I won't be able to afford it.

PROF. SENGUPTA: But don't give up your writing habit. Your pieces on village life in the college magazine were quite—(*Apu laughs, embarrassed*). No, no. It's not something to laugh about. It can become a vocation, you know. Of course, not everybody becomes a Saratchandra.

Apu and Professor Sengupta wait at the door of the Professor's room, as a strikers' procession passes on the street outside, shouting slogans.

APU: Goodbye, Sir.

PROF. SENGUPTA: Goodbye.

1

A room on the terrace. A torn piece of cloth covers the window. It is raining outside and the wet curtain billows in the breeze. On a bed near another open window lies Apu, fast asleep. The whistle of a train, and the noises of the railway yard near the house, finally wake him. There is a small table clock by the bed. Apu looks at the time, then starts getting out of the bed. He sits up and yawns, stretching his arms. On the bed lies a sheaf of papers, and a bottle of ink turned on its side, with some of the ink staining the sheet. Apu hurriedly removes the sheet, takes out a shirt from under the mattress, is relieved to find the ink hasn't stained it; he puts it on a table near the bed, along with the papers and the bottle of ink. He goes out to the terrace and puts the sheet in a bucket. He stops to look at a train that stands puffing and whistling in the yard below, then walks with the bucket to another part of the terrace. Leaning over the parapet, Apu looks at the courtyard below, where the women have gathered in the rain, near an open tap. Apu takes the easy way out. He puts the bucket under a stream of water falling from a rainwater pipe on the roof of his room, stands in the rain for a while, pushing back the wet locks of hair from his face, then goes and stands near the door of the room and starts doing his physical jerks.

When the landlord appears on the terrace, announcing himself with a discreet cough, Apu is shaving in front of a small mirror. The landlord is a wiry, middle-aged man with a rasping voice. Apu continues to shave as he talks to his guest.

LANDLORD: Namaskar!

APU (*casually*): Namaskar. Take a seat.

LANDLORD: Will taking a seat bear any fruit, Apurba-babu?

APU: It'll rest your tired limbs. Walking up three flights of stairs is hard work.

LANDLORD (*smiles*): I haven't come up all those stairs to rest my limbs. You know as well as I do what I've come for. I'll put a straight question to you and you give me a straight answer, and all our troubles will be over.

APU: Go ahead.

LANDLORD (*sternly*): What is the date today?

APU: The tenth.

LANDLORD: And how many months' rent do you owe me?

APU: Three.

LANDLORD: Three. Three times seven, twenty-one rupees. Do I get the money now, or do I have to come back in the evening?

APU: Oh dear! That's three questions and not one. That's not fair!

LANDLORD: A lot of things are not fair, Apurba-babu. You seem to have decided that I should house you for nothing. Is that fair? Is it fair that you should burn up precious electricity in the daytime? You've had education. You've pictures of great men hanging on the wall. And yet, when it comes to paying me the rent, you don't like it.

APU: That's a sign of greatness too. Don't you know?

LANDLORD: I can't win a battle of words with you, Apurba-babu. I could turn a phrase too, but it won't be fit for your young ears. Never mind. I'll come back in the evening. Keep the money ready. Or I shall look for a new lodger.

APU: Straight words.

LANDLORD: Straight words.

The landlord puts out the light before going out of the door. Apu goes to the switch and turns the light on again. He is about to go back to his shaving when he thinks of a better revenge. He comes out of his room, sends a murderous glance down the stairs, and switches on the staircase light.

Dressed to go out, Apu sits on the bed and takes out a fat book from a shelf near the bed. He turns the pages, puts the book in a bag and picks out another book. Turning the pages, he finds a pressed fern, which he removes carefully before putting the book in his bag. The leaf goes into another book, which he replaces on the shelf. The sky has cleared and the sun is shining outside the window. Apu slings the bag on his shoulder and goes towards the door. He goes down the stairs, past women busy with their day's work, a hum of noise floating around him from the various households sheltered under the same roof. As he reaches the ground floor, a man calls out to him from one of the rooms.

MAN: I say! Come here, will you? You see, we have the same surnames. Hence this confusion. (*He gives Apu a letter.*)

LETTER: We are pleased to accept your short story, 'A Man of the Soil', for publication in the Bhadra issue of the *Sahityik*.

MAN: Not bad news, I hope.

APU: Oh, no.

MAN: How is it that you get so few letters? Does no one write to you? Not even a girlfriend? (*Apu turns and shakes his head.*) Eh? It would be nice to open a love letter by mistake. (*Apu laughs.*) You really don't have any?

APU: No.

MAN: I'm glad to hear that. The longer you put it off the better. Don't ever get embroiled in the complications of matrimony. I've had to suffer for it.

APU (*smiles*): Goodbye.

Children play cricket in a lane. The ball comes and hits Apu on the chest. He dusts his shirt as he turns the corner, carrying an umbrella and some papers in his hand. He stops in front of a signboard which says, 'Harimati Primary School, established 1302'. Apu goes into the house. Entering a room which vaguely resembles a classroom, Apu

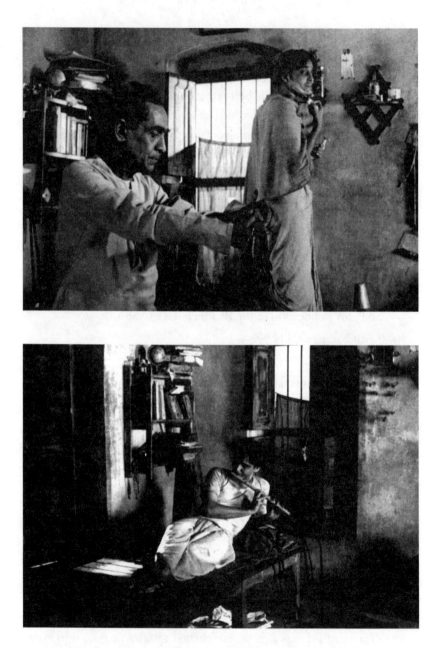

Above. 'I can't win a battle of words with you, Apurba-babu.'
Below. As Apu starts playing on the flute, there is a knock on the door.

stands hesitantly looking into an adjoining room where two old men sit playing a game of dice. One of the men addresses Apu, without looking up from his game. The man is bald and toothless, and speaks with great vehemence, shaking his old head and rattling his gums.

MAN: One, two, here's three. (*To Apu*) What do you want?

APU: You have advertised in the papers for a teacher.

MAN: Qualifications?

APU: I've passed my Intermediate.

MAN: Won't do.

APU: Why not?

MAN: We want a matriculate.

APU (*smiles*): Well, I had to do my matriculation before I . . .

MAN: What did the advertisement say?

APU (*apologetic*): Well, it did ask for a matriculate.

MAN: Well, then why are you harping on Intermediate? What good is an Intermediate? Will ten rupees a month do for you? Intermediate indeed!

He goes back to his game. Apu stands for a while with his head bowed, then turns to go.

Apu stands before the manager of a drug factory. The manager, a man with a full head of hair, a large moustache under a pointed nose, and ears that fan out, looks up raising a cigarette to his mouth.

MAN: What do you want?

APU: I understand you need men in your pharmaceutical works? I— I am a matriculate.

MAN: Sit down. Any experience of labelling work?

APU: Labelling?

MAN: Yes.

APU: I can learn it.

The man gives him a speculative look. Aware of being scrutinized, Apu looks uncomfortable. He smiles hesitantly. The manager smiles back, shaking his head.

APU (*scared*): Can't I learn?

MAN: I suggest that you take the door at the back and go straight in. You'll find the labelling department on your right. Go and have a look first.

Apu walks through a long, dark passage, cautiously, crunching broken glass underfoot. He stops in front of a door and looks inside. Men and boys sit in rows on stools, labelling bottles. Each has a small pile of bottles in front of him. Apu's heart sinks. He looks at the workers with his mouth hanging open. A stocky, snub-nosed man, with his glasses sliding down his nose, looks up at Apu. Apu quickly looks away, embarrassed.

On his way back home in a tram, Apu takes out the letter from the publisher once again. It helps to restore his good humour. He puts it away again and looks up dreamily.

It is early evening. Apu comes down the tracks of the railway yard, past a herd of pigs, down a road where the children play near a slum just behind his house. The temple bells ring, the sound of conch shells fills the air as Apu enters his room, throwing his umbrella and his bag on the floor. He empties his pockets, humming all the while, takes off his shirt and his shoes, and sits on the bed. Through the bedside window, Apu can see a girl standing at a window in the house opposite. He cautiously slides backwards, picks up his flute from the shelf and pushes the window shut with it. The clock on the shelf says five to six. As soon as Apu starts playing on his flute, there is a knock on the door. He pauses, then goes back to the flute. But the knock is repeated, louder. He switches on the light and opens the door. Outside the door stands a pleasant-looking young man.

APU: Hullo there, Pulu!

PULU (*walking in*): You're a fine friend!

APU: Why?

PULU: You didn't write and tell me you'd moved from the hostel.

APU: Why! But . . . I . . .

PULU: I have been searching the whole of North Calcutta ever since
four in the afternoon!

APU: But how would I know that you'll turn up here so suddenly?

PULU: I went to the hostel. They said they didn't know. I went to the
restaurant where we had our meals. They didn't know. I went to
Anil's, and he had gone to watch football.

APU (*laughs*): And from there?

PULU: From there to Beadon Street, where you give private lessons.
I got your address from them. Took me another good half hour
to find the house. (*Apu rolls with laughter.*) What's so funny? You
ought to be ashamed of yourself.

APU: You—you've grown fat!

PULU: I was fat. Three hours ago.

APU: Have some tea?

PULU: Tea? Where?

APU: In the cafe.

PULU: How far?

APU: Round the corner.

PULU: Let's go. But I am carrying tickets for *Sadhabar Ekadashi* with
me.

APU: Very good. Just a minute.

He goes to put on his shirt. Pulu gets up from the bed and takes
a look around the room.

PULU: What's the matter with you? Why are you hiding away like this?
You haven't been forging banknotes, have you?

APU: Wish I could!

PULU: An oil cooker! Have you been cooking for yourself?

APU: Yes. I'll cook you a meal one day. Rice and boiled potatoes.

Apu and Pulu sit at a table in the cafe.

PULU: Tell me, why didn't you take that job in the railways? I was quite certain that you'd got it.

APU: There was a strike on. They were taking people to replace the striking workers. I didn't know when I applied.

PULU: So all this time you've been without a job?

APU: I give some private lessons. Turning dullards into prodigies.

PULU: How much do you make?

APU: Fifteen rupees. (*Smiles.*)

PULU: Didn't you once take typing lessons?

APU: Yes. I thought it might come in useful one day.

PULU: Good. You'll get a job as soon as you return. There is a firm I know.

APU: Return? From where?

PULU: Listen. On Monday my cousin is getting married. You'll have to come with me.

APU: Where?

PULU: It's a matter of five or six days.

APU: But where?

PULU: Khulna.

APU: Khulna! Have you gone crazy?

PULU: You'll love to be there. I can guarantee that. (*In a mock poetic manner.*) A remote village. A river, with boats on it. Endless fields of grass and paddy, mango orchards, bamboo groves, a path through the groves—well, well? How do you like it? Eh? (*Apu laughs.*) Trees full of birds, magpies, bulbuls, nightingales. And

with nightfall, the song of crickets, fireflies, cry of jackals. Kerosene lamps—no electricity. Eh? Aren't you tempted? Got you where it hurts? (*Apu laughs.*) Well? You'll come, won't you? Won't you?

Night. Apu and Pulu are on their way back from the play. Apu recites a poem at the top of his voice, spreading his arms dramatically, as they walk across an overbridge, and come down the stairs into the railway yard.

APU: Take me back, O Mother Earth,
 Take thy son to thy lap, wrap him in thy flowing veil.
 Let me be one with thy soil, and spread myself
 Far and wide, like the joys of Spring.
 Let me burst open the heart's narrow cage,
 Break down the hard stone walls,
 The dark and cheerless prison of my mind
 To rush forth in a rapture of delight,
 Surging, billowing, tossing, rolling on . . .

PULU: I say! A policeman!

POLICEMAN: Who's there?

APU (*playacting*): I am Mainak, son of the Himalayas, hiding my wings in the sea!

PULU: What's the matter with you? Another Nimchand, are you? And without the aid of alcohol too! (*Apu starts singing a tune loudly.*)

APU: You know, Pulu—

PULU: What?

APU: I won't take that job.

PULU: What job?

APU: The one you told me about.

PULU: Why not?

APU: Why should I become a clerk? Why? There's no reason why I should. I am a free man. No ties, no responsibilities. No

problems, no one to worry about. Why should I suddenly become a clerk?

PULU (*angry*): So you'll go on pawning your books to pay your rent? Don't you want to improve your lot ?

APU: Things will improve.

PULU: Without any earnings?

APU: Listen, those who have genuine talent . . .

PULU: Don't need to earn a living?

APU: Goethe, Dickens, Keats, Lawrence, Dostoevsky. . .

PULU: Apurba Kumar Ray!

APU: Go on, laugh if you like. But just wait and see.

PULU: Hey, have you been writing something? Poetry?

APU: You're too prosaic.

PULU (*angry*): Prosaic!

APU (*bitterly mocking*): Engineering is the only thing that you can do. You'll go abroad for a degree, come back home to take up a job with a fat salary, and then settle down. That's all.

PULU (*menacing*): Prosaic!

APU: What else?

PULU: Who made you read *Sadhabar Ekadashi*? You used to be a country bumpkin.

APU (*surprised*): Don't tell me it was you?

PULU (*louder*): A country bumpkin—that's what you were. Every time you had to cross the street, you broke out in a cold sweat! Do you remember? Who read your first story? And what did he tell you after reading it?

APU (*with a disarming smile*): Sorry, sorry, sorry!

PULU: And all will be forgiven!

APU: Don't get so worked up. I'm feeling somewhat excited today. It's ages since I had such a filling meal. Thanks to you.

PULU: Hey, have you been writing? Tell me, what are you writing?

APU: A wonderful novel.

PULU: Really? And you've kept it from me all this time!

APU: Do you know of any publisher?

PULU: Oh, that can wait.

APU: Look, Pulu—

PULU: What?

APU: A young boy.

PULU: Huh?

APU: A—young boy.

PULU: All right.

APU: A village boy.

PULU: Very well.

APU: Poor, but sensitive. (*Smiles*) Father's a priest. He dies.

PULU: Hmm.

A flute plays a forgotten tune, bringing with it the memories of a village home, rain clouds hanging over paddy fields, fireflies on the pond, and a path left behind.

APU (*dreamily*): The boy comes to the city. He will not be a priest. (*Defiantly*) He will study. He's ambitious. Through his education, his hardships, we see him shedding his old superstitions, his orthodoxy. He must use his intellect. He cannot accept anything blindly. But he has imagination, he's sensitive. Little things move him, give him joy. He may have in him the seeds of greatness, but . . .

PULU: He doesn't make it.

APU (*delighted*): He doesn't. But that is not the last word. It is not a tragedy. He does nothing great. He remains poor, in want. But in spite of that, he never turns away from life. He doesn't run away, he doesn't escape. He wants to live! He says that the act of

living is in itself a fulfilment, in it lies happiness. (*Excited*) He wants to *live*!

PULU: No.

APU (*deflated*): What do you mean?

PULU: Where's the novel? It's your own story!

APU (*defiant*): Some of it is autobiographical. A lot of it is fiction. Besides, there are imaginary characters, there's a plot, love interest . . .

PULU: What? Love?

APU: Why not?

PULU (*astounded*): Love!

APU (*insisting*): Why not?

PULU: What do you know about love?

APU: Why?

PULU: What *can* you know about love? Have you ever been within ten yards of a girl? Have you any *experience* of love?

APU: So what if I haven't?

PULU (*shocked*): So what if you haven't? Lovely! You'll cook it up? Is it so easy to write a novel?

APU (*shouting*): Does one have to experience everything?

PULU (*shouting back*): Certainly!

APU: Is imagination worth nothing?

PULU: Nothing, where love is concerned. Not a thing.

APU: Who told you?

PULU: I'm telling you!

APU: Rubbish! You know nothing. If a man has talent——

PULU: Yes?

APU: He can do anything!

PULU: No!

APU: If a man . . .

2

A river in Khulna. Apu and Pulu go down in a small open boat. Apu plays on his flute, looking at the passing view—villages among fields of paddy, golden in the sun, cattle grazing on wide meadows, the sloping river bank, and women bathing in the shallows. The boatman's oar moves in rhythm, making a splashing sound on the water. Pulu sits reading Apu's manuscript.

APU: Pulu—

There is no reply. Apu turns away and starts reciting a poem loudly.

APU: How much further wilt thou lead me, O Fair One?
Tell me what shore thy golden boat will touch.
Whenever I ask thee, O thou from distant lands,
Thou only smilest in thine own sweet way.

The boatman, old and emaciated, gives Apu a toothless grin.

APU: And I can never know what is in thy mind.
Silently thou liftest thy finger
To point at the trackless sea rising in tumult,
As far to the west the sun goes down in the sky.
What lies there? What do we go to seek?

Pulu finishes reading and looks up at Apu with a smile.

APU: Tell me, I pray thee, O stranger fair,
Where, at the edge of the evening, glows the day's . . .
He turns towards Pulu and stops reciting, looking enquiringly at him.

Pulu puts away the papers and extends his hand. Apu frowns, looking worried.

APU: Well?

PULU: Give me your hand.

APU: You've finished! (*Smiles.*) What did you think of it?

PULU: Give me your hand, you idiot!

Apu smiles, then with a sudden movement, puts his hand into Pulu's. Pulu smiles back as he shakes Apu's hand.

PULU (*excited*): Wonderful! Really wonderful!

In the home of Pulu's uncle, preparations are on for the wedding. A girl decorates a low wooden seat which will be used during the ceremony. Other girls stand watching. They look up, hearing Pulu's voice. Pulu's uncle leads the two friends into the house.

PULU: Where's everyone?

UNCLE: Look who is here!

GIRLS: Pulu-da!

PULU: Pulu-da is not alone. There's someone else with him.

Pulu puts down his suitcase and picks up a child before moving away. His uncle turns to talk to Apu, who smiles shyly. Pulu's cousin, Murari, a thin, young boy, comes and stands near them.

UNCLE: There you are. I hope you didn't have an uncomfortable journey. After all you are city people. We are country folk. Here's Murari. He's my younger son, studying in the Intermediate class in Daulatpur College. (*To Murari*) Take his things inside.

APU: No, no. Let it be.

UNCLE (*moving away*): Hey, Harey! Come here quickly! (*To Apu*) All right then.

Pulu comes into a room with the child. He puts the child down and touches his aunt's feet. The room is crowded with young girls.

AUNT (*blessing him*): There, there. How are you, my child? (*Apu comes in.*)

PULU (*to Apu*): My aunt.

Apu touches her feet. Pulu's aunt stares at Apu, her eyes shining.

PULU: Here I had such a good match for your daughter, and you fixed Aparna's marriage somewhere else.

AUNT: Where have I seen this face?

PULU: You couldn't have seen it anywhere. This is his first visit here.

AUNT: No, no. I know this face very well. Oh yes! I know where I've seen it before, in the paintings of gods!

PULU: Lord Krishna incarnate! Complete with flute. (*Apu smiles, embarrassed.*) But where's the most important person? Aparna? Where's Aparna?

GIRL: You want Ranga-di?

PULU: Yes, yes!

GIRL: She's upstairs.

AUNT (*to Apu*): Bless you, my son, may you live long.

3

The shehnai players sit playing on a specially constructed platform above the gates of the house. In a room upstairs, Aparna is being dressed for the wedding. A girl slips a bangle on her wrist while her mother puts an ornament on her forehead. Now she decorates Aparna's face with sandalwood paste.

Some distance from the house a band plays as a procession goes past the river. It is the groom's family and friends going to the wedding. The groom sits in a palanquin.

Up on a slope near the river, Apu lies asleep under a tree, holding his flute in his hand.

Pulu's aunt finishes decorating Aparna's face and puts a garland of flowers round her neck. Young girls stand chattering excitedly in the room. A girl runs up to the door of the room.

GIRL: The bridegroom is coming! The bridegroom is coming!

She runs out again, followed by a stream of girls, all rushing to see the groom.

In the room Aparna's mother gazes at her daughter lovingly.

Outside, the bagpipers come up to the gate. Children rush out to greet them.

Pulu's uncle and other elders go out to meet the groom's party. People crowd around the palanquin, eager to get a sight of the young man. Pulu too stands among them.

The groom's father comes to the door of the palanquin. Inside, sits the groom. He looks dishevelled, disturbed, and is tearing pieces off his headdress, muttering incoherently.

GROOM'S FATHER: Binu, my son, come, get down. My son! Binu! Get down, come on!

ANOTHER MAN: Come out, Binu!

PULU: What's the matter? Is he feeling unwell?

Murari takes one look into the palanquin and rushes away. The second man plucks at the sleeve of the groom, who snatches his arm away and shouts at him.

GROOM: Get out!

SECOND MAN: No, he is—he's been in the sun all afternoon—

PULU: Shall I get some water?

SECOND MAN: Yes, yes! Please get some water—

PULU: Murari!

UNCLE (*approaching the palanquin*): What's the matter? What's happened?

GROOM'S FATHER: I think he is not feeling well. He has been fasting all day. He's probably feeling ill. Why don't you get some water? A fan—some water—

UNCLE: Ray-mashai! Fan! Water!

MAN: In a minute! In a minute!

SECOND MAN: Binu! I say, Binu!

MAN: Why don't you stop crowding around?

The second old man looks up helplessly, then moves away from the palanquin. The groom does not respond. As the people push towards the palanquin door, he suddenly lets out a scream and dives into the crowd. They carry him into the house.

Pulu's uncle comes into the room where the bride sits waiting. Inside the room Pulu's aunt stands holding her daughter in her arms protectively. She looks at her husband in grief and anger.

AUNT: Who are you giving your daughter away to?

UNCLE: Why?

AUNT: The bridegroom is—mad!

UNCLE: Who says so? (*Pulu comes in.*) He is perfectly sane. It's just the long journey and the heat—

AUNT: Listen to me! This marriage cannot take place. I will not allow it!

UNCLE: Have you taken leave of your senses ? The auspicious hour is slipping away!

AUNT: Go away! Or I'll—kill myself!

UNCLE: You're out of your mind!

AUNT: Go away! Go! At once!

Pulu's uncle backs out of the room. His aunt shuts the door and turns to her daughter sorrowfully.

UNCLE: Bara-bou! Bara-bou! Once the appointed hour goes, my daughter won't get married again! (*Breaking down*) Bara-bou! (*Turning away*) What a calamity! What a calamity!

PULU: Isn't there another auspicious hour, Uncle?

Above. '. . . my cousin is getting married. You'll have to come with me', Pulu tells Apu. *Below.* Pulu's aunt and the women of the house await the groom's arrival.

Above. Apu aquiesces to Pulu's request that he marry Aparna.
Below. Apu asks Aparna in the bridal chamber after the wedding, 'Aparna, will you be able to endure poverty?' Aparna answers, 'Why not?'

UNCLE: Eh?

PULU: At ten o'clock?

UNCLE: I don't know anything. I can't think clearly. I'm ruined! I'm ruined!

Pulu stands silently watching his uncle as he moves away, a broken man.

It is nearly evening when Pulu finds Apu lying asleep near the river, with a book under his head. Down the path below the slope a stream of people can be seen walking away from the house. Pulu has come with Murari and some elders from the family. He shakes his friend awake.

PULU: Apu! Apu! I say, Apu!

APU (*waking up suddenly*): What is it? Have I missed the wedding?

PULU: No.

APU: What do you mean?

PULU: There won't be any wedding.

APU: What? (*He rises to his feet.*) What's the matter?

PULU: The bridegroom is mad.

APU: What!

PULU: Listen to me, Apu! Everything depends on you now.

APU: On me? Are you joking? (*He looks at the others.*) What is all this?

OLD MAN: If you don't save us, no one else can. You know the custom. By the morning the girl will be unfit for marriage.

APU: But what can *I* do?

SECOND MAN: Where could we hope to find a more suitable bridegroom tonight? So, if you—

APU (*shaken*): Is this what you've come to tell me?

PULU: Listen to me—

APU: What—what's the big idea? Is this a play, or a novel? What do you take me for? You'll just put me on the bridegroom's seat without so much as a by-your-leave? Are you still living in the Dark Ages?

PULU: Will you calm down and listen to me?

APU: No, I won't! I won't! I won't waste time listening to a pack of lunatics.

OLD MAN: Everything depends on you.

PULU (*suddenly, sternly*): Let's go, Majumdar-babu. Let's go.

Pulu leaves. Apu walks up and down near the tree, then stops to pick up his book and brush the dust from it.

Standing on the top of the rise he looks at the house in the failing light. Down the path below, the mad bridegroom is being escorted home by two old men.

GROOM'S FATHER: Would I have come here if I had known this would happen? What a disgrace!

GROOM: Won't I get married?

Apu stands watching the little group from the river bank.

The shehnai players are descending from their platform when Apu approaches the house slowly. On the veranda outside the house sits Pulu's uncle with other members of the family; they look despondent.

APU: Pulu—

From the shadowed veranda, Pulu replies.

PULU: What is it?

APU: Come here for a moment.

Pulu walks up.

PULU: Yes?

APU (*looking away*): Can you really get me that job?

PULU: What do you mean?

APU: You'll have to lend me a shirt. I haven't even had a shave.

He looks away almost guiltily. But Pulu is delighted.

PULU (*runs off shouting*): Uncle!

The shehnai players are back on their high platform. Apu and Aparna are being married to the sound of chanting and the *hulu*. Apu sits looking uncomfortable. Aparna's father holds the hands of the bride and groom and repeats a prayer after the priest. Pulu's aunt stands with the other women, watching the ceremony. A woman standing behind her speaks to her.

WOMAN: The curse has turned into a blessing for you, Bara-bou. Your daughter hasn't worshipped Shiva in vain.

AUNT (*looking fulfilled*): And what a blessing! The moment I saw him with Pulu, I knew he was nearer to me than my own kin. So many boys have come with Pulu before. But I've never felt so drawn to anyone.

Night on the river. A boat glides down the water in the moonlight, the boatman's plaintive song floats in the air in the silent night.

In the decorated bridal chamber in Aparna's home, Apu turns and comes towards the bed, where Aparna stands in silence. The room is lit by candlelight and the bed has flowers strewn all over it.

APU: Aparna, there are a few things that I must tell you. I haven't had an opportunity in the last two days. How much do you know about me? Has Pulu said anything?

APARNA: Yes.

APU: What has he said?

APARNA: You don't have anyone of your own.

APU: That's true. My father died when I was ten years old. Then my mother, when I was seventeen. I had a sister too, an elder sister. What else did he say?

APARNA: That you write well.

APU (*pleased*): Oh, that too? Just like Pulu. Can you read?

APARNA: Yes. Bengali.

APU: Oh. I am writing a novel. In Bengali.

APARNA: I know.

APU: You know that too? What else did he say?

APARNA: Nothing else.

APU: I see. Then he hasn't told you anything. Not the most important things, anyway. You don't even know who you're married to. Have you ever heard of a bride and groom spending the third night of their marriage in the bride's home? (*He paces up and down.*) I don't have a house of my own, nothing. Neither home, nor hearth. I've no regular income. What kind of a home shall I take you to? And the way you've been brought up—this spacious house, servants, these beautiful rooms. Believe me, the marriage was forced upon me. I was strongly against it. But the way the request was made, I thought I would be doing something noble. Everything got confused. Why don't you say something? I can't decide anything till I know your mind. I don't know what to do. Aparna, will you be able to endure poverty? Can you live with a poor husband?

APARNA: I think so.

APU: Can you, really?

APARNA: Why not?

APU (*immensely relieved*): In that case, I shall take you away with me. Your father might object, but I won't listen to him. Have you any objections?

APARNA: I don't know.

APU (*laughs*): I wonder what they'll think!

APARNA: Who?

APU: My neighbours. I told them I was going to a wedding, and now I'm returning with the bride! (*He laughs loudly.*)

4

A hackney carriage drives up a lane and pulls up. Apu steps out with a suitcase, then holds the door open for Aparna.

APU (*to the coachman*): You take down the luggage. I'm coming.

Aparna comes out of the carriage and follows Apu into the court-yard, up the staircase, still wearing her bridal veil.

In a room off the first floor landing, a woman sits working at a sewing machine. She has her back to the open door. Apu and Aparna cautiously slip past the door and go up another flight of stairs.

On the terrace, Apu unlocks the door of his room and goes in with the suitcase.

APU: Come. (*Aparna enters.*) My room. Give that to me.

He takes the bridegroom's ceremonial headdress from Aparna before opening one of the windows to let some light into the room.

APU: Sit down. I'll be back.

Apu goes out by the door.

Aparna advances into the room, looks around, then goes to the open window.

She sits down on the sill, and starts sobbing quietly.

The sound of a child's laughter floats up from the slums below, and through a hole in the curtain a large, tearful, but curious eye surveys

the world outside Apu's room. A child runs laughing to her mother's arms, and looking at them, Aparna forgets her tears. She turns away from the window with a sigh, and wipes her tears with the end of her sari. She rises as Apu enters the room, looking pleased. But Apu has seen the trace of tears on her cheeks.

APU: Aparna! You must be feeling very sad.

Aparna looks up at him with a smile.

APARNA: No.

APU: Is that the truth? (*Aparna nods.*) Come, let's go downstairs.

Downstairs, on the landing, children crowd around for a glimpse of the new bride. The woman who had been sewing in her room pushes the children aside and comes forward. Aparna comes down the stairs, followed by Apu. Amidst all the noise and chatter can be heard the sound of a conch shell.

WOMAN: Out of the way! Out of the way! Don't crowd in here. Let her come down the stairs!

Aparna comes and stands in front of her. The woman holds Aparna's face in her hands affectionately and gazes at her in admiration.

WOMAN: What a lovely bride!

5

The windows in Apu's room have new curtains. The room looks clean and tidy. There is even a little potted plant on the window sill. Apu and Aparna lie asleep in the bed.

The alarm-clock rings and wakes Aparna, who sits up, then starts moving away from the bed. But the end of her sari pulls her back with a jerk. Surprised, she tries to pull it off the bed, only to discover that it is tied in a neat knot to the sheet that covers Apu. She unties the knot, slaps Apu on the back playfully, then goes to the

door. The alarm stops ringing, and Apu slowly turns his face towards
the door, smiling. He lies listening contentedly to the familiar sounds
of the morning.

He lifts a hairpin from near his pillow, looks at it tenderly, yawns, then
settles his head comfortably on the pillow again, watching Aparna's
movements outside the room through the door.

On the terrace, Aparna prepares an old-fashioned stove before light-
ing the fire. She looks up at Apu, smiles faintly, then goes back to
work.

APARNA: What are you staring at me for? Am I new here?

Apu smiles. Now he puts his hand under his pillow and takes out a
packet of cigarettes. He opens the packet and a slip of paper appears
with a message in a neat, childish hand: 'Remember your promise—
only one after every meal.' He smiles, puts the packet back under the
pillow, and turns to lie on his back once more.

The stove is ready. Aparna goes to the coal bin on the terrace. She
recoils at the sight of a cockroach; then brings down a broom on it
with all her might. She turns back to the coal bin and starts breaking
the chunks of coal.

Apu comes out of the room, playing on his flute.

Aparna wipes the sweat off her face with the back of her arm, and
places the chips of coal on a tray.

Apu suddenly stops playing and stands looking at Aparna, frowning
and thinking. Aparna carries the tray to the stove and pours the coal
chips into it. The stove starts smoking.

Apu stands silently, his head bowed in thought. Aparna carries the
stove past him, further up the terrace. She puts the stove down near
the parapet, and stands staring at the railway yard, where an engine

moves in the distance, letting out a sharp whistle. Aparna covers her ears and moves away quickly, going past Apu into the room.

APARNA: Let me pass.

Apu moves away from the door and goes and stands near the smoking stove.

Aparna sits undoing her hair. Apu enters the room and sits down near the door. Aparna throws him a glance, then turns away again. Apu sits staring at the floor.

APU: Aparna—

APARNA: Mmm?

APU: Don't you ever repine?

APARNA: Don't I what?

APU: Repine.

APARNA: I don't understand such difficult words.

APU: Do you understand 'sorry'?

APARNA: Yes.

APU: Don't you feel sorry?

APARNA: Sorry for what?

APU: Do I have to explain that too?

APARNA: Yes you do.

APU: Sorry that you missed a rich husband. Don't you regret it? You're laughing!

APARNA (*laughing*): No, I'm not laughing. I'm crying.

She goes and picks up a fresh sari from a peg on the wall.

APU (*sulking*): You must feel sorry. You don't tell me.

Aparna stops near a little shelf on the wall to pick up her hair oil and soap.

APARNA: Of course I do. I could have just sat back and relaxed!

APU (*upset*): I'm going.

APARNA: Where?

APU: To look for a servant. (*He goes out of the room.*)

APARNA (*smiles*): Listen, don't be childish. Come back here.

APU: Let me pass.

Aparna moves away from the door and Apu comes in solemnly. He sits down on the bed, takes off his slippers and throws the flute on the bed. Aparna suppresses a smile and comes and sits beside him, putting her head on his shoulder.

APARNA: And who will pay the servant's wages?

APU: I'll find another tuition job.

APARNA: Then you may as well send me back to my parents.

APU: Why?

APARNA: One tuition job is bad enough after a whole day's work. It is already late when you get back home. If you take another . . .

APU: What else is there to do?

APARNA (*smiles*): Shall I tell you what? Give up the one you have.

APU: And then what?

APARNA: Then my poor husband will come home before it's dark, and I won't have anything to repine at.

Apu turns to look at her and smiles at last.

6

Afternoon. Aparna puts vermilion on her forehead and in the parting of her hair, then pulls the end of her sari over her head. The alarm clock rings. She smiles and goes out into the terrace. She looks at the courtyard below, runs into the kitchen and comes out blowing up a paper bag. She bursts the air-filled paper bag with a bang as Apu appears at the terrace door, then runs away from the startled Apu, who laughs and follows her.

Aparna fans Apu as he eats. Then it is Apu's turn. Aparna sits at her meal. Apu fans her, looking bored and sleepy. Aparna looks at him, amused.

Now Apu teaches Aparna English. They both lie sprawled on the bed, on their stomach. Aparna stares at Apu as he teaches, only half listening to what he says.

APU: At. C-A-T cat, F-A-T fat.

Apu, who knows that Aparna has not been paying attention to the book, turns to her and shuts the book. Aparna opens the book again.

APARNA: Go on. Go on, will you?

APU: R-A-T rat.

Now Apu takes her to a cinema where a mythological film is being shown. On the screen trees sway in a violent storm, shafts of lightning crack open the sky. Little Dhruva, endowed with superhuman powers, prays undisturbed among the rocks while the storm rages around him. Apu, amused, turns to Aparna to find her totally engrossed in the film. To the sound of horrid laughter, a fat and toothy demon and a thin ghost come to break Dhruva's concentration. Dhruva, praying with his eyes shut, does not even see them. Lord Vishnu's weapon, the *sudarshan chakra*, suddenly appears in front of the praying boy. The intruders fall back in alarm. Now three divinities appear on the screen.

A GOD: God of fire! Exert all your strength to destroy his meditation!

Lightning flashes, and a great fire leaps around the boy. Dhruva sits unmoved.

At the end of the show, Apu and Aparna come home in a hackney carriage. Aparna sits looking out of the glass-covered window, at a blurred view of the busy streets outside.

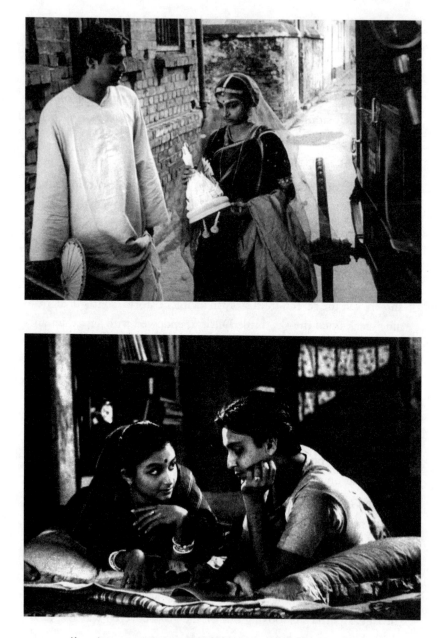

Above. '. . . my cousin is getting married. You'll have to come with me',
Pulu tells Apu. *Below.* Apu teaches Aparna the English alphabet.

APU: What's the matter? Are you angry? Or sad? Or hurt?

APARNA: Angry.

APU: Why?

APARNA: Can't I ride in a bus or a tram?

APU: They're so crowded. Here we can be all by ourselves.

APARNA: But we spend so much.

APU: Only seven annas.

APARNA (*turning to Apu*): Well then?

APU: In a few days you'll go to your parents, and my expenses will be halved.

APARNA: But that's only for two months.

APU: Isn't that a long time?

APARNA: And what about the additional expenses when we return?

APU: Ah yes! You know, Aparna, I didn't want to let you go. But your mother was so insistent. And then I felt that perhaps at a time like this—

APARNA: Just as well. It'll be a relief for you. At least there'll be no one to bother you for two months.

APU (*smiles*): But one job will get done. I'll have time to go back to my novel. I haven't written a line since we were married.

APARNA (*reproachful*): Is that my fault?

APU (*smiles*): It's your virtue. You know how much my novel means to me? (*Aparna smiles.*) You mean much more.

APARNA: Really!

APU: I'll dedicate it to you.

APARNA: What 'cate'?

APU (*airily, in English*): To my wife.

APARNA: I know what wife means!

APU: You don't. I do.

APARNA: I do too.

Apu puts a cigarette in his mouth. Aparna turns to him and looks pointedly at the cigarette. She extends her hand. Worried, Apu takes the cigarette from his mouth.

APU: What is it?

APARNA: Matches.

Apu smiles in relief and gives her the matchbox. She lights a match. In the dark interior of the carriage, the small flame brings a strange and beautiful glow to her face. Apu sits staring at his wife.

APU: What is there in your eyes?

APARNA (*looking up*): Kohl.

She smiles and blows out the match.

7

The clock at the railway station shows a quarter to eight in the evening. A porter pulls a trolley full of bags across the platform. Apu stands near the door of a compartment. Aparna is sitting inside, near a window. Her brother Murari, who has come to fetch her, climbs in.

MURARI: So, goodbye, Apu-da. You're coming during the *puja* holidays, aren't you?

APU: Goodbye. I hope so. Send me a wire when you reach.

MURARI: Yes, yes.

APU: It takes three days for a letter to arrive. Go on, get in.

Apu moves towards the window where Aparna sits. He looks upset. The guard blows the whistle. Apu and Aparna stare silently at each other, both unhappy. The engine puffs and whistles. The train starts moving slowly out of the platform. Apu keeps walking alongside till it gathers speed.

APARNA: Will you come?

APU: Have I ever broken a promise?

APARNA: You must write, twice a week.

APU: You'll write too, won't you?

APARNA: Not unless you do.

APU: Listen, write to me at the office address, or Ray-mashai will open and read the letters.

APARNA: Listen—

APU: Yes?

APARNA: Oh, I'm forgetting everything. Oh yes! Pintu's mother will make a pudding for you.

APU: Yes, yes.

APARNA: Remember to eat it.

APU: Yes, yes.

APARNA: And there's some money due to the grocer. Remember to pay him.

APU: Yes, yes.

APARNA: And I've left behind some of my jewellery. Keep them safely. All right?

APU: Of course I will.

APARNA: And please take care of yourself . . .

The train speeds out of the station. Apu falls back and stands, watching it unhappily.

8

In the office Apu sits staring out of the window, his work left unfinished on the typewriter. At a neighbouring table, another clerk finishes typing a letter, stretches his arms, and smiles at Apu.

CLERK: I say! Hullo there!

Apu comes out of his reverie with a start. He smiles apologetically at the man and settles down again at his typewriter. His colleague rises and goes across to Apu's table.

CLERK: You'll be seeing her in just a few more days. So why worry?

APU: No. What's there to worry about?

CLERK: Why don't you tell me your secret?

APU (*smiles*): Secret?

CLERK: How to be happy in these hard times, with a wife and a job that pays forty-five rupees a month ?

APU (*smiles*): How do you know I'm happy?

CLERK (*laughs*): I can make out. I don't know what your wife is like, but mine—(*He grimaces.*)

APU: Well ?

CLERK (*dramatically*): I like them to be a little quarrelsome, a little saucy, don't you understand, a bit mischievous, a bit smart; things warm up then. (*He shakes his head despondently.*) The one I have is just the opposite.

APU: How do you mean?

CLERK: She wouldn't complain even if you treated her badly. If there is nothing to eat for a meal, she won't say a word. If she doesn't have anything to wear, she wouldn't care. Tell her to turn right, she'll turn right. Tell her to go left, she'll go left. Absolutely bland! Tasteless, my friend. And look at this—(*He waves a baby's bottle.*) coming on top of everything else!

The man shakes his head sadly. Apu smiles, then quickly turns away to unfold a letter behind the shelter of his typewriter.

APARNA'S VOICE: You have promised to come on the eighth day of the puja festivals. I'll be waiting for you. If you don't come, I shall never speak to you again. You are a dreadful liar. Last month you sent seven letters. You owed me eight. Really, I should never

trust you. (*Apu smiles.*) I've been counting the days ever since I came here. And if you don't come after all that . . .

CLERK: I say, come on, hurry up, will you?

Apu rises, putting the letter in his pocket.

On his way home in the tram, Apu takes out the letter again.

APARNA'S VOICE: And that girl next door. I feel so jealous of her. Do you know why? It's because she sees you every morning and every evening. And I don't. It's most unfair. Keep the window shut.

A fat, middle-aged man, standing beside Apu, has been watching him inquisitively. Apu looks up from his letter and tries to outstare the man. But the man is quite unabashed, and it is Apu who lowers his eyes and puts away the letter.

Running down the stairs of the overbridge near his home, Apu takes out the letter once again, reading it as he walks along the railway tracks.

APARNA'S VOICE: What more could I add? I have ended my tale and made a lot of spelling mistakes as well. I know you will laugh. Go ahead. I'm no writer. This is good enough for a letter. Do take care of yourself. I am well, but my heart is sick. It will heal when you come. You'll come, won't you? If you don't, I'll never speak to you again. Never, never . . .

Apu puts away the letter. Walking down the railway tracks, he comes to the slums behind his house. He sees a child sitting near the tracks. Picking him up, Apu walks to the shacks, and places him on a rope cot outside.

Coming into the house he meets Ray-mashai at the doorstep.

RAY: Everything all right?

APU: Yes. Everything is fine.

RAY: What about the family?

APU: All well.

Apu comes up to the terrace and is unlocking his door when he notices Murari standing on the terrace. Murari stands silently in the gathering darkness, a sheet around his shoulder and his hair uncombed, his young face lined with grief. Taken aback, Apu gives him an uncertain smile and goes to him.

APU: Hullo Murari—What's the matter?

MURARI (*hesitant*): Aparna—

APU (*a chill settling around his heart*): What's happened to Aparna?

MURARI: At childbirth . . .

APU: What? What?

Murari does not reply, but Apu knows the answer already. He turns away, his face distorted with pain and horror, and finally, an over-whelming anger at the unfairness of it all. Murari watches the violence of his grief tensely, helplessly. Shaking with emotion, Apu turns to Murari and slaps him hard, sending him reeling against the parapet.

Shocked and bewildered, Murari stands holding his palm against his cheek.

Apu goes in, shuts the door, panting, then falls on the bed and lies staring at the wall, dry-eyed.

Apu lies in the bed with a blank look in his eyes.

Apu still lies in bed, a day's growth of beard on his cheek.

The woman from the first-floor flat comes into the room, carrying some food for him.

WOMAN: Only the other day we met near the tap. She said, 'Aunty, I'm leaving him in your care. He's so forgetful, engrossed in his

writing all the time. He'll probably never remember to eat after coming home from work.' Such gentle ways she had, and so good-natured. (*She wipes a tear.*) She came just the other day, and now she is—well, it's a good thing the child was saved. Everyone has his share of sorrow and suffering, my son. A man mustn't break down in this way. And you're still young. As the saying goes—'As long as Krishna has his knot of hair and his flute, there'll always be women to serve him.' Why one? You can marry ten of them, my son. You've nothing to worry about.

She puts the plate of food on a chair beside the bed. When she leaves, Apu rises from the bed with an effort.

He stands holding on to the wall, staring at his reflection in the mirror. The whistle of an engine is heard. He frowns and turns away from the mirror.

Apu stands beside the railway tracks as a train approaches. A veil of smoke drifts towards him as he lowers his eyes in despair, unable to take the final plunge.

A loud, screeching sound breaks into his thoughts and he turns, startled, to see people from the slums running towards the tracks. The train rushes past, leaving behind a dead pig on the tracks.

The men from the slums pick up the pig. Apu still stands with his head bowed as the train goes past him.

9

Apu writes a letter to Pulu.

THE LETTER: Dear Pulu, You must have heard the news by now. I hear you are going abroad. I wish you all success. I am going away too. I don't know where, but I know why. I want to be free. I am taking the manuscript with me. I shall send it to you if I

ever finish it. You may publish it if you still like it enough. Yours, Apu.

Apu sits in a moving train near the window. The train rushes away.

In Aparna's home, the baby sleeps in a cradle. Aparna's mother sits nearby, sobbing as she sews.

Apu stands on the seashore. The waves crash on the beach, obliterating his footprints on the sand.

We see Apu once again standing near the sea, looking out towards the horizon, with the sound of sea birds and the noise of crashing waves in the background. But he has changed. With a full beard, he looks older, more solemn.

Now he walks alone in a pine forest up in the hills, looking around, listening to the sounds of the forest, stopping to feel a fern.

Now he stands on the crest of the hill as the dawn spreads across the sky. Apu sits down on a rock to watch the sunrise. He takes his cloth bag off his shoulder, turns to look at it, then takes out the pages of the manuscript.

He lets the wind sweep away the pages from his hand. They drift down the hillside as he stands staring in front of him.

10

Aparna's home in Khulna, near the river. A little boy, Apu's son Kajal, in a striped pullover and wearing a horrid, toothy mask on his face, goes wandering through the trees, with a sling shot in his hand. He aims the sling. Pulu stands watching him from the river bank, as Kajal walks over the grass to a dead bird. He lifts his mask from his face and inspects the bird, holding it by the leg.

Now he walks away with the dead bird, which dangles from a string tied round its leg.

An old woman sits frying fritters near a tree. Kajal goes behind the tree, and lowers the dead bird in front of the woman's nose. She screams and collapses from fright. Kajal drops the bird, picks up some fritters and runs away. The woman sits up gesturing wildly.

WOMAN: Look at him! Look what he has dropped here! (*Wailing*) He has spoilt all my food. Oh! Oh!

Kajal runs through a bamboo grove. A man walking down the path stops and turns, hearing the wails of the woman. He spies Kajal and goes after him.

MAN: I'll show you! So you have taken to stealing, eh?

He grabs the boy, but lets go of him immediately.

MAN: Oh! Oh! Oh! What a devil! He has bitten off my arm! Beast! Shall I tell the master? You know what'll happen then!

KAJAL: Will you tell Grandpa?

MAN: Won't I? You won't learn a lesson till you've been thrashed good and proper!

KAJAL: He's going to bash your head in.

MAN: What? What did you say? Bash my head in? Who will?

KAJAL: My father. He lives in Calcutta.

MAN: Huh! Father! Lives in Calcutta! So what? Should I hide away for fear of your father? We haven't seen the colour of his pigtail these last five years. Father indeed! And he'll bash my head in too! Huh!

KAJAL: Do fathers have pigtails?

Pulu's uncle sits on the veranda in front of the house. Pulu stands in front of him, back from his sojourn abroad.

UNCLE: Just think of it—not once in these last five years has he been to see his own son. Have you ever heard of such a thing? He thinks he has done his duty by sending a money order now and then.

PULU: Do you know where he is?

UNCLE: I was dead against this marriage. You and your aunt, the two of you took my daughter—

PULU: Do you know where Apu is?

UNCLE: Why? What good will it do?

PULU: Why don't you tell me ?

UNCLE: He's working in a colliery in Nagpur or some such place. The good-for-nothing vagabond! And the boy is just like him. Runs around all the time, planning mischief. The other day he broke my marble tumbler. As long as your aunt was here, she could handle him. Now it's too much for me with my failing health.

PULU: Do you have Apu's address?

UNCLE: Whatever is there on his letter. But what will you do with his address? You think you will persuade him to return? Even his child couldn't bring him back. The heartless brute!

Kajal appears at the gate of the house. He puts his mask on again and jumps about. Pulu takes a step towards him, smiling. Then his smile fades and he looks away.

11

A hill path near a ropeway. Apu comes walking up the path, stopping to light a cigarette. A siren is heard. Apu adjusts his watch, then moves up the path to a wayside spring. He cups his hands to drink the spring water. As he rises and starts walking again, Pulu appears at the other end of the path. Slowly, hesitantly, and with caution, the two old friends move towards each other.

APU: You? When did you return?

PULU: I'd gone to my uncle in search of you.

APU: Oh.

PULU: What are you doing here?

APU: I have a job.

PULU: Since when?

APU: A year or so.

PULU: Did you have to come so far for a job?

APU: I didn't come here for a job.

PULU: Then?

APU: I just arrived here one day, on my wanderings.

PULU: And then?

APU: I had to think of filling my stomach.

PULU: Hmm. Have you been filling your stomach?

APU: More or less.

PULU: And other things? Your writing? That novel of yours?

APU: I threw it away.

PULU: What? Why?

APU: What's the point? Let's go.

They walk up the path together.

PULU: Are you planning to stay on here?

APU: No.

PULU: What then?

APU: I think I'll leave. I don't feel happy here.

PULU: Where will you go?

APU: Somewhere. Out of this country. I'm saving up.

PULU: You will go alone?

APU: Who else is there?

PULU: Why, there's Kajal.

Above. In the gathering darkness, Murari brings Apu news of Aparna's death in childbirth. *Below.* 'It is because Kajal exists, that Aparna does not'—deeply shocked by the violence of his friend's emotions, Pulu stands, helpless, looking at Apu, unable to offer solace.

APU: Who?

PULU: Kajal.

APU: Kajal?

PULU: Your son.

APU: Oh. Is that what he is called?

He quickly moves away from Pulu, up the road.

PULU: Apu—! Apu! Listen to me!

APU: What is it?

PULU: Go back home.

APU (*turning away*): Why?

PULU: You have to bring up the boy. There's no one to look after him. Besides, you're his father. And there is something called duty. Or have you thrown that away as well, like your novel?

APU: Duty? Who says I haven't been doing my duty? Who's been sending money?

PULU: Is that all you can do?

APU: I can't do anything more.

Apu walks away again. Pulu follows him after a pause, running up to him.

PULU: Apu! What are you saying? Don't you have any feelings for your own son?

APU: No.

He moves away again. Pulu stands staring at him. Apu slows down, hesitates, then stops to talk to Pulu again.

APU: How can I have any feelings for him? I have never even seen him. To me he is unreal, untrue. For me he doesn't exist.

PULU (*shocked*): You are out of your mind! Well, I've done my duty. The rest is up to you. Goodbye.

APU (*agitated*): Pulu!

PULU: What is it?

APU: Come here a moment!

PULU: I have to catch the seven o'clock train.

APU: Come here, please!

PULU: What is it?

APU: Why don't you do something for the boy? Put him in a boarding school?

PULU: You can do that too.

APU: No!

PULU: Why not?

PULU: It's not possible for me.

PULU: Why isn't it possible? That's what I can't understand.

APU (*agitated*): There's one thing—that I can never forget—

Apu sits down and looks away. Pulu goes up to him. Agonized, Apu speaks with difficulty, close to tears.

APU: It is because Kajal exists, that Aparna does not.

Pulu is deeply shocked by the violence of his friend's emotions. He stands looking at Apu, unable to help him, unable to offer him the compassion that wells up within him in spite of himself. Apu sits imprisoned by the walls of his grief, alone, near a dried up, leafless tree on the hilly path.

APU: I have sent him money three times so far. If necessary, I can send more. More than that, I—I cannot take any responsibility. I admit that I have no love for him. If you think he is not being brought up properly, you make some arrangement for him. I'm willing to pay for it. Shall I give you some money now?

PULU: That won't help. I have to join work the day after tomorrow. At this point it won't be possible for me to do anything.

Pulu walks away. Apu suddenly finds himself facing all the pain that he has been running away from. He is bewildered, desperate. He rises,

and runs tearfully down the mountain path. But Pulu has left, and his voice echoes in the emptiness around him.

APU: Pulu! Pulu! Pulu!

12

Apu comes to Khulna. He stands waiting on the veranda outside the house till Pulu's uncle comes out to meet him. Apu still has his beard and the old man does not recognize him at first.

UNCLE: Who is it? What do you want?

APU (*touching his feet*): I am Apurba.

UNCLE: You've come to take your son away?

APU: I've made arrangements. I'll leave him in Nishchindipur. I'm going away.

UNCLE (*not looking at Apu*): He is in the bedroom upstairs. He had fever. He's better today.

The bedroom on the terrace. Kajal lies asleep on the bed with his mask next to him. Apu, looking at his sleeping child, turns away, disturbed by his vulnerability.

He goes and sits down on a chair near the window, waiting for Kajal to wake up. Through the window, a boatman's song floats in from the river, bringing with it memories. Apu rises from the chair and comes to the bed. He places his hand with great tenderness on Kajal's sleeping head. Kajal wakes up, turns and stares at Apu gravely.

APU (*with love and sorrow*): Kajal!

Kajal rolls off the bed and runs out of the door, and out of the house.

Apu turns and goes after him.

APU: Kajal! Kajal!

Above. Disturbed by the vulnerability of his little son Kajal, Apu sits by the window, waiting for him to wake up. *Below*. Kajal walks up to the old man, who raises his stick, ready to strike the boy.

13

Pulu's uncle comes out on the veranda and stands looking at them silently. Kajal runs out of the gate. Apu comes up to the gate and stops.

APU: Kajal! (*As if uttering a magic word*) I am your father!

Kajal stops and turns around, frowning, still poised for flight.

APU: I am your father!

Pulu's uncle comes up to the gate, near Apu. Kajal picks up a stone and flings it at Apu, who ducks, startled. The stone flies past him.

UNCLE: Kajal! Come here! Come here!

Kajal starts retracing his steps slowly. Apu, defeated, stands with his head bowed.

Kajal walks up to the old man, who raises his stick, ready to strike the boy.

Apu suddenly darts towards him, catching his arm in mid-air. Pulu's uncle glares at Apu, his hand shaking.

APU: What are you doing? You'll kill him!

The old man slowly brings down the stick and goes back towards the house. Apu stands looking at Kajal, who has been watching the scene with solemn interest. But he walks away again as Apu calls him.

APU: Kajal!

A toy engine moves across the floor. Kajal stops it with his toe. He is sitting near the door of the room on the terrace, playing with his kite. His mask lies on a chair. Apu stands with the empty box which held the toy, waiting expectantly for some response from his son. He smiles at Kajal as the boy looks up at him gravely, silently. He picks up the toy and throws it at Apu with a vehemence that startles him.

At night, Apu lies beside his son on the bed, still trying to win him over. Kajal lies turned away from his father, staring in front of him, rejecting every small gesture of affection.

APU: Kajal, will you make friends with me? I can tell very good stories. Ghost stories, stories of demons, kings and queens, of princes and winged horses.

14

In the morning, Apu hands over to the old man the jewellery that Aparna had left behind with him. He is leaving once again, without his son.

APU: I would like you to keep these ornaments, in case Kajal has to be sent to a boarding school. I'll try talking to Pulu once more. In the meanwhile, you'll have to bear with his company for a few days. (*He touches the old man's feet.*) Goodbye.

UNCLE: You are his father. Don't you have the right to take him away by force? He's only a child. Why don't you insist on taking him with you?

APU: No. I can't do that.

He turns and walks away from the veranda.

UNCLE: Huh! You can do nothing. I knew that all along. You can do nothing!

Apu walks down the path by the river. He turns and finds Kajal standing near the house, watching him. He hesitates, starts walking away, then cannot resist looking back once more. Kajal still stands near the house with his hands in his pockets, looking gravely at Apu. Apu retraces his steps, but stops before he is too close to the boy.

APU: What do you want, Kajal? Do you wish to say something?

KAJAL: Where are you going?

APU: Will you come with me ?

KAJAL: Will you go to Calcutta?

APU: If I do, will you come?

KAJAL: Will you take me to my father?

APU (*smiles*): Of course I will.

KAJAL: Will my father be cross with me?

APU: Why should he, Kajal?

KAJAL (*looking away*): He won't leave me and go away?

APU: Never!

KAJAL: Who are you?

APU: Your—friend. Will you come with me?

Pulu's uncle comes round the corner of the house, looking for Kajal.

UNCLE: Kajal! Kajal!

Kajal turns to look at his grandfather. Apu smiles at Kajal.

APU (*conspiratorially*): Kajal! Come away! (*Kajal turns back to him.*) Come! Come away!

KAJAL: Grandpa will scold me.

Apu looks animated, full of hope. He has almost won his battle.

APU: Grandpa won't know. I won't tell him. Come!

Kajal looks up at Apu, then smiles as he moves towards him.

Apu stands near the river. He stretches out his arms and swings up Kajal as he runs up to his father.

The old man stands watching them from a distance. He smiles, lowers his head and turns to go.

An old, familiar tune sweeps across the forgotten paths of Apu's mind, as he walks along the river, smiling, his son perched on his shoulder.

SATYAJIT RAY

in Conversation with Shyam Benegal

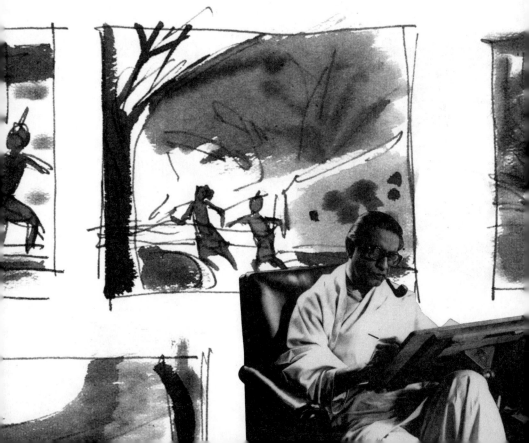

DISSOLVE 20

Ray, relaxing in a comfortable chair, one leg above the knee of the other, with a bookcase behind him, and an open window at left, both only partly visible. Shyam Benegal, back to camera, interviewing Ray. Ray is dressed in an off-white kurta and white pyjamas, sandals, and a shawl wrapped around him. The camera zooms to him slowly as he speaks.

Memories and Influences

RAY: I was born in a place called Gadpar Road, in a printing press actually. In fact, it was a huge building which housed the printing and blockmaking departments which my grandfather had started, called U. Roy and Sons. I was born there in 1921, and I spent the first six years of my life in that place.

I think the most vivid memory is of the printing press and block-making department because I used to spend my afternoons there in the department of the compositors. I would just walk in . . . And there was the process camera which used to fascinate me a great deal. Then I would take little drawings with me . . . doodles, and tell the blockmaking department chaps to make a block of them for the *Sandesh*. They would always say, yes, it will come out next month, but they never did.

That really is the dominant memory, and the smell of turpentine which I had forgotten, but I smelt it again when I went to a press when I was in advertising, and immediately all the memories of Gadpar came rushing back.

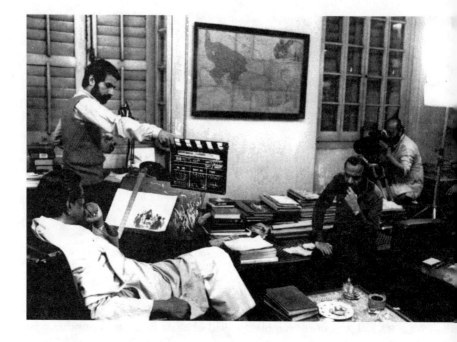

I didn't actually have any brothers or cousins or anything, but there was a servant's son . . . They used to fly the kite every afternoon from the roof and we have this puja, you know, the Vishwakarma, on which particular day the sky is just full of kites. I never saw my grandfather because he died five or six years before I was born and my father fell ill almost about the same time that I was born, and he was in bed most of the time for about two and a half years. He had Kala-azar, and he died in 1923. I was two and a half then. Another three years I think we stayed in Gadpar Road in north Calcutta. Then the business folded up for reasons which I never found out. My mother and I moved to my maternal uncle's house towards south Calcutta, Bhowanipur. My mother and I were staying there. I remember her as always working. She was a very hard worker. She used to do embroidery, clay modelling, drawings, sewing, and she had learnt leatherwork also at one time. She used to keep herself busy, and in

the afternoons I would watch her always doing this and that, all kinds of things, and I did a lot of sketching also at that time.

I was studying at home. My mother taught me whatever I had to learn. I was very close to my mother, this much I can remember. She taught me history, geography, arithmetic, English and Bengali, in the early days, but she was very particular that I should be sent to a good school and eventually to a good college so I had the best of education.

She herself took a job later in a widows' home, and she was teaching, and we used to spend very exciting holidays in hill stations in Bihar, and we spent a long holiday in Darjeeling . . . the first sight of Kanchanjungha was really just unforgettable, that I remember very, very well. At six o'clock in the morning my mother woke me up and said, Come and have a look, and I stood at the window, and there were the snows, red, pink, with the sunlight, with the snow catching the sunlight . . . and the first sight of the sea at Puri was very exciting also. So these are the memories that come back to me and then my uncle's first motor car, our trip to the maidan every afternoon and around the Victoria Memorial, and then at the age of nine I started going to school. It was called the Ballygunge Government High School. Did turn out to be a very good school.

It would be 1930 when I joined school and I was interested in games—quite a bit more as an observer. I was very interested in football and cricket and there were cricketers in the family. The leading Bengali cricketer was an uncle of mine.

Even before my grandfather brought out his children's magazine, he had done abridgements for children of the Mahabharata and the Ramayana, and another collection of stories from the Mahabharata, which do not directly relate to the Pandavas and the Kauravas. You know that there are lots of stories within stories and they were already very famous. They were among the first abridgements for children and they have not been improved upon since.

And he was quite close to the Tagore family because they had the same kind of activities. In fact the Tagores had brought out one of the first children's magazines long before *Sandesh*, and he was writing for that also, and he was a friend of Abanindranath who was a painter, because there was this common interest and Rabindranath who was about the same age as my grandfather. They were very close to each other particularly because my grandfather would often go to Tagore's house in Jorasanko in Calcutta to play the violin during the Magh Festival of the Brahmos. They have the Maghotsava as it is called, and he was needed to play the violin along with the chorus and the solos. So he was very close to them.

But around 1912–13 he felt that he had to bring out his own magazine. By that time the printing press was well established and you can see from the first year or two of *Sandesh* .that the quality of printing was extraordinarily high. But soon after that my grandfather died, and my father took over. He was also a very extraordinary writer and illustrator. He was not as professional as my grandfather, but he had certain unique qualities, like the drawings he did for his nonsense rhymes or the funny stories that he wrote. He had an absolutely unique style of doing comic illustrations which nobody else has shown in India.

I remember songs and singing a great deal, because my mother used to sing very well and my aunt was quite a celebrated singer. She used to make records for HMV and I remember very vividly my trips to the HMV—the Gramophone Company—studios, and the first recording session which I attended. I think I was about six and a half or seven at that time. That was before the electrical recording days. They used to have to sing in front of a horn. And they were all English engineers, that I remember very well.

For some mysterious reason there were some records of classical music in our house although nobody was really interested—Western Classical music. There was one movement of Beethoven's violin concerto. They were the usual things, which I think even the Bengalis

bought then, violin records by Chrysler, songs by Chaliapin, and things like that. Every well-to-do or upper class Bengali or middle class house had some records of Western music. Violin was very popular as an instrument, so there would be records of Chrysler playing odd pieces.

Sketching, painting, drawing, I had it at the back of my mind, while I was in college or even late school, that I would be a professional artist doing perhaps some kind of commercial art, but I had no training for that.

When the time came for me to decide what subjects I should specialize in, a very close friend of my father's who was a statistician—Professor Mahalanobis—he said, 'You should study Economics, because I have a magazine, a statistical magazine called *Sankhya*. You can always get a job there for two hundred and fifty rupees a month or something.' I was not terribly interested in Economics really, and I think my two years as a student of the BA class was more or less wasted. I lost interest in college, because it was not really for me. I had to study, I passed, I got an honours in Economics, but it was not really my subject.

But then my mother suggested, and I also agreed rather readily, that I should go to Santiniketan and spend some time there. Tagore was still living and they had some marvellous teachers like Nandalal Bose and Benodebihari Mukherjee, Ramkinkar Baij, and she thought it would be a good thing to be in Santiniketan in proximity to Tagore.

BENGAL: When would you say you had your first exposure to art, the art of the world, not just Indian art or music?

RAY: Well, I would say it all happened at Santiniketan, within the three years that I was there. We had a magnificent library, and I had a couple of friends. One is now a celebrated Professor of Indian art in Hawaii. We became very close friends, and he had a fantastic knowledge of art—world art—and great perception and sensitivity. So I came under

his influence at that time. As a student of painting he had as much to teach me as the professors of Santiniketan really.

I had some reservations about Indian art. The wishy-washy kind of rather sentimental stuff which used to come out in Ramananda Chatterjee's magazines, *Modern Review* and *Prabasi*, at that time. Every month there was a colour reproduction, and I didn't very much care for those, but I found eventually, after joining Santiniketan, that Indian art could also be very strong and virile, and it's not all that sentimental or Victorian kind of stuff.

I studied painting in Santiniketan but never meant to become a painter. I needed the background of Indian classical art perhaps to be able to use it in commercial art later. So I got to know about Eastern art, Chinese, Japanese, our own schools, and also Western art, I mean, starting from early Egyptian, cave paintings, rock paintings, down to the Post-Impressionists, or even the later ones.

BENEGAL: When you came to Calcutta looking for a job did you find it very difficult?

RAY: No, actually I found one very easily. It so happened that there was somebody who knew the Assistant Manager of D J Keymer and Company who was a Bengali, and it turned out that we had known the family. I knew his brother, sister; my wife knew the family very well, so this old chap took me to Mr D K Gupta, who eventually founded Signet Press, and I began almost as an apprentice, actually a Junior Visualizer.

I was getting sixty-five rupees a month, a dearness allowance of fifteen rupees, and I was learning visualizing and typography and layouts, and there was a lot of illustration in those days, not like now when you have mostly photographs. Illustrators were actually needed in those days. There was a lot of hand-drawn illustrations, not photography, not models so much. Very few in those days actually.

BENEGAL: There was a lot of typographical work done by hand?

RAY: Also. Yes, yes indeed, because we didn't have a very wide range of types in those days . . . So that is what I was doing, and I think there was a series which came later. It was a series for Paludrine—enormous ads, just an illustration of various classes of people in Calcutta, the lower middle class, the middle class, even Englishmen. I think there was a series of six advertisements showing in great detail the interior of the houses. The idea was to take a Paludrine every Sunday morning, so somebody was taking a Paludrine or distributing a Paludrine. There were children around—filmic, very, very filmic.

What I was getting slightly fed up with was having to deal with the clients. Awful! You had very few enlightened clients actually . . . very demeaning, and I was really getting very tired of advertising, and I wanted to be absolutely free as an artist.

BENEGAL: And your interest in the cinema. When did that start?

RAY: Well, it's very hard to say when it started, because I remember being a film fan as a very small boy, and even early in the school years, I used to buy magazines like *Picturegoer*, *Photoplay*, and *Film Pictorial*, and I had my own star rating system. I used to keep notes of the films I would see, and give them ratings, my own sort of ratings in stars. So it started as a kind of interest in film stars, and then the films along with the stars. But the interest in the directors came later, I think in the early days of college I became more and more interested in this directorial aspect of filmmaking. I became aware of the director . . . I became conscious of the cinema bearing the stamp of its own maker. And I was reading up on people like John Ford and Ernst Lubitsch, William Wyler and Frank Capra, and looking for their speciality in the film, their sort of special characteristics.

Then again things happened in Santiniketan, where I was helped by the fact that there were in the library, which consisted mainly of books on art and painting, some film books. You know, the standard film books—like Pudovkin' s *Acting and Film Technique*, and Rotha's *Film Till Now*. Those two or three books I read again and again. That

made me conscious of cinema as an art form, the narrative styles that one uses—terms like close-ups and long shots, trolleying, and cuts and fades and what not, and dissolves.

BENEGAL: Were you fond of certain kinds of films?

RAY: Well, I think when we were very young, we were allowed to see a certain kind of films, because our parents and elders usually told us what we should see. So in the very early days it was things like *Robin Hood* and *The Count of Monte Cristo*, and that sort of thing. Later on, I think when I was nine or ten, in the early days of sound, mind you, that would be the thirties, the very early thirties, I remember seeing the early Lubitsches, nearly all of them, with Maurice Chevalier, you remember, and Janet Macdonald, *Love Parade*, *Smiling Lieutenant*, and all those Lubitsch films I remember exceedingly well. So they must have made a very strong impression. Not the stars so much as the way of telling the story, the witty kind of things that Lubitsch was doing all the time.

BENEGAL: What about Westerns?

RAY: Westerns, yes, but not to the same extent. When I really got interested in Westerns, I was already very seriously interested in cinema, and so I was looking for John Ford and William Wyler and things like that. I saw whatever John Ford films I could get to see and then, even later, the early forties or late thirties, Hollywood comedies and the Hollywood thriller, very hard-edged films like the Billy Wilder of the early forties—*Double Indemnity*, *Lost Weekend*—and comedies like *Major and Minor*, Lee McCarey's comedies with Cary Grant and Irene Dunne, which were very fine, and I have re-seen them on television, and they are still marvellous, and the Frank Capra films of the thirties like *It Happened One Night* and *Mr Smith Goes to Washington* and all the others.

They were very, very well crafted films, so my education really is based on these extremely well-written, well-directed, well-shot,

well-acted films of the thirties and forties. I got to know the American films made by French directors, who had left France and settled in Hollywood like Duvivier, Renoir himself and a few others, and the Germans like Fritz Lang and others who were making American films—making them in a very German sort of way.

The same goes for the French films, for instance for Renoir's first film that I saw—*The Southerner*. It's an American story in an American film made by a French director, acted by Americans, but looking completely different from the American films. It was more French. I mean one could certainly recognize a completely new approach, a narrative approach, a new style of filmmaking from looking at these American films made by a French director. So when Renoir came here, I was familiar with his French-American films like *The Southerner*, the various other things he made *The Diary of a Chambermaid, This Land is Mine*. But I didn't know his French films as yet.

But in Santiniketan I was away, cut off from films. I remember that *Citizen Kane* came and went in Calcutta and I was away in Santiniketan. It was a great regret that I was not in Calcutta when *Citizen Kane* was shown but I made up for the lack of opportunity to see films by reading on the cinema as an art form.

BENEGAL: What about Indian films? Bengali and Hindi films?

RAY: No, really. I think we avoided them as much as possible. Well, there were relations working in the cinema. I had an uncle who was one of the major directors, Nitin Bose at New Theatres. His brother, Mukul Bose, was the audiographer or the sound recordist, as they say. They were both very talented, particularly from the technical point of view. So we inevitably saw their films in those days, and I could see that they were well photographed and that the sound recording was of a high calibre. But I was never interested in the stories or the way they were told. It was a strange concoction. They seemed to stick to a formula even in those days. So I wasn't looking at the Indian films really for any kind of real edification or education.

They were there, they had to be seen occasionally, but the real interest was in foreign films. And foreign films usually meant American films in those days.

BENEGAL: Were you aware of the work Prabhat was doing, for instance?

RAY: Not really, not before we started our film society. I knew there was somebody called Shantaram, and there was a Prabhat Studio, and they were turning out big films, ambitious films. But it was only after we formed the film club that we deliberately got films from the Prabhat period and showed them to the members, and we were impressed by them. Some of them, and *Ramshastri* in particular, I remember. I don't know whether that was a Prabhat film but that was certainly one of the Marathi films that seemed like a very serious effort, and impressive.

BENEGAL: What motivated you to start the Calcutta Film Society?

RAY: Aw, just that it was a big thing in Europe. I think I found a lot of young people who shared my interest in the cinema. And it just came up one evening while we were sitting and chatting—'Why don't we start a film society'—there were Chidananda Dasgupta and three or four others—and it was 'OK, let's get going.' That's how it happened. When it did happen we were all very serious. We started a library of film books, we had seminars and discussions. When Renoir came to Calcutta to shoot *The River*, we invited him, and he gave a talk. Verrier Elwin gave a talk. Soon after we formed the film society in 1947, we were lucky to have some celebrated filmmakers and film actors arriving in Calcutta from abroad. Pudovkin and Cherkasov came as part of a delegation. They came with some films, and they gave talks. We also had showings of films like *Ivan the Terrible* and some of the early Pudovkin classics. We were quite active in the early days.

BENEGAL: When did you first get to know films other than American films?

RAY: When I went to London, in 1950.

BENEGAL: What was the impact of that when you first saw . . . ?

RAY: Oh, that was fantastic. Actually I had gone to work in the head office of my British advertising agency. But my wife and I immediately became, as soon as we arrived, members of the London film club. They had a Marx Brothers season on. And we were living at Hampstead close to Everyman's Cinema which was a sort of a permanent film festival. And so in the space of four and a half months we saw something like a hundred films. The Neo-Realists had just come up, you know. *The Bicycle Thieves*. Italian films, French films, German films, we were seeing all, we were just lapping them up.

Coming to Filmmaking

BENEGAL: Mr Ray, why did you start making films and what made you start making films?

RAY: I was, as you know, in advertising even when I made *Pather Panchali*, I still had my job. But I was deeply involved, not in the making of films, but in the study of films, with the film club, being an avid moviegoer, and I was reading a lot on cinema, all aspects of it, and I was getting a little tired of advertising as a profession, and the ethics of advertising. The fact that you had to contend with clients and all that didn't make me very happy, till there came a point where I decided that I'll try and change my profession. But I couldn't afford to leave my profession at the time when I made my first film, because part of my salary went into the making of the film, so that I was shooting over weekends and holidays.

BENEGAL: But why film? Weren't you a painter?

RAY: Yes, I was a painter, but cinema seemed a far more exciting kind of medium. Cinema, not painting, was really my first love. I never called myself a painter. I was taught as a painter in Santiniketan, where I studied fine arts, but then I went into advertising art, and got involved with a publisher, doing book jackets and photography. But the first interest was cinema all along.

Nobody thought that cinema was a very secure profession or much good for making money. No, it was not that certainly. Films were something to enjoy, not something to make myself. So there was no question of that at all. In fact that came very much, much much later. Even when we were running the film society we were anxious to study films, not to make them, but to understand them, that was the situation, and even the first time I got involved or was about to get involved in a film it was as a scriptwriter.

You know, one of my hobbies was taking up a story which has been sold for filming to somebody else, to do my own treatment and compare it with the treatment on the screen. At one time Jyotirmoy Ray was making a film, and he offered me the job of the art director, which didn't happen eventually, and then when we decided to do Tagore's *Ghare Bairey* I was to be the screenwriter. I had a contract as a screenwriter with a certain producer, and my friend, Hari Sadhan Dasgupta, was supposed to be the director. It was only after I decided on *Pather Panchali* after reading the book when I illustrated it that the idea of turning that into a film and directing it myself occurred.

So that was that. I mean it had to be a choice of a subject and it just so happened that I knew this best and I wanted to handle children—I thought I had it in me to do so—and this business of the rural countryside which we knew quite well because my art director Bansi, who was then not an art director but a friend of mine, and I used to go on weekends into the villages. Just take a train and get off anywhere.

BENEGAL: When you started making films, Mr Ray, did you feel anything . . . did you have a view about the state of cinema in India?

RAY: Well, we were certainly very strongly critical of the Bengali films of that period. In fact, that's one of the things that we did at the film society. We were studying foreign films—we were having seminars on the Indian cinema of that period. We were always strongly critical. We found most of our stuff very false, unrealistic and shoddy, commercial in a bad way. That sort of thing. They were very theatrical.

The First Film

BENEGAL: But when you decided to make a film, how did you go about writing a script for it?

RAY: I really started as a scriptwriter with my second film when I had more confidence. What I did for my first film was . . . you see, I had to go from door to door to various distributors and producers to tell them the story in order to interest them so that they would put up the money. I did a book of drawings of the film, of frames. Fairly elaborately done in wash, black and white, and I would tell them the story and at the same time show them the drawings, and this is what I had, even when I started the film.

The actors would be given their lines a week before shooting, and we had discussions with the crew, with my assistants, with the cameraman, so we knew the set-ups more or less and we knew the trend of the story—we knew the structure of the story. For *Pather Panchali*, there was no, really no, script as such. There were notes and things like that. I had it all in my head. I mean there were notes for dialogue. Most of the dialogue came from the book. I didn't know how to write dialogue. I didn't have any confidence as a dialogue writer at that point. But fortunately Bibhutibhushan wrote very life-like dialogue.

BENEGAL: One might say that there is a Satyajit Ray style of film-making, but when you look at *Pather Panchali*, for instance in the use of lenses, sometimes it appears that there is a certain arbitrariness, in the way the lenses have been used.

RAY: Oh, certainly, that's possible, because that's one of the hardest things to learn, which lens to use at which point. And then they didn't always have the lenses we would like to have. You know we were using three different cameras in the films. There's a Mitchell, an old Mitchell, there's an Eyemo used, and there's a Wall camera used, so whatever was available for hire, we were using, and they didn't always come with the right lenses, so that didn't leave us much of a choice.

BENEGAL: But what about pacing, for instance? If you don't write a detailed script or even a treatment, how would you get an indication of how you are going to pace?

RAY: Well, if you have it fairly clearly in your head, I suppose that's enough. You shoot according to what is in your head rather than what is on paper.

BENEGAL: Yes.

RAY : Because the unit, the crew members, get to know what the story is, how the story goes, etc. But at that point since we were shooting maybe only four to five days a month, sometimes not even that, there was a six months' gap, and there was no shooting, and no money, so that was all right. There was no compulsion to write a script. But we had all the time in the world to shoot the film.

In fact, we learnt filmmaking through the process of making *Pather Panchali*. We knew nothing. We were most of us new, and in fact the editor was also comparatively new. He had probably cut only one film before that, and in the final cut, at the time of final cutting, we were rushed. There's no question about that, so we might have done unorthodox things without realizing it.

That's because the final cut was done over a period of ten days and ten nights, working all the time, because we had a deadline to catch.

BENEGAL: But you did have, even if *Pather Panchali* was your first film, quite a remarkable control, particularly with the climactic moment when the husband Harihar comes back—that was such a sophisticated thing.

RAY: We shot the film in sequence, starting with the early part and going on chronologically, yes. . . so the early parts show a lot of rough edges, in the cutting, in the shooting, in acting, in everything, whereas I knew that all the difficult parts came in the second half, starting with the old woman's death, and then reaching a climax with Durga's death and Harihar's arrival, the father's arrival, and the very end of the film, so by that time we had learnt a little. And don't forget that it took us two years and a half to make the film, which means that we probably had some shooting one year and we had four to five months to think about it, to look at the rushes, to judge, to find out the mistakes, and not to make the same mistakes again, so it was like that. . . I feel that the second half is distinctly better made than the first half. You can see it.

BENEGAL: You set a certain kind of photographic style when you made your first film, because Indian films used to rely a great deal on what one might call a manufactured kind of feel and look, which was highly cosmetic, and did a great deal for the main actors, you know, to make them look good, and so on, and you changed it. Was there a very conscious attempt on your part?

RAY: It was very, very conscious. It was something I discussed with my cameraman right at the start of the shooting. We were both great admirers of Cartier-Bresson. And we believed in available light, the source of the light, for photography, I mean maintaining the sources as far as possible and for the day scenes, unless there was sunlight. Well, for location, you chose certain times of the day to shoot certain

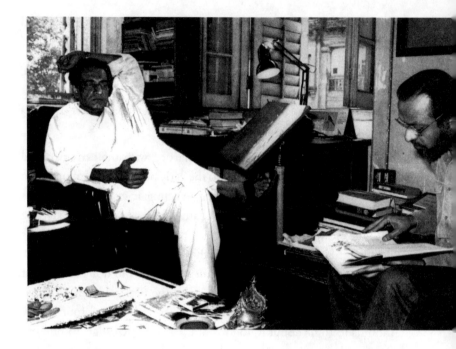

scenes. In fact, before we started we discussed this with a lot of film people, and they said, you can't shoot in the rain, you can't shoot on a dull day, you can't do this, you can't do that. So we made some experiments with 16mm camera shooting, and all kinds of light conditions, and we found that everything came out. So we decided to do the realistic kind of photography.

But really the 'available light' problem showed up when we were shooting in the studio, because for the day scenes, for instance, the normal practice in those days was to use direct lights which would cast shadows all around, and I hated the idea of having characters move across a wall or something casting shadows, and the shadows moving at the same time. So we started using bounce lights, not so much in *Pather Panchali*, because in *Pather Panchali* the only day scenes were night scenes—only the studio scenes were night scenes—and that didn't involve available light or bounce lighting to that extent.

But in *Aparajito* for instance, in the house which was built in the studio, the house in which the family lived, and the only source of light there as in the usual Benaras houses was from above the courtyard, which was open and from where you could see the sky if you looked up, and we had a cloth stretched right across the top and the lights were bounced off the cloth there to suggest a kind of top source, a top indirect source, not the sunlight, but when using the sunlight as a source through a window or somewhere, we were using direct lights all the time.

The Apu Trilogy

BENEGAL: Mr Ray, in the Apu Trilogy there's a lot that appears by way of detail that is not used for information's sake but expresses much more. It expresses relationships between people, it expresses emotions at that particular time and so on. Now I can give you a few examples, say, from the little brass vessel that rolls into the water, when the old lady dies in *Pather Panchali* . . . In *Aparajito*, there are any number of these wonderful details; for example, when Harihar is ill and he tries to button up his shirt and his wife comes and pushes his hands away and starts to button up and then there is the tugging of the rope, you know, at the end of the bucket on the other end of the branch, and so on. Now you haven't used very much of that in films after that. Is there any particular reason?

RAY: Well, I think that the Trilogy stories needed details because from the narrative point of view there wasn't that kind of strength of appearance as you'd find in a normal screenplay. These are more sort of lifelike fragments, you know, so that they have to be made effective by means of details. Some of the details come from Bibhutibhushan Banerjee, some of them come from the European cinema which I admired—and I am very fond of details myself. I have been very conscious of details right from the beginning.

Details have been part of most of my films, but not perhaps to the extent they were used in the Trilogy. Bibhutibhushan himself was fond of details of that nature—he uses details like this often, very often, and in a very effective sort of way, which is very, very cinematic.

For instance, there's a situation in a story which has not been filmed, where you have—I'll tell you exactly, because this is very very filmic—you have this family, the father goes insane, and it's impossible to keep him at home, and the family decides to leave him somewhere else. So the son, the young boy, and the group of elders take this mad man, just take him a couple of miles away, and leave him behind a bush, push a packet of *bidis* in his hand and a cigarette, and a matchbox, and just leave him there, and the boy who feels for the father suddenly turns round on the way back, and finds smoke coming out from behind the bush. It's very very cinematic, because the mad man is smoking, you know, and that sort of thing is very cinematic, and it comes often from literature, and from Bibhutibhushan. I have used that kind of details often, so that I do not have to use words, spoken words, trying to be as expressive as possible through action, through objects, through details, things like that . . .

Sometimes you are left with no choice but to use a literary kind of symbol, as in *Jalsaghar* where the problem was that this character, this zamindar was the only one on the screen for minutes on end, there was no communication, no verbal communication with anybody. One could perhaps have used words on the soundtrack, but that again would have been even more literary, conveying his thoughts in a stream of consciousness kind of thing. One has to use it when you are left with no other choice but to use that kind of a literary device, which I'm not very fond of myself frankly. But at other times, I think, even after the Trilogy, even in films like *Charulata* and others you find details of this nature.

BENEGAL: But when you are already at the script stage, now with Bib-hutibhushan's novels, you've of course mentioned this, but when you're yourself working them out, does it happen at that scripting stage, or is it when you are actually starting to shoot that it might occur to you . . . ?

RAY: Well, very important details can be there at the script stage itself. But details of action as you suggest, for example, in *Aparajito*, where you have the father trying to button up his shirt, but being ill, the wife, you know, sort of does it for him . . . that sort of thing prob-ably often happens at the stage of filming, at the time of filming. You suddenly have an idea which will make a shot or a scene or an action more expressive, more telling . . . there is always room for improvi-sation of that nature during shooting.

BENEGAL: The Trilogy shows yet another quality which I don't believe was part of the Indian cinema at all until that time, which is that you don't use what one might call the automatically information scenes, scenes that are obligatory, that explain particular situations and so on. There are, I mean, very, very few scenes in the Trilogy where you might say that this is an information scene. In *Apur Sansar*, for instance, when your Apu is talking about his novel, you know, on the tracks, and when he starts to talk about the book he is going to write, which is really his autobiography, this is done with such economy. But in the later films sometimes you find those obligatory scenes, you know. There is direct information.

RAY: I think they arise out of the material, which you cannot help sometimes. Sometimes you have to use a conventional method, some-times you can do without them. I don't think it's that I don't find the methods which I used in *Apur Sansar* and the other Trilogy films use-ful any more, or that it's because of that, that I've stopped using them. It's just that I've been using different kinds, other kinds of material which demand other kinds of treatment.

BENEGAL: In *Apur Sansar* you had a much stronger narrative line than the first two parts of the Trilogy. It has a kind of movement—while the other two films have exceedingly short scenes put together, *Apur Sansar* has longer scenes. There is a story movement that is evident. How did it happen?

RAY: Well, for one thing it was difficult to find a clear narrative line in the first two parts. For another, by the time of *Apur Sansar* I had learnt to write a scenario and structure a film. In fact *Apur Sansar* is more me than the other films in the trilogy, although the main events, even in *Apur Sansar*, come from the book itself—like the death at childbirth, Apu leaving the son and then coming back and finding him again—all those sort of crucial points, the turning points, are there in the original book, but the structuring—for the structuring I used a lot of my own experience. It was a properly developed scenario.

BENEGAL: I see. There is another very interesting thing about the Trilogy. As it deals with a village and eventually with the city, it appears to be in some ways a kind of idealization of a certain way of life, a certain kind of living, it also sort of stresses that there is a certain kind of harmony accommodating a whole natural order of things.

RAY: That's very much Bibhutibhushan, and I wanted to stick to it. I wanted to stick to the philosophy of the book, to his attitude to life. That is very much Bibhutibhushan.

BENEGAL: Do you agree with that yourself?

RAY: I did agree. Certainly at that point it seemed right for the three films.

BENEGAL: You didn't wish to editorialize or comment on it in any of the three films?

RAY: No, not at that point. No, certainly not.

BENEGAL: There is another thing in the Trilogy. Apu growing up in this village, being part of that situation, and eventually breaking out of it, and that, you know, happens because of his Western education.

RAY: Yes. That is the point that he makes, and I felt that it was absolutely right, it had to be emphasized, it had to be kept, and also his growing up and away from his mother, which was strongly criticized in Bengal, as being wrong.

BENEGAL: But isn't there also a kind of confronting position arrived at on one level, if you look at it philosophically? There's the question of this whole natural order of things, with acceptance as way of life, and suddenly one person breaks out of it. And then it seems to be done so very painlessly. But do you yourself see it happening in the same way in life?

RAY: Well, perhaps not today to that extent. But don't forget that this deals with an earlier Bengal. The book came out in the 1930s, and Bibhutibhushan was talking about his own childhood and his own manhood eventually. So it was all very turn of the century, and I saw no sense in departing from Bibhutibhushan's conception of life.

BENEGAL: But do you yourself sort of feel comfortable with the sense of order you like in . . . ?

RAY: I did. I did at that point. It felt right. To me it felt right.

BENEGAL: Yes.

RAY: In the two stories, in the three films, there are pretty harsh, really harsh things—the death of the old woman, the death of the father, all those things that are shown there in a fair amount of brutal details.

BENEGAL: But don't you see that death is never there, and there is no sense of horror about death, for instance? It seems like you accepted this whole process. If you take the choice of subjects even after the Trilogy, what you have chosen always appear to relate somehow to an

attitude of accepting the natural order of things. Do you feel most comfortable with subjects of that kind when you make films?

RAY: I think it applies more to my early films than the later ones. I think I have changed directions, even if imperceptibly, over the years—occasionally, certainly. But I certainly felt very comfortable with the material which I got from Bibhutibhushan's two novels, and I had no doubts when making the Trilogy as to what I wanted to say, and how I said it, and how much it was all related to the original book. In fact, I was trying to stick very closely to the spirit of the two books, and I think, to a certain extent, I did succeed.

BENEGAL Was there a kind of autobiographical resonance in these films?

RAY: Well, not in *Pather Panchali* frankly, because I know hardly anything about village life. I was a city-born and city-bred person, and I didn't know the village at all till the age of thirty— twenty-five or thirty—but in the second part, the fact of Apu's adolescence and his mother being a widow—the mother and son relationship—that can have autobiographical elements in it certainly, because I was in a similar situation.

BENEGAL: Did you identify with Apu?

RAY: I suppose one does. One has to, particularly when you deal with a character through three films right from his childhood to adulthood. You do identify, otherwise there is no getting under the skin of the character.

BENEGAL: But tell me, did you plan it as a trilogy when you first started *Pather Panchali*?

RAY (*shaking his head*): Oh, no, no, no, no question of that. In fact, I couldn't see beyond just that one film at that point when I made *Pather Panchali*. It was only after the acceptance of *Pather Panchali* by the public in Calcutta itself, before it won prizes or anything, that I really

decided to give up advertising and get into filmmaking. When I looked for a second subject for a while, then it suddenly struck me, why not make another film about Apu? Well, there was this other book *Aparajito* left. I made it, and then, even then, even after making *Aparajito* I didn't have a trilogy in mind, because *Aparajito* was a failure at the box office. Since it was a failure I had to think of doing something completely different. I did a comedy that worked reasonably well, and then I did *Jalsaghar—The Music Room*, because even *Parash-pathar*, the comedy, wasn't such a success. So I was again in doubt about what kind of a film to make, and I decided to make a film about music and dancing, the conventional, the sort of formula that the Bengali public was used to, although in developing it, it became a completely different kind of film. It was not a light-hearted commercial sort of thing at all.

After *Aparajito* had won the prize at Venice, at the Press Conference I was asked whether I had a trilogy in mind, and I found myself saying, Yes.

BENEGAL: Did you ever think of adding another film to the trilogy?

RAY: No.

BENEGAL: With Apu as father?

RAY: No, not really. But in the third part of course he grows up. Then you have another Apu. No, another film would have been too much. This is right. In fact, he comes back to life at the end, which he doesn't in the book, where he again becomes vacant and goes on wandering, leaving Kajal alone. I thought it needed a positive ending after all the deaths and tragedies and separations and what not.

BENEGAL: There is a point of view that the film could easily have ended with his throwing away of the novel . . .

RAY: Oh, there!

BENEGAL: . . . you know when.

RAY: But I think one would have wanted to know what happened to the child. It was very necessary, it was obligatory to bring the child in, and bring the father back to the child, and have the father take the responsibility of bringing up the child. I think that was my view, and it was a long, long film if you conceive it in terms of one single unit, and then it needed that positive ending, a jubilant kind of ending.

Rabindranath Tagore

BENEGAL: After the Trilogy, after the Bibhutibhushan novels, you went on to Tagore.

RAY: Yes, I did. One of the reasons was that it was Tagore's centenary that year.

BENEGAL: But do you now feel that at that time that was the real reason?

RAY: Certainly. I was asked to make a documentary on Tagore, and I wanted to pay a sort of personal tribute. And I had been wanting to . . . I have always admired his short stories. Many of his short stories are not expandable. So I decided, why not make a package of three short stories, and keep them short, that was the idea. A personal tribute to Tagore, a sort of a centenary tribute.

BENEGAL: Then you made *Charulata*.

RAY: Not after that. That was three films after that.

BENEGAL: But do you identify with Tagore in any way?

RAY: Well, certainly. Some of his things, I do identify very strongly with. He was far ahead of his times. We looked up to him and we admired him—as a musician and as a writer of short stories. Some of his novels

too I greatly admired. *Charulata* is not a novel however, it's a short story really.

BENEGAL: The reason I ask you this question is that Tagore was a many-faceted personality, a Renaissance man. You have a great many interests yourself. You are interested in painting and music and cinema and literature. You do several things. Is that why you feel greatly at home with Tagore?

RAY: Well, I don't know. If you are talking about versatility, it runs in the family. My grandfather was a similar kind, a many-sided genius. He was painter, musician, poet, photographer, blockmaker, scientist, astronomer. So was my father, except that he died very young. In his short life, he wrote, he painted, and, well, he was very versatile, and I have never thought in terms of identifying with Tagore, except that we all—most Bengalis, educated Bengalis—admire him tremendously as a giant among Bengalis, a many-faceted genius.

BENEGAL: Yes, but wouldn't there be as one aspect of it an evaluation of Tagore from the contemporary sensibility?

RAY: Yes, it could happen maybe in turning his stories into films. I was not doing them slavishly, there was a considerable amount of bringing them up to date, in the sense that I myself as a filmmaker was viewing the stories from my contemporary point of view. All the stories, if you compare them with the originals, are considerably adapted, they are just not exact replicas of the originals.

After Charulata

BENEGAL: Mr Ray, in your work there seems to be certain distinct changes that have occurred particularly after *Charulata*. In the beginning, in most of the films that you handled there was a very distinct lyrical kind of approach that appeared to be missing in a couple of films in between which seem like aberrations, but it concludes with

Charulata, and then you have a different kind of sensibility starting to operate. What do you think is the reason for this?

RAY: One thing which I have tried to do is not to repeat myself thematically. I made the Trilogy, OK; but in between I had made a comedy, and I had made a film about the past, about a zamindar, and then again I have gone back to that from time to time. *Devi* was about the nineteenth century.

I think a director is fascinated not only by theme or subject matter, but also by certain visual aspects of a story. I'm interested in recreating the past in the visual aspect of opulence, for instance. That fascinates me very much. So I occasionally do that. And *Charulata* was certainly a culmination of that.

But after that I decided, perhaps it's difficult to recall the state of mind that prompts you to do certain things, I perhaps felt, maybe I came across certain contemporary stories by young writers which dealt with the contemporary local problems of Calcutta at that time, and I decided to, again for a change, to do some of those stories.

BENEGAL: Would you say that you knew that the environment was changing around you, and there was the effect of that on you?

RAY: Well, that . . . that did happen towards the end of the sixties.

BENEGAL: When did you start to feel being affected by your environment? At what stage in your life were you looking at life and relating to other people? Let us say, for instance, the problems of the city of Calcutta itself.

RAY: Well, as an illustrator—I was an illustrator before I was a filmmaker—as an illustrator, one has to be very observant, observing people's behaviour. When you illustrate, when you are a realistic kind of illustrator, which I was—I have also done a lot of stylized work but there was a lot of realistic illustration work which calls for a great deal of observation of people's behaviour, physical types, and

environment, and this and that, so that had already happened even during my advertising days.

BENEGAL: Now with *Sadgati*, you have a story, where you have taken a very strong stand. I mean the film comes through with a tremendous amount of power and strength, and you do see oppression of a particular kind in full force. It isn't the kind of your gentle, the more ironic look at things. Is this a kind of new trend you see in your own work?

RAY: If I had found a story like *Sadgati* earlier I would have certainly done it. It's just that the story called for that kind of treatment because that force, that anger is already there in the original story. And it seemed absolutely right for this particular story. It didn't need the softening of contours. I mean it had to be hard-edged. I really don't know, I haven't worked it out whether this is a sort of inner change in myself, a looking at things in a more harsh sort of way than in an oblique way. It's just that this style seemed absolutely right for *Sadgati*, and it's exactly how Premchand conceived the story. I've made almost no changes [to the story] except perhaps add a few scenes here and there.

I think there is anger when it is called for, or anger is needed, as you will probably find in my latest film. About the other thing, as you say, I have converted it into irony. It is something that came from a remark which my teacher, Nandalal Bose, made in Santiniketan. He once said—apropos what I have forgotten—he said, there are two kinds of people. One, the very angry people, who give vent to their anger. But he said, I feel the stronger person is the angry man who can control his anger, stronger than the person who gives vent to his anger. That struck me as an interesting remark. And irony has of course appealed to me all along, I think. Why, I can't say . . . perhaps because life itself is ironic, when you juxtapose it with death, you know.

BENEGAL: There is also another thing, about your children's films. Now you've said of course that they are children's films for everybody, that doesn't exclude adult characters . . . You have this special way with children. But when you deal with adult characters in children's films, they also seem to assume childlike qualities. Is this your own sort of ideal, in your way of looking at the world?

RAY: I don't think children's films call for child actors in them, they could well be about older people. Just as in *Goopy Gyne*, there are no children in *Goopy Gyne* at all, playing any leading part. There is *The Golden Fortress—Sonar Kella*—based on characters which I have created over the years, the detective and his young assistant and the original stories are all written from the point of view of this adolescent boy who is Watson to the Sherlock Holmes of Felu-da, played by Saumitra.

BENEGAL: So far it appears that you have a preference for older writers, most of whom have written in the early years of the century. Of course you have made films from Sunil Ganguly's stories and so on . . . but do you have any special preference for that period of writing or some reason why you have done this over a period of time?

RAY: But again I have to work this out to find out if it is true. I mean, I've done Tagore three or four times. I've done Bibhutibhushan . . . well, the Trilogy itself. . . that's three films from one writer, then again *Ashani Sanket*. But there are a whole series of films which are by comparatively young writers. All the contemporary city stories are by Sunil [Gangopadhyay], Shankar, or myself, I mean, *Kanchanjungha*.

When I write original screenplays like *Nayak* or *Kanchanjungha*, I like to write about people that I know at first hand, who belong to the world I am familiar with—the middle class of today, the urban middle class, shall we say. I couldn't write about workers in a factory . . . But I would like to make a film about workers in a factory. But for that I need material . . . I need a story for that, which I haven't found yet.

BENEGAL: Now you have, say, written material or a short story that you might use, and then in adapting it, how much of your own experience would you put into it, for instance, into the script before you make a film of it ?

RAY: Well, I can't talk about experience, for that—because, well . . . the change varies from film to film . . . you do make changes . . . I mean in adapting a story for a film, for instance in *Pather Panchali*, it involved just cutting out characters . . . three hundred, I once counted about three hundred characters in the segment which I have used for the film. In my film there are about thirty. You have to cut them out in a way that people are not aware of any essential things left out. But then with Tagore, for instance, some of the early short stories have a streak of sentimentality in them . . . a sort of Victorian attitude, and that I've had to change, to give it a more hard edge, a more contemporary kind of feeling. I had done that with the *Tin Kanya* stories, all of them.

And later, with the contemporary stories, from the younger writers, I have . . . the changes have been called for, because sometimes the main character has changed, because in the process of preparing the script I have noticed flaws in the development of characters, what had struck me as flaws in adapting them, and their characters had to be given a more sort of logical development which has brought about changes in the structure of the story itself. So that has happened. These are basically . . . and sometimes you worked towards the conclusion . . . there is not a satisfactory conclusion to the original story. You must have the feeling of doing the right thing in the right circumstances. And that comes from observation, your personal experience, although the story may be somebody else's. And there may be incidents which you have not experienced personally, directly. There is this thing like logic in a story which you . . . which makes your story ring true . . . whatever you make happen on the screen, you make ring true.

BENEGAL: You have always been an observer of, let's say, reality, if I might use the term, and whatever statements you have had to make have always been oblique.

RAY: By temperament, I think I am a filmmaker who likes to be oblique, if such a thing is possible or valid in relation to the subject.

BENEGAL: I have an elaborate question now. In your rural films you have a central character with a quality of innocence about him. But when you come to the urban films there suddenly appears to be a loss of such innocence. When I saw *Pratidwandi* for instance, it represented to me that loss of innocence, and then it is carried on in *Jana Aranya* and several other films you have made since and even before that. Is this your own world view? Is it your view that rural life is basically innocent and in urban life there is a process of a loss of innocence?

RAY: That would apply certainly to the films that I have made on rural life, except *Ashani Sanket*, where you have this brahman character who is in a way quite worldly wise, in a way quite clever and resourceful. But that's different from the city kind of resourcefulness or vanity or sophistication. And when I have dealt with urban characters they have mainly been the literate middle class or even the slightly upper class. So naturally it would be true to life to make them aware, that's all.

BENEGAL: But is it only awareness, for there also appears to be a breakdown somewhere of a whole set of moral values?

RAY: Yes, but that is because I've chosen that kind of a story to show a certain aspect of society, and that has been the theme of the films, particularly *Jana Aranya* or even *Seemabaddha* or *The Adversary*. So it had to be part of the film, had to be part of the attitude.

BENEGAL: But does that reflect your own view?

RAY: Obviously I was sympathetic to these views. Otherwise I wouldn't have made the films.

BENEGAL: But now when you proceed further—for instance, you mentioned how in the late sixties and early seventies you were passing through a process of revaluating and reassuring your attitude about your own environment—has that been continually reflected in your work, or in the way you think about films?

RAY: Up to a point, yes. As it has always been my method not to repeat myself, I have tried out new things and themes set in new milieus as I have not done before. But I have also this desire to go back to the world of earlier times, like for instance in my next film, *The Home and the World—Ghare Bairey* by Rabindranath, which is a political story with a political background, the first terrorist movement in 1905 over the partition of Bengal. I think it is interesting to be able to recreate an earlier period. That's an interest in itself, carrying out research on the period, on the furniture, on the dress, on the speech—this in itself is a preoccupation of mine.

BENEGAL: Then it must be more than nostalgia.

RAY: It's not nostalgia. I don't think it's nostalgia, it's taking up a sort of a challenge, like in *Shatranj ke Khiladi*. Well, it was interesting to grapple with this problem of showing something which happened in the middle of the nineteenth century, and to view it from perhaps a contemporary point of view, from an attitude. It is not just a straight re-creation from what's in the book. It is a re-creation filtered through my own personality which is, I think, a middle-of-the-twentieth-century personality.

BENEGAL: There is a criticism from some quarters that you have been a little too even-handed in *Shatranj* between the colonial masters and the Indians in the story. How do you react to that?

RAY: I don't agree with that. It's just that I felt it would be so easy to run down the colonial representative—it would have been an easy target, and I'm not interested in easy targets really. The point is made nevertheless, but it was necessary, it was interesting, I think, to show a colonial representative having his personal qualms about what he was supposed to be doing.

BENEGAL: The criticism, I think, is based on the assumption that for the colonized people, the only valid attitude is one where you would want to get rid of the colonial masters, and the critics make the point that in this kind of a situation the attitude appeared to be a bit even-handed.

RAY: Yes, but the ultimate point that the film was trying to make was that the two representatives of the Nawabi class were willing to carry on with their game of chess and not so anxious to get the colonialists out of their way. It was their non-involvement that was made responsible up to a certain extent for what happened. The annexation and the whole business of how the British were able to do what they did were because of certain traits in the Indian character itself.

Director to Director

BENEGAL: When you started making films you used to rely entirely on block lenses, and once the zoom came in, you never left the zoom. Any particular reason in that change of style?

RAY: I think we used the zoom for the first time in *Charulata*, and that was the time when I started operating the camera also. Formerly my cameraman would operate, but then I started using, operating myself, because I felt that looking through the Arriflex, that was the best position to watch the action from, and with the zoom—not that I used to zoom a great deal—but with the zoom—I think we were using the blimp zoom—I found it was very convenient in long

dialogue scenes to zoom occasionally very slightly for emphasis—which was not rehearsed, but improvised, let us say. While watching through the lens I felt at certain points that if I got a little closer or a little further away it would help, and this was almost like using the zoom as a substitute for tracking. But a very very slight zoom. At other points I occasionally used the zoom as a sort of flourish. It's hard to describe it without examples, but there is for instance a shot in *Charulata* which comes at the end of the first long sequence of Charu being alone, and establishing her loneliness, and the very last shot is where she watches her husband through the opera glasses, and then she, well, obviously arrives at some sort of conclusion, and the opera glasses come down like that, and there we zoom back immediately to a mid-shot from a close-up, and that ends this sequence. It is sort of a flourish as you put a flourish at the end of an article or a letter.

Then again, I felt, if I wanted to get very close to a character right up here, normally it would mean tracking on a dolly, bringing the camera right up to here, but it would be disturbing for the actors, and then with a zoom you could have the camera at a distance and then zoom in to a very big close-up.

This happened again in *Charulata* when Charu is on the swing and has her memories of her childhood and gradually, gradually very slowly I bring the zoom forward which couldn't be done with a dolly.

BENEGAL: We are aware of course that with the block lens the character and the environment have a certain kind of relationship which does not arbitrarily change. Once you use a zoom this tends to change because the perspective tends to get flashy.

RAY: Yes, it does actually. I would never or very seldom use a zoom as a substitute for a trolley. But for certain things, for instance, a man suddenly notices an object, which has a certain importance for him, and he reacts to it—and then we show the object—formerly we would dolly in if we wanted a certain emphasis. But obviously the

character is not walking towards the object but the object is being brought forward. So I thought the zoom would be more logical to use in those circumstances.

BENEGAL: I remember once reading somewhere about the way you locate. You know, say, you go shooting on a location, and when you build a set, there are some very distinct positions where you are likely to shoot from. That's how the set is designed. But when it comes to going on a location, there is, you have always said that, you know you cannot leave the familiar. There are two or three familiar positions that you are likely to take, and that's how the place gets located and recognized. I would like really for you to add something on that because I myself have learnt a great deal from it.

RAY: Well, I don't think that I was particularly aware of that when I made my first film. For instance, in *Pather Panchali*, we had this house with the courtyard, the old woman's house, the main part of the house, and the kitchen, and perhaps I should have stuck to certain specific positions in order for the geography to be clearer to the audience. But watching *Pather Panchali* today, I find that I haven't done that to that extent. So perhaps the audience takes a little longer to realize in which part or where the old woman's house is situated, where the kitchen is situated.

But on location I think you don't have to be, you can't afford to be so specific in your angles, because you change your angles. Sometimes the light dictates a change. Sometimes you discover new interesting angles which you didn't discover when for the first time you found the location. That happens during the shooting all the time, but with this in mind, you mustn't confuse the geography very much.

BENEGAL: I have another question which is of a technical nature. In *Sadgati* you have a rain sequence. Now since you always carefully work out your scripts and your scenes and so on well in advance—and particularly on location where not everything is likely to go right, what

happens when nature provides opportunities like this? What do you do?

RAY: Well, if it provides an opportunity which fits the story or may even improve the original, it would be accepted as an improvement on the original conception. For instance, in the scene which I think you refer to, where the *chamar's* wife comes to her husband's dead body, the rain was supposed to come much later. The rain was supposed to start at night, when the brahmans, husband and wife, can't make up their minds about what to do with the body. But since we had this downpour, this extraordinary downpour at the time of shooting during the day, we immediately decided: why not have the rain start earlier? We had to think immediately of what comes before and what comes after. There was a mental calculation which had to be done on the spot, and immediately we decided to use the rain. But of course there was the problem whether the rain would last that long. It did last that long, and there were three changes of set-up and other considerable preparations, for instance, laying long tracks and all that. We were just lucky that the rain lasted for something like three-quarters of an hour in which time we were able to take all those shots covering the entire scene. If we had not been able to do it, then we would probably have to re-shoot it without rain. It has just so happened several times in the past. We have had such weather or certain sudden changes in climate that at the moment I felt that this would enhance the scene or be usable for a certain scene, and I would use it. That needed very quick preparations and very quick working out how it fits into the scheme of things, what comes before and what comes after, whether it upsets the continuity or not.

BENEGAL: How much of a film of yours, once you've worked out the sequence or the sequences within the film, is improvised by way of breaking down shots, or . . . ?

RAY: Well, I seldom depart from the master plan. There's never getting away from the total structure which is very firmly in my head.

But within that structure there is a considerable lot of things that are improvised at the shooting stage . . . changes of angles, a little business, the dialogue for instance is constantly being pruned—I mean, I've written the dialogue, the actress has learnt the lines, but at the time of rehearsal perhaps I feel that I can prompt three words there or an entire sentence perhaps, and use it, just for instance . . .

BENEGAL: Oh no, what I meant was, for instance, in the change of angles.

RAY: Oh, yes.

BENEGAL: You might work out a different set of angles, you might break down a scene differently from what you had conceived on paper.

RAY: Yes, that also is done occasionally, particularly in scenes of dialogue where two or three persons are speaking. I have the alternatives to break it up, to take it in one shot, to break it up into overhead shots, and things like that. After the rehearsals, you often have ideas which you try to incorporate.

BENEGAL: Do you try to change in the editing stage?

RAY: In the editing stage I never look at the script. I look at the material of the shot, and I get ideas from that. They even lead to conclusions where you might want a new shot, perhaps you want to add something. But I never look at the script again. I only look at my shots.

Sound and Music

BENEGAL: Now before you came on the scene in the Indian cinema, certainly there never used to be what one might call an ambient sound, an effect outside of the synchronized effects. You started it. Now why did you do it? What led you to use sound like that?

RAY: I think in the use of sound, we were not being very original. We were doing what the best European cinema had done, which we admired very much. We didn't really learn from the Indian cinema. We learnt in fact what not to do rather than what to do. So we had the examples of the best cinema of the West, that is what we had in mind. With *Pather Panchali* as well as *Aparajito*, there was this question of filling long stretches of silence because both films had very little dialogue. Naturally we had to think of what to do there and all sorts of sound effects and music were used in order basically to fill those long stretches of silence and also at the same time for them to work as ambient sound.

BENEGAL: But didn't you suddenly come upon the idea that this could also be used creatively, because obviously. . . but after that . . .

RAY: Yes, yes, but both things came at the same time. I think you have to have both in mind, creatively, in the sense that you add to the atmosphere, you also suggest things which are not suggested by the dialogue or by the images. So that's another dimension to the film.

BENEGAL: When you started, your music was very different from the way it was being used in Indian films. You developed a very strong thematic score, you had a very strong thematic line running through-out the Trilogy, and you used music also in dramatic ways which were much more conventional, underlining emotional moments, anticip-ating, and so on. But over a period of time, you have given up the use of dramatic music, and you do use thematic lines, but often not even that.

RAY: Yes. Well, in the beginning, I had no confidence in myself as a composer. Of course I was very aware of music in films, and there were certain basic instructions always given to the composers I worked with, like having certain themes for certain situations or for entire films. *Pather Panchali* had such a theme which recurred seven or eight times in the film. Ravi Shankar had the theme in mind even

before he saw the film. He hummed it to me, I said it was marvellous and this would go very well with the film. It comes back at certain points, and gives it a unity, because, if you are using a new piece of music every time, it doesn't work, because the audience is also looking at the images, following the story, listening to the dialogue— and the music is lost generally if it's a new piece every time. So unless the piece of music recurs at least three or four times in a film one doesn't remember it, one doesn't know it, and one doesn't connect it with the film, and it doesn't become part of the film.

In the early films and also in the period films, we moved away from our own time, so they were on a slightly different level, and we had to have more music. Ali Akbar working on *Devi* or Ravi Shankar on the Trilogy, or Vilayat on *Jalsaghar* always provided me with quite an amount of music which was used in the films.

But later I took over composing myself because for one reason they were not available half the time, as they were on tours, and by that time I had acquired a certain degree of confidence as a composer myself; and in any case even at the beginning I was getting ideas of my own and it was often not very convenient to be dictating, telling them what to do. They had to be left there to their own devices to a certain extent. So music in the Trilogy takes a big part, and is, as you say, both incidental and dramatic, underlining certain emotions.

But this business of underlining—in fact the films of the thirties and the forties, the American films, that we admired in those days, were often drowned in music—I never liked it, you know. Some of the European directors making films in America opened my eyes to the other kind or use of music—like the first film of Jean Renoir that I saw, *The Southerner*, which had very little music, but had a rich sound-track. That I saw some time in 1944 or 1945. So that was the model for me. Music when it is a must, but again one uses it with the audience in mind, when you think perhaps they would not be able to get the meaning, the emotional content of the scene. So you underline it. That I have done. But the thematic music that gives the film unity,

that also is a very important element which I still keep using, when I'm using music. But sometimes they are just effects, or very close to effects, not necessarily melodic, linear melodic music.

BENEGAL: And you seem to be doing more of that now than . . .

RAY: Yes, I'm trying to be economical with music.

BENEGAL: Do you write your own scores?

RAY: Yes, I do.

BENEGAL: Wouldn't you be able now to use a composer for your films, where your ideas can be conveyed to him and he could work out a score?

RAY: Well, the ideas now would be in the nature of actual lines of melody with the orchestral colour and everything. So why? If one uses a composer one has to give him a certain degree of freedom, and there's always a possibility that he will provide me with something which I don't like. And then there will be clashes, and this and that.

BENEGAL: Yes.

RAY: So I have avoided that more or less.

BENEGAL: How did you come to music initially?

RAY: I was surrounded by music. Everybody on my mother's side could sing, all my aunts, all my uncles; my mother was an exceptional singer. It was mainly Rabindrasangeet, Tagore's songs, that I heard as a child, and the Brahmo Samaj songs—some of them are wonderful, really magnificent songs based on classical ragas, and those I remember very well. As I said, music was all around. Of course, I never heard my grandfather play the violin, but I'm told that he was exceptional. Music, I never studied. It was just with me all along. Towards the end of my school days, I became interested in Western Classical music. Some years later there was a gramophone club in

Calcutta, and we became members. By that time I had started buying miniature scores. There would be mainly Parsis really, and some foreigners who were still in town. There were very few Bengalis really. There was a Calcutta Symphony Orchestra. I started going to the concerts of this orchestra. Nirad Chaudhury was one of the few Bengalis who used to go to those concerts.

I took my collection of records with me to Santiniketan, where the one big advantage was that there was a Professor of English or Comparative Literature, a German Jew called Dr Aronson, and he had his own collection of records. We used to listen to music every evening in his house. He had his gramophone. And he played the piano. There was a piano in Uttarayan in Santiniketan—in the building where Tagore lived. Aronson lived in one of the smaller houses, but in the big house there was a piano, not very well tuned, but he used to go there and play the piano. I persuaded him to play the piano

for me, and I turned the pages for him. So that was one additional thing which made me familiar with Western notation. So throughout my Santiniketan days I was pursuing music, along with painting.

BENEGAL: But when you were in college did you find friends who shared your interests?

RAY: Well, there was one friend—yes, I did have one friend—who certainly shared my interest in music, and Western classical music. And he kept it up even after college—he was quite wealthy certainly, much more affluent than I was. He built up a huge collection of records quite early on, he could afford it. He had a very big radio, and used to listen to foreign broadcasts of music, particularly the German stations were very powerful. It was the Nazi year, and you could hear a lot of good music at the time

BENEGAL: Was there nobody at all besides him?

RAY: No, there was nobody, certainly not in the early stages. Later there were others. But in the early stages I was certainly very much alone, going to the record shops, just rummaging through their collection. Then there was a point when I found that there weren't that many records of classical music on the catalogue. I started corresponding with the Gramophone Company manager. He was an Englishman. Then I suggested they bring out regular issues of classical music in Calcutta, because there were people interested. Not that I knew very many who were interested, but I had to tell this little lie. Anyway he reacted very favourably, and I had in fact given him a list of classics which I felt would be right for Calcutta, and then they did manage to bring them out eventually.

BENEGAL: It was a kind of lone quest?

RAY: It was a lone quest, very much a lone quest. I started building up my collection of records. At first I could afford only one movement a month maybe, so it took about three months to build a

symphony or a concerto. But later on, when I had my job, it was a little easier on the finances.

BENEGAL: You have also done a great deal in the use of music in your films, because when you started there would be a thematic score, and there also used to be a lot of incidental music, which over a period of time you have not used. I mean, incidental music, particularly to underline, say, an emotional moment or a climactic moment—things like that. Have you thought of the way you have evolved in the use of music itself?

RAY: Well, in the beginning, of course, I was not my own composer. I was using other composers like Ravi Shankar and Vilayat Khan and Ali Akbar. I worked with them. . . but I always knew where the music would come, and this was . . . I had to tell the composers beforehand that these are the points where I needed music. And so that was done. And this, of course, led to some difficulties because I was getting musical ideas of my own at that time, and it was difficult to dictate to professionals . . . I mean, they were not professional film composers, they were virtuosos really. Ravi Shankar particularly was very gifted also in this direction because he had done ballet scores and all that. And that's how we worked and later, of course, I took over composing myself. Because, for one thing most of the time they were not available, and for another I felt that since I couldn't think of other composers to use (I didn't think there were very many good professional film composers), I started doing it myself. I have a piano, which I play, but I also hum and whistle a great deal.

I developed the habit of listening to Western classical music with a miniature score and that used to be my bedside reading. I would listen to a piece, a new symphony perhaps, with a score, and then go to bed with it, and going through it, the symphony would come back to me, and that's how I learnt Western notation. I mean I didn't learn consciously at that time, but when I decided to compose, I had to teach myself the Western notation, but later I discovered that most

of the musicians here know the Bengali notation only. But when there's a violinist who knows the Western notation, it is converted on the spot and given to him.

Of course, I am a composer only fifteen days of the year. The rest of the time, nothing—the piano is shut, it is not used at all. It gathers dust, that sort of thing.

But over the years of course I have come to the point where I use less and less music. Music is something which I always feel is, after a point, a dispensable element. One uses music more with the public in mind than anything else, because one is afraid that the public will not be able to get . . . the mood of a certain scene and you want to underline it so that they don't miss it. It is unfortunate, but you have to do it. I'm trying to be economical with music. There are other reasons for that too. We have lost most of our musicians. They have gone to Bombay now. So we have to be content with second-rate players mostly. So one has to be inventive and use simpler things.

BENEGAL: For instance, the Trilogy has one of the most beautiful thematic lines.

RAY: Oh, that! I have always believed in having leitmotifs which would reappear in a film from time to time to give it a sort of unity. For instance, the main theme of *Pather Panchali* was a brilliant invention of Ravi Shankar's. He had the theme in mind even before he saw the film.

BENEGAL: Your musical ideas are Indian, or Western, or . . .

RAY: No, it depends on the film really, because for a film like *Pather Panchali*, or perhaps any of the Trilogy films, it would have to be Indian to a large extent, but I have also tried fusions—fusions between Indian and Western idioms. This I do constantly in films that deal with contemporary Calcutta, for instance, which in itself is a kind of fusion . . . the lifestyle.

Editing

BENEGAL: As far as editing is concerned, do you keep to a fairly conventional scheme in the style of editing in your films? Haven't you felt the need, for instance, to break out of that? Didn't you feel the need particularly in your films that didn't have any strong narrative central line?

RAY: It's all a matter of telling the story in the best possible way. If I had a complex kind of a story, which I had in certain films like *Days and Nights in the Forest* (*Aranyer Dinratri*) and *Kanchanjungha*, which are not at all conventional films, because they don't deal with one central character whom you follow or identify with. They are about a family or group of people where the story line is not really conventional.

But I have tried to keep the editing scheme as simple as possible, because I have a message to communicate also, but there are points where even as early as *Aparajito*, there were fairly bold cuts.

In *Pratidwandi*, for instance, I used a lot of negative images, I think, in four or five different sequences ... and it was dictated by ... I can tell you why I did it. Because the film starts with the scene of the boy's father dying, and his dead body being brought down the staircase, put on the floor, being garlanded, etc. Now I feel that if I had the normal positive image, people would look for signs of life immediately and it would be very difficult to make a convincing dead man. So since I had used negative in the opening sequences, I found reasons for using it as part of the language of the film in three or four other sequences. So that is how that grew in that particular film.

But generally I would say that I am not interested in form to begin with, that I am interested in the subject, and what interests me is density, how much can you tell, how telling can you make your images, and how much can you pack into a film without using gimmicks, or whatever you wish to call them. Unconventional

photographic or editing techniques . . . that sort of thing does not interest me to that extent. I think formally there are films I have made like *Kanchanjungha* and *Days and Nights in the Forest* which are quite original though they don't appear to be so, because the general story-telling is quite simple. But they grapple with a lot of things, a lot of characters and the attempt is to achieve clarity, with a group of characters, with a group of situations which don't follow a normal narrative pattern.

Using Dialogue

BENEGAL: A lot has been said about the way you use dialogue in your films, that it approximates closest to direct speech, and I'm told that this is very unusual in Bengali cinema. Where did you get that from?

RAY: Actually, as I told you earlier, I didn't have much confidence as a writer of dialogue when I started, but I was lucky to be using Bibhutibhushan's material—he wrote marvellous lifelike speech, and I was able to lift the dialogue from the books and use in the films. But later on, when making *Jalsaghar*, and particularly with *Parashpathar*, I started being creative as far as dialogue-writing was concerned. And gradually what happened was that I wrote more and more a sparse kind of dialogue, which was a very functional kind of dialogue. As you probably know, a dialogue, apart from revealing characters, is also supposed to advance the story and give information, and all this.

BENEGAL: . . . and also humour.

RAY: . . . also humour, yes. So it was again a question of trying to be as economical as possible, while at the same time remembering the functions of a dialogue. And apart from that I suppose you have to have a good ear. You study the kinds of speech various kinds of people use, and eventually use that in the film.

It's only while dealing with a village that one uses the convention of a roughly rural speech, without being consciously too regional, because that gives rise to all manner of problems with the actors. So in my Trilogy . . . well, I was using the speech Bibhutibhushan Bandyopadhyay had written. But even later for *Ashani Sanket* I had to fall back upon the kind of speech Bibhutibhushan had used, and this is accepted as rural speech.

BENEGAL: You have so many dialects in Bengali. How do you use them in your films?

RAY: Well, in my urban stories I try to retain the dialect as far as possible, in the sense that, for instance, the North Calcuttans would speak a different kind of Bengali from the South Calcutta people, or people who have migrated from East Bengal would retain in their speech a lot of the East Bengal accent. All that one has to keep in

mind. But when dealing with the village one uses the convention of a roughly rural speech without being too regional, consciously regional. Even in older or other Bengali films, in the films from Saratchandra Chattopadhyay and other Bengali writers who had written about village life, they would use a kind of speech which would not be too strongly a dialect, but be a sort of general rural dialogue which was accepted as a convention. We didn't depart from that, we used that in *Ashani Sanket*, which, for instance, is supposed to have been set in the region of Birbhum where the speech is not like what is used in the film really. But then I don't identify the place too much because most of the villages look alike anyway.

Women

BENEGAL: Mr Ray, most of your films have dealt with change actually. Your characters, your main characters are usually either coping with or adapting to this change. It starts with your trilogy and carries all the way through to *Jana Aranya*. When you have dealt with that, you have also dealt with women in *Charulata* and *Mahanagar*, and how they are coping with change. But beyond that I don't think you have done very much work about women in films. Why are you not interested?

RAY: Well, I'm trying to think what I've done actually. In the Trilogy of course Apu was the main character, then *Jalsaghar*, *Parashpathar*, *Abhijaan*—all films about men really in the centre. *Mahanagar* presumably was the first film (about a woman), although in *Devi* you had this young girl who, you know, was a victim of circumstances, not so much change; well, change also in a way, but not in the sense *Mahanagar* is about change or *Charulata* is about change. After *Mahanagar* and *Charulata*, *Kapurush* to a certain extent is about the same thing. Then what did we have? Then we had the Calcutta stories which deal mainly with jobless young men or men with jobs. No, it's not that I'm not very interested in that question, but it's just that I didn't come

across an interesting enough story. My next film, *The Home and the World*, is again about a woman in the centre, and about change, very much about change. But it's just one of those things, because I've been doing all kinds of different things over the years.

On Reception

RAY: It takes a long time to . . . (*pause*) . . . gauge an audience. You know, one makes a film with a sort of ideal audience in mind. One hopes that one can do what one likes oneself, gets excited about it . . . finds it absorbing . . . hopes there will be an audience to have the same sort of reaction to the film once it is made. But in the earlier stages, I think I made many mistakes, because, for instance, *Pather Panchali* was a great success, *Aparajito* was not. It was a failure from the box-office point of view, and that applies to *Aparajito* all over the world, it is the same reaction everywhere, which is very interesting, because you obviously have a kind of standard general audience reaction to a film regardless of where the audience is. But watching the film with the audience one realizes that there are mistakes in the film, and the mistake is not perhaps in the audience, but in the maker. Since I have tried not to repeat myself, there has been an element of risk in almost everything I have done because I was trying out something new, something which the audience had not seen before. So it has been like that, and also the fact is that the audience has grown over the years, has become more mature, more sophisticated over the years. Partly from the film society movement, partly from the fact that seeing my latest film has been a sort of necessary cultural sort of necessity, and they have followed *my* trend very very carefully. I am talking only of the urban audiences. I don't really know what happens outside the city limits.

BENEGAL: For many years you have been . . . you know . . . your status in Indian film has been, as one might call it, one of splendid isolation.

You have been quite alone in what you have been doing, and with the kind of concern you show in your films. Now, has that affected you in any way, because there hasn't been enough of a kind of a bouncing board to react against or to place yourself in the milieu?

RAY: Well, this is not something of my creation. I mean one would have wanted, for instance, to start a trend, a whole new trend or something like that. But we have had directors here in Bengal—a couple of directors here certainly who have been working almost simultaneously with me. They started at about the same time as I did, Ritwik and Mrinal. They were both working, not Ritwik so much, but Mrinal worked fairly regularly, and then Ritwik off and on. They were making films very different from mine, very different, but very powerful, I think. So in any case filmmaking has so many hassles that ... so problematic here to get a film done ... one stops thinking whether you are creating a school or whether others are following in your footsteps. You just keep on working because after all it's also a living, and you make a living, and you express yourself at the same time, crossing many obstacles on the way. Filmmaking has never been easy here. Certainly not.

BENEGAL: But doesn't it ... don't you feel the need that you do require a kind of stimulus, outside the one that you generate for yourself as a filmmaker?

RAY: What stimulus are you talking about? Because by and large my films, many of my films, have been received well, for instance, if not here ... sometimes here, sometimes abroad. So there has been a sense of satisfaction after making a film. Nothing, almost nothing, with the exception of two or three which either didn't export or didn't go down well here, most of the films have eventually had success, been successful in the sense that they have got either money or recognition. Almost none of my films has lost money. Eventually, in course of time, they have brought back their cost. So it's been more or less

. . . the feeling has been a fairly happy one. But the difficult part has been the making of it.

This is an edited and reconstructed version of a series of interviews done by Shyam Benegal which were published as *Benegal on Ray: Satyajit Ray, A Film by Shyam Benegal* (Calcutta: Seagull Books, 2003 [1988])